THROUGH TIBET TC

THROUGH
TIBET TO EVEREST

BY

CAPTAIN J. B. L. NOEL

FELLOW ROYAL GEOGRAPHICAL SOCIETY, ASSOCIATE ROYAL
PHOTOGRAPHIC SOCIETY OF GREAT BRITAIN, HONORARY LIFE
MEMBER AMERICAN MUSEUM OF NATURAL HISTORY

Hodder & Stoughton

LONDON SYDNEY AUCKLAND TORONTO

British Library Cataloguing in Publication Data

Noel, J. B. L. (John Baptist Lucius)
 Through Tibet to Everest.
 1. Asia. Everest. Mountaineering expeditions,
 history
 I. Title
 915.49'6

 ISBN 0-340-49092-6

Published by Hodder and Stoughton,
a division of Hodder and Stoughton Ltd,
Mill Road, Dunton Green, Sevenoaks, Kent TN13 2YE
Editorial Office: 47 Bedford Square, London WC1B 3DP

Printed in Great Britain by Butler & Tanner Ltd, Frome, Somerset

To

MY FATHER

FROM WHOM I INHERITED

A LOVE OF TRAVEL

FOREWORD

to the 1989 edition

CHRIS BONINGTON

At ninety-eight, Captain John Noel is the sole surviving member of the 1922 and '24 Everest Expeditions. As expedition cinematographer, he helped to immortalise the mystery of the loss of Mallory and Irvine high on Everest's North East Ridge and has also left us with some wonderful images of Tibetan landscapes and the expedition to Everest in his hand colour tinted photographic plates, taken on a primitive frame camera and developed in the field. His photograph of the mighty citadel and monastery at Xegur (Shekar) is particularly poignant, for today it is a shattered ruin, destroyed with 2000 other monasteries during the Cultural Revolution. But his sense of adventure dates back still further, to before the First World War. As a young lieutenant in the army, serving in India, he went exploring in the Himalayan foothills before conceiving the ambition to reach the foot of Everest, at a time when both Tibet and Nepal were firmly closed to foreigners.

Through Tibet to Everest starts with a description of this journey. Having driven across Tibet on the roads built by the Chinese, I can't help envying the sense of adventure and the unknown he experienced in those days when there was no wheeled transport, no roads and yet when it was possible to talk and argue your way past Tibetan officials. He got within forty miles of Everest, exchanged shots with Tibetan troops, and was eventually forced to retreat.

No doubt he would have returned to Tibet if he hadn't

been caught up in the First World War. Noel had a distinguished war career, which he was undoubtedly fortunate to survive, having fought at Mons, Le Cateau and Ypres. Once the war was over, his interest in Everest revived. He was planning another journey into Tibet with Kellas, perhaps the greatest of all the pre-war mountain travellers, but the Alpine Club and Royal Geographical Society were also casting their eyes towards Everest. Kellas was a member of the Everest Reconnaissance but died on the way into the mountain.

In the following year, Noel was invited as expedition photographer and film-maker. It was an invitation that was not popular with several members of the expedition, who objected to the intrusion of someone they saw as an outsider and media man, even though Noel had a wider background as a mountain explorer than most of the other members of the team. He certainly faced a huge challenge on the climb, for not only did he reach the North Col in 1922, staying there for a fortnight, but he also had to develop all his film, both movie and still, in a makeshift darkroom in a specially designed tent.

After the two expeditions he showed his film and slides publicly, even bringing back to Europe in 1924 a group of Tibetan lamas to provide background music to his show. Without the competition of television, his lectures had an impact that I today cannot help envying. He filled the Scala Theatre in London and followed this with eight coast to coast tours in the United States, filling halls wherever he went. He was probably the most successful mountaineering lecturer of all time.

But beyond that he is a great character and a fine mountaineering film-maker, who worked in conditions that make the efforts of the modern film-maker seem very easy. While in his book *Through Tibet to Everest* he succeeds in capturing, not only the story of the 1922 and '24 expeditions, but also the atmosphere of a Tibet that has been changed for ever.

CHRIS BONINGTON
August 1988

FOREWORD

to the original edition

This account of great enterprises is written primarily for those who are not ordinarily interested in mountaineering and Himalayan exploration. In it I have tried to tell of the lure which led men to adventure in fascinating forbidden lands, and to the lofty summits of the world's highest mountain. I have tried to write always from the human point of view ; those who are interested in the scientific aspects, which I have deliberately only lightly touched upon, I refer to the admirable official accounts of the Everest Expeditions.

If the story fosters the love of adventure, and evokes emulation of the dauntless spirit of the men of whose exploits it tells, then I shall feel indeed rewarded.

J. B. L. NOEL.

For the incorporation in this book of some material previously published in the Sunday edition of the *New York World*, I thank the Editor of that journal. I would like also to mention Mr. J. M. O'Connor for his assistance in the final preparation of the manuscript for the Press when I was occupied in a long journey in America. I have to thank the Editor of *Punch* for an extract, the editor of the *Sphere* for the use of a drawing, Messrs. Johnson & Hoffman, Calcutta, for a photograph, and Mr. Francis Helps for the cover design and sketches.

J. B. L. NOEL.

CONTENTS

PART I

PART II

THE FIRST EXPLORATION AND CLIMB

PART III

THE SECOND CLIMBING EXPEDITION

ILLUSTRATIONS

between pages 144 and 145

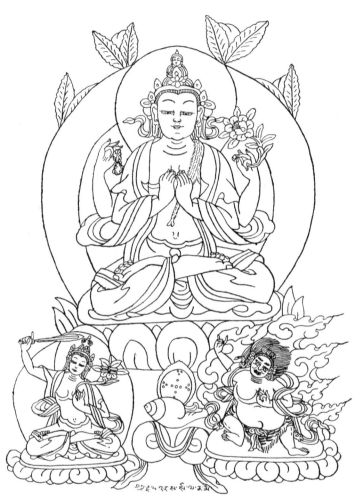

ཨོཾ་བཛྲ་སཏྭ་ས་མ་ཡ་མ་ནུ་

SPECIMEN OF TIBETAN DESIGN. NO. I.

PART I

THE CHALLENGE OF THE MOUNTAIN

CHAPTER I

THE BLANK SPACE ON THE MAP

The first scene in the series of dramas which together constitute the Story of Everest has for its setting prosaic Indian Government Offices where one day in 1852 the Bengali Chief Computer rushed into the room of the Surveyor-General, Sir Andrew Waugh, breathlessly saying : " Sir, I have discovered the highest mountain in the world ! "

The Office of the Trigonometrical Survey had been long engaged on a series of observations of the peaks of Nepal from the plains of India. Native names had been officially adopted where native names were known, but many of these mountains, so numerous, massed together and towering one above the other, were nameless even to natives. Numbers therefore had to be given to distinguish them. Among these unnamed peaks was one " Peak XV." Observations of it were recorded in 1849, but were not worked out for some three years afterwards.

Then, leisurely working over the accumulated data, the Computer made his dramatic discovery and immediately hastened to his Chief with the news.

Excited as he was, he could have had no conception of the adventures to which his mathematical calculations were destined to lure men. The sequel was to be a struggle with gods and demons— existing only in the minds of the dwellers in the remote country of the mountain, but none the less real opponents. It was to be a contest with Nature in her cruellest moods, waged where the earth, surging upwards, thrusts herself, stark, bleak, and lonely, through her enveloping atmosphere into the Great Void.

Immediately the officials got busy. Carefully the observations from all six stations whence this Peak XV had been observed were checked, and the mean height of 29,002 feet was arrived at. The measurement was in later years carefully re-checked and raised to 29,145 feet. Sir Andrew Waugh named the mountain after Sir George Everest, his predecessor, the Surveyor-General of India, under whose directions the triangulations had been started, but afterwards the Everest Expeditions discovered that the Tibetan name is Chomolungma, which means " The Goddess Mother of the World."[1]

All sorts of people have from time to time told stories of mountains higher than Everest; but it is definitely known that there is no higher mountain. Thus it became the dream and goal of explorers and

[1] Some nations have named the mountain Gaurisankar, but this is wrong, for explorers have ascertained that this is the native name of a mountain in Nepal, over a hundred miles from Mount Everest.

mountaineers. But nobody could reach it, although it was so tantalizingly near. It was computed to be only 110 miles, as the crow flies, from Darjeeling, and to be situated on the borders of Nepal and Tibet; but the Tibetans refused, as also did the Nepalese, to give permission to approach it.

Access to the giant peak was not to come for many years. The mountain land of the Himalaya that bounds India on the north like a huge wall of rock and stretches beyond to the east and the west, might be called the backbone of the world. There are 2,000 miles of giant mountains, one hundred peaks each 24,000 feet in height, higher than any mountains in other parts of the world; twenty giants 26,000 feet in height; six super-giants of 27,000 feet; and finally the culminating summit of Mount Everest, 29,145 feet—5½ miles high. This mountain range, one of the youngest in the world, is still being pushed up, so geologists tell us, by the pressure of the oceans on the crust of the earth.[1]

What were the secrets guarded by these colossal natural ramparts ? Now we know the geography, but it is not long since Central Asia, from the Pamirs to Tibet and the Gobi Desert as far as the steppes of Siberia, were white space on the best of maps, except where dotted lines marking the routes taken by rare explorers, such as the Abbé Huc, Bogle,

[1] " Odell, a geologist and climber of the last Mount Everest expedition, found fossils at a height of 25,000 feet. They belonged to a period over one hundred million years ago when Everest was below the level of the ocean."

Turner, Manning, and some Russians from the other side, stretched tenuously.

The position of Lhasa, the mysterious home of Buddhism in the heart of Tibet, was only guessed at. Such data as its latitude and longitude were unknown. Only vague knowledge existed of the Tsanpo, the great river of Tibet which becomes the Brahmaputra in India, and of the great Indus which comes down from Tibet, carving its way through a series of terrific gorges in the mountains.

All this geographical knowledge had to be sought. But how?

The Himalayan passes were walled, barricaded, and guarded by hostile Tibetan soldiery. Beyond the passes the lamas in their fortress monasteries ceaselessly spied the land for foreigners, and captured and tortured any they found. It was hopeless for any white man to attempt to go.

The story of how the prayer wheels and rosaries of the Tibetans, instruments of piety, were cunningly turned to use against them, is one of the most fascinating romances of Asiatic exploration.

In 1860 Captain Montgomery, an active officer of the Indian Survey, hit upon the idea of training certain intelligent Indians in the use of scientific instruments. They became known as the " Pundit Explorers." They were not all Hindoos, although styled Pundits. Some were Mohammedans, like Ata Mahomed " The Mullah," who explored the gorge of the Indus. Another was a Persian, the

intrepid Mirza Shuja, who found his way through
North Afghanistan and the Pamirs, but in later
years was foully murdered in his sleep at Bokhara.
Because of the secrecy of their explorations the
names of these men were not published until later
years. They were known by two letters, Kalian
Singh becoming " A.K." ; Hari Ram, who explored
towards Mount Everest, " M.H."

They were trained in the making of route traverses
by compasses and the pacing of steps. They
travelled in disguise and were allowed a free hand,
earning only a few rupees a month. They were re-
warded only when they returned—if they returned !

What perseverance in the face of danger and what
skill they showed in their scientific observations !
" A.K." from his traverse fixed the longitude of
Yarkand as 77° 15′ 55″, and seven years later this
was checked by wireless telegraphy and found to
be actually 77° 15′ 46″.

They would leave on their journeys and disappear
sometimes for years, reappearing unexpectedly with
the geographical knowledge so laboriously collected.
They counted their every step by the revolution of
their prayer wheels, or by the beads on their rosaries.
At night they would write their notes on a roll
of paper hidden inside the prayer wheel. They
recorded compass bearings of mountains and rivers
passed, by means of little compasses cleverly dis-
guised as amulets worn round their necks. They
carried boiling-point thermometers inside hollow

walking sticks for the measurement of altitudes. Some pretended to be pilgrims and others traders, carrying medicines in order to ingratiate themselves with the lamas and officers they met in Tibet.

The physical hardships and nerve-racking effects of such travels told heavily upon them, and not more than two or three journeys could any one explorer accomplish in his lifetime. If he survived these he was withdrawn and employed to teach and train other men to continue the work. Time after time they suffered robbery by bandits or desertion by companions and caravans to which they had attached themselves, as in the case of " A.K.", who, after he had been away for four years and had been given up as lost, made his way back through China, destitute except for the knowledge gained of another two thousand miles of the Forbidden Land.

One of the most romantic of all these adventures was that of the Pundit, Kintup. He was sent to trace the course of the great Tibetan river, the Tsanpo, and to find out if it was the same stream as the Brahmaputra which pours into India from the Himalayas through the impenetrable forests of the Abor Savages.

For two whole years, every day and night, Captain Harman of the Indian Survey, who sent Kintup on his hazardous mission, had the river watched in India for the special blocks of wood that Kintup was to cut and throw into the river in Tibet. But never a block was seen. Then Captain Harman fell

seriously ill, left India, and the watch was abandoned. So also was hope that Kintup would ever return.

Kintup meanwhile had fallen a prisoner in Tibet, and been sold as a slave. Four years later, however, he gained his freedom and then—such was the amazing devotion to duty of the man—instead of making his way home, he set out to accomplish the work for which he had been sent. He followed the course of the Tibetan river into the unknown, within 60 miles of the plains. There he came to forest lands where he cut logs and threw them into the river. But more than four years of dwindling hope had gone by and there was no longer anyone watching for them.

Brave Kintup got back to India at length, and went to report to the Survey Officers and to ask who had found his logs. The story he gave of his wanderings was so romantic that many disbelieved him, but the Survey Department trusted his account officially ; and, indeed, later his discoveries were proved true. Kintup received just reward for his devotion. The Geographical Society honoured him, while the Indian Government gave him the Order of Commander of the Indian Empire and a gift of a prosperous village where he could spend the remainder of his days.

The Explorer Hari Ram, " M.H.," was sent in the direction of Everest. He made his way from India secretly, disguised as a pilgrim, by the Kosi, one of

the great rivers of Nepal. He crossed a pass, 20,000 feet high, west of Everest, and reached Dingri, north of the mountain, in Tibet. He gained valuable knowledge of the surroundings of Everest, particularly to the north, but he found himself so blocked in by enormous peaks that he could not reach or identify his real objective. Vague rumours, however, he heard of the " Lamasery of the Snows."

This journey of " M.H." and that of Sarat Chandra Das in 1879 were the nearest foreign approaches made to Mount Everest. Sarat Chandra Das made a journey to satisfy a religious ambition, travelling from India to Lhasa. He was not a trained geographer and his account of the country along the eastern approaches to Mount Everest was vague, but interesting as showing the hardships of travel over high mountain lands. He wrote a delightful book, *A Journey to Lhasa and Central Tibet* (John Murray, 1904).

The plateau north of Everest was known as the Dingri Maidan. Besides the work of " M.H.", the Dingri Maidan had been crossed by some Capuchin Friars, who established a Mission at Lhasa in the eighteenth century and who reached Tibet via Khatmandu in Nepal, where they had their headquarters. It is significant to observe the influence which these Roman Catholic monks had upon the Tibetan lamas in matters of ritual and ceremony. The lamas copied from the Friars many things now seen in their vestments, etc. But these Franciscans were permitted

to remain for only a short while and then they were banished from Tibet.

The route they followed was far to the north of Everest, and their writings contain no mention of the mountain. For Everest is shy and retiring. She hides behind a wall of other mountains, which are nearer and appear to be higher.

At the conclusion of Sir Francis Younghusband's military mission to Lhasa in 1904, Captain Rawling and Major Ryder passed by Shigatse and surveyed the Tsanpo Valley and the mountains forming the watershed between the Tsanpo and Dingri rivers. But owing to the lateness of the season and the length of the journey that they had to accomplish to Rudok, they did not deviate sufficiently far to the south to reconnoitre the Dingri Plain, and the northern approaches to Mount Everest. As late therefore as the early years of the present century, the journeys of Sarat Chandra Das who passed by the east, and of the Explorer " M.H." who passed by the west, comprised the sum total of our knowledge of the approaches to Mount Everest. It was known that on the east side was a deep gorge, where the Arun River breaks through from the plains of Tibet ; while on the west side there appeared to be no river breaking the chain of mountains, and only high and difficult passes between Nepal and Tibet, with no practicable pass anywhere near the mountain. No explorer had penetrated to Everest's glacier valleys. Surrounding the great summit, which had been plotted by

observation from India, was a blank white space on the map. The mountain stood, stupendous; seen through telescopes; its slopes untrodden by human beings as far as we knew.

Lord Curzon, when Viceroy of India, had suggested the exploration of Everest to the Royal Geographical Society and the Alpine Club. Sir Francis Younghusband had previously talked the matter over with General Bruce, then Colonel Bruce, when they were together at Chitral in 1893. General Bruce had tried several times with Mumm and other distinguished Alpine climbers to organize an Expedition, but always political difficulties intervened. The Tibetans would not let white men approach. Nepal, an alternative through which the mountain might be reached, was closed to whites except to the political representative of the Indian Government, who is permitted to reside at Khatmandu, the capital. The Indian Government supports this policy of independent buffer States round her frontiers, into which she refuses to allow even her own subjects to enter. In return the Native States refuse ingress to foreigners from the other side.

But mountaineers, although barred from Everest, had made assaults on other giant mountains of the Himalaya. Mr. W. H. Johnson, of the Indian Survey, reached an altitude of 22,000 feet as far back as the sixties in the last century. Then in 1883 Graham raised the record by another 2,000 feet, and in 1909 the Duke of Abruzzi, accompanied by the

Brockerels, the celebrated Alpine guides, reached 24,600 feet on the Bride Peak in Kashmir, breaking down when only 400 feet from the summit, from sheer lack of air to breathe. The achievement, a marvel which astonished the world, was considered by scientists and explorers as approximately the limit to which human beings could ever climb.

When the North and South Poles had been reached, the ambitions of explorers centred more than ever on Everest. Here was a last task perhaps even more stupendous than the others. Here was a challenge to man's skill and courage, the alluring, fascinating challenge of Nature's last secret stronghold.

CHAPTER II

IN DISGUISE TO TIBET

Having already accomplished a good deal of mountain travel on the borders of India and Tibet, I decided in 1913 to seek out the passes that led to Everest and if possible to come to close quarters with the mountain. Everest ! hitherto unapproached by men of my race; guarded, so fantastic rumour said, by the holiest lamas dwelling in mystic contemplation of the soul of the giant peak, communing with its demons and guardian gods ! It was an alluring goal.

I thought that if I went with only a few hillmen from the borders of Tibet and India, I should avoid the attention a group of white men would attract. This proved to be the case. I was within 40 miles of Everest before a force of soldiers turned me back.

To defeat observation I intended to avoid the villages and settled parts generally, to carry our food, and to keep to those more desolate stretches where only an occasional shepherd was to be seen. My men were not startlingly different from the Tibetans, and if I darkened my skin and my hair I could pass, not as a native—the colour and shape of my eyes would prevent that—but as a Moham-

medan from India. A Moslem would be a stranger
and suspect in Tibet, but not as glaringly so as a
white man.

I dared not hope to escape observation entirely,
but thought I could minimize it and perhaps reach
my goal before an intercepting party would catch
me up. I planned the route from the writings of
Sarat Chandra Das.

I intended to cross the mountains by a high pass
which was not used by the Tibetans nor watched by
them. It cut off the populated districts of Southern
Tibet round Khamba Dzong and Tinki, and it would
open, I hoped, a high level road behind Kangchen-
junga to the gorge of the Arun, and then to Everest's
eastern glaciers.

All this was an ambition of years, and the result
of careful study and preparation. It would have
been impossible of accomplishment but for the help
of the men who had travelled with me before. I
could impart my plans to them. They were simple
wild men of the mountains. I talked their tongue
and they trusted me as I did them. If you travel
with a man, you must either fall out with him or
make him your good friend.

Adhu was a Bhutia with all the vigour of his race
and the youth of the twenties. His broad Bhutia
face smiled all day long whatever happened—that
is chiefly why I took him.

Tebdoo was a Sherpa Nepalese, a rough but
golden-hearted fellow who knew everything that

there is to be known about mountains and wild sheep.
After this journey he said he would come to work
for me in India ; and refused to believe that there
were no wild sheep to hunt there. But at the end
of the journey I had to part with him and send him
back to wild Nepal. I honestly regretted doing so.

Badri, a little man from the mountains of Garhwal,
had always been a favourite companion of mine on
journeys in the Himalaya. I kept him beside me
to carry the rifle and camera. He had a keen
appreciation of mountain scenery ; perhaps not for
the beauty an artist would find in it, but born and
bred among mountains, he felt their peculiar charm,
that something which draws, gladdens and mas-
ters the soul of a hillsman. How impatient and
miserable he was on the plains of India before we
were able to start for the Himalaya ! The keen,
hardy, vigorous little figure felt lonely among the
Hindoo people in that flat land. But as the days
went on and the time for the start came nearer he
responded to the delight of making " bandobast."
Then all day he was light-hearted and happy.

I intended to be free to wander where I wished,
unencumbered, so took no more baggage than would
go into two small tin trunks from the native bazaar,
a supply of blankets and two native tents. I con-
cealed in the trunks two cameras and instruments
for drawing and mapping ; a boiling-point ther-
mometer for altitudes ; a good take-down model
American rifle, that could be tucked away in any

blanket, with plenty of ammunition; also my revolver, and automatic pistols for the men.

Enthusiasm filled me for this adventure. Darjeeling was to be made the base for meeting Adhu and Tebdoo and buying ponies. Then we would plunge into the heart of the great forests that clothe the foot-hills of the Himalaya. We would pass through the tangled thickets of the tropical forest, climb into the regions of pine, larch, juniper and rhododendron, then beyond the tree line through snow-bound passes into unmapped Tibet.

" Why, look, Sahib ! There are the mountains ! "

I was awakened by little Badri, who had climbed into my carriage on the Bengal Express that runs from Calcutta overnight to Jalpaiguri and Siliguri. At Jalpaiguri at daybreak the traveller gets his first sight of the forests of the Terai with their stagnant morasses, clearings of ricefields and tea gardens. A dull green forest-clad wall of hills rises abruptly out of the hazy stretch of plain. Here and there on the distant slopes the white tin roofs of the tea-planters' bungalows flash in the sunlight. Some of them occupy solitary clearings in the green mantle of forest which covers every inch of the hills.

If the morning is clear, far to the north, over-topping the tangle of green hazy foot-hills and rising to an incredible height, may be seen a serrated line of dazzling white peaks extending the whole length

c

of the horizon from east to west, the great range of the Himalaya.

A little toy-like train starts from Siliguri. It is called the crookedest, and it is the tiniest mountain railway in all the world. Yet it does a giant's work. It climbs 8,000 feet in 40 miles to Darjeeling on the hill-top. It journeys from the plains through the heat of the tropical forests, through the Terai where tigers lurk and tea-planters cultivate clearings. Up and up it goes, turning and twisting and shunting backwards and forwards. A dozen times it makes figures of eight and zigzags and loops, where the engine passes the tail of the train, and the driver leans out and talks to the passengers in the end coach.

The track is laid along the cart road; and the engineer whistles to wake up the bullock carts and frighten away chickens and children in the village streets. At night time a man sits in front of the engine, holding a great tar torch to light the track and see that no stray tigers or elephants cause a bump!

At Ghoom comes the first view of the snows. That view rewards hours of waiting, when finally it reveals itself as the train, rocking from side to side, flies round a corner. So unexpected is the height of Kangchenjunga, the third highest mountain in the world, 28,000 feet, that people often mistake its silver spearhead for a cloud formation.

I remember the remarks of the people in the compartment, mostly residents, some invalids, and

business men who would not leave their newspapers to look at any mountains. They agreed that Kangchenjunga, a spire of ice that pierces the heavens, is a mighty sight, but their attention was given to collecting their parcels and guessing if " So-and-so " would perhaps be at the station to meet them. We were running into Darjeeling.

Darjeeling, like all Indian hill stations, is built on the very top of the hill. It has its fine club houses—its Gymkhana Club where a London quartette plays for dances, apparently all day and all night. There is a Scotch Mission, a Barracks, a Hospital, and an Observation Point to which tourists ride in a rickshaw, to lean over an iron railing and look down 6,000 feet into the steaming valleys below. From there the eye can sweep in a panorama embracing tropical forests and eternal snow.

At two o'clock in the morning, the hotel porter rings a 12-inch brass bell outside your door, and comes again every ten minutes to make certain that you do not forget that ponies and rickshaws are waiting to take you to Tiger Hill where people go to see the run rise on Kangchenjunga and Mount Everest. It is an unforgettable spectacle. Kangchenjunga commands the attention because it is so prominent, so near, and so huge. Far away to the west is a mass of huge peaks. Among them the guide points out a pyramid peeping behind the others and seeming to be smaller ; that mountain is Everest.

Just as interesting as the first sight of the mountains is a first acquaintance with the hill people. In the market place on Sunday morning may be seen a throng entirely different from the people of the plains of India. They are jovial, happy folk, and you see no veiled women's faces. There are jolly Bhutia girls—very pretty some of them, but they win you most by their high spirits and their laughter. Everyone of them is naughty. They smoke cigarettes all day long. They do most of the hard work, while the Bhutia men collect in circles to gamble for hours with dice at the street corners, or else lounge against walls, grin broadly, and doff their hats to anyone from whom they think they can get baksheesh. They are good-humoured; handsome; with gaily coloured clothes, raucous joking voices, and tangled, loose, flowing hair. They earn enough to get drunk on by pulling rickshaws or by carrying luggage to the Everest Hotel. Both men and women are immensely powerful. There is a true story told of how a Bhutia woman porter once carried a grand piano unaided 500 feet from the station to this same hotel.

It is these people with whom one lives when wandering in the forests and mountains beyond Darjeeling. They make jovial travelling companions; but the traveller must understand them and know how to manage them. They have a habit of calling at their pet drinking houses in outlying villages and getting hopelessly drunk, leaving

him without bed and supplies the first night
out.

I selected my ponies with great care. A man can
entrust his life to a good pony and not even bother
about holding the reins along the narrow paths
through gorges and across precipices, they are so
sure-footed.

Adhu and Tebdoo having been met according to
plan, all was ready for the start. The cool of
Darjeeling and the breeze that refreshed the hill-
tops changed rapidly as we dropped down and down
into the Tista Valley nearly 7,000 feet below. We
found ourselves entering the humid forest, whose
vegetation grew thicker and thicker until the trees
and the twisted creepers that climb over them,
interlaced above, formed a tunnel of greenery
hiding the sky.

We were dropping down mile after mile. The
road was the hottest I had ever felt. The blazing
sun boiled the thick, damp, rotting jungle into a
thousand oppressive smelling vapours. Swarms of
insects filled the air with incessant hum and buzz.
There came land leeches to attack our legs from the
ground and fix themselves to our boots ; others on
the trees above, warned by some instinct,—wonder-
ful but horrible, since they are blind,—swung their
bodies in the air on our approach and dropped down
on us as we passed below. There is no escape from
the leech. You must make up your mind that you
are going to lose a lot of blood. To compensate

slightly there were remarkable butterflies on this road. They were gigantic, measuring up to 4 inches across the wings and unequalled for colour and diversity.

During the next few days' march, each bend of the road—and the track was twisting and turning continuously through the forests following the bank of the river—opened a new peep of the Tista, here a broad flood broken into foam by large boulders in mid-stream, and flanked by steep mountain walls, from which the superabundant vegetation hung down and trailed into the water. We crossed a chasm by a wire suspension bridge, a frail structure swinging and lurching under every step, where the torrent below had carved itself a gorge, only some 30 feet wide, but almost 300 feet deep.

As we continued day by day the path climbed higher and higher, and the scenery changed as if by magic. The tangled jungle dropped away and we entered a smiling valley. There were meadows dotted with pine, larch, and rhododendron, with Alpine flowers and primulas beside clear streams that meandered through the pasturages.

Lachen occupies a shelf high above the torrent which tears and foams through a 500-foot cleft below. The village stands on a shelf thrown out from the flanks of snow-capped Lamadong, in a recess snug and protected from the cold. It was here I planned to leave the ponies and get six of the hardy hillmen of this village to come on with me to Tibet. They had been hunting with me on a former occasion.

Here, while making these arrangements, my men first seemed to realize the nature of our journey. They became filled with doubts and fears. "We have no man who knows those parts," they said. "How will we find the way to this mountain in Nepal that the Sahib wishes to see?" They had little faith in my map; and, truth to tell, I had little too. They feared maltreatment should we enter Nepal; and they told stories of the fierceness and exclusiveness of the Nepalese.

We went on to a high grazing ground called Tangu, 13,000 feet, where I could acclimatize and prepare for the rough work. One day, in order to spy out the geography and to exercise my men, I decided to make the ascent of one of the surrounding peaks, which promised from its position to reveal the panorama ahead. We started before dawn to climb the snow-covered slopes. The ground was smooth and of even inclination, and there was no difficulty in making good pace all the way. Finally we gained the summit of the ridge, and found that we could not have taken a more lucky direction. We were looking at the giants of the Himalaya from their very midst.

It was shortly after dawn. The slanting rays of the sun caught the fantastic crest of the immense mountain Tsenguikang in a bright flaming glow. Mists scattered, and flying erratically in whirls and eddies, chased each other over the shining ridges, now hiding the peak entirely, now evaporating and revealing fresh vistas of ice and rock and precipice.

Looking west in the direction of Kangchenjunga we saw the first pass over the ridge towards the tangle of snow mountains into the heart of which we were to go. Deep below us was the cleft of the valley through which we had come from India. It continued to the north towards the Koru Pass that leads to Tibet, but is watched by Tibetans and guarded by the fortress of Khamba Dzong on the other side of the divide. There was no way for us into Tibet there. To the north we saw the landscape broadening, and in the far distance we got a glimpse of the plateau land of Tibet that stretches on for hundreds of miles, bleak deserted plains that roll away to Central Asia.

I could not have struck a better place for observation. The boiling-point thermometer measured the altitude as 16,700 feet. There was not a cloud to spoil the splendid view; and I lingered, contemplating the solitudes and admiring and storing in memory the beauties of the crystal air and turquoise sky. The men grew cold in the biting wind that blew in fitful gusts over the ridge. Although fine as a view-point, an exposed ridge at this height is no place for a doze.

From here I was to strike to the west and take a high level track that would take us out of the Indian Empire behind Kangchenjunga into Southern Tibet.

We carried fourteen days' food with us. The first pass of 16,000 feet was no great obstacle. In two days we were across, spending one night at a

Tibetan camping ground called Chabru, where there
is a cave making a fine shelter. From there we
looked down to the high verdant pasture lands of
Lhonak where the Tibetan shepherds come in the
height of summer by the Naku Pass from Khamba
Dzong. The valley is a lofty secluded basin at an
elevation of 16,000 feet, surrounded by walls of
snow. In a hidden nook deep in the heart of undis-
covered lands we stood alone among the solemn
majesty of the sentinel mountains.

We sampled the variable Tibetan climate, where
the sun shines in the rarefied air with dazzling
brightness and burning heat. The rays parch the
lips and tan the skin, even blistering it. Suddenly
the sun may veil over and the wind spring up. Then
—pile on your thickest clothes if you would not feel
perished with cold.

I challenged Tebdoo to a race down the hill. In
the mountains it is often easier to run down slopes
than to walk ; and, indeed, when one is tired, it is
often a relief to break into a run. But you must
have strong knees and a good stick to lean back upon.
Tebdoo, who was at heart only a boy, delighted in
amusements of this kind, and won the race, at the
cost of his skin boots. However, he could mend
them quickly by sewing on a new piece of the un-
tanned sheepskin which all hillmen carry in their
bokkus.

We pressed forward through this country and
got behind Kangchenjunga, where our course turned

again to the north to cross the high Chorten Nyim
Pass. The pass is a cleft in the mountains, blocked
by snow and the debris of rock avalanches. I
had learned that the Tibetans had abandoned the
pass, and by crossing it I hoped to get into Tibet
unobserved.

The day before crossing we made camp on a shelf
looking right across to Kangchenjunga's precipices
to the south. That evening I spent watching. It
is in the evening that these mountains wear their
most fairy-like aspect. Vapours and mists, evapora-
ting, form themselves again, and coil worshipfully
round the cliffs and ridges. Kangchenjunga's pre-
cipices rise 12,000 feet sheer from the glacier below.
As I watched, the slanting shafts of light crept up the
fluted precipices and caused their draperies of ice
to scintillate as with fire. On the eastern side the
shadows gathered. Twilight conquered, the depths
became a dark chaos,—in such shadows might have
been enacted the primal mysteries before Time
began — but the summits of Kangchenjunga re-
mained aflame, like beacons high above the night-
enveloped world below, and seemed to shine with a
luminosity all their own.

With the darkness came biting frost; and I
turned quickly to creep into the tent and wrap a
blanket round me.

I brought three of the men into my tent, as there
was plenty of room, while their tent was overcrowded.
They curled themselves up side by side, wrapped

tightly in blankets, and so kept each other warm. I woke in the cold and darkness of the night to stir the smouldering juniper logs of the fire. Outside all was silent, and nothing could be seen except the still shining ghost-like mountain spires of Kangchenjunga.

Unable to sleep because of the cold, I remembered eerily how once, in a previous Himalayan adventure, I had seen at the monastery of Gantok, the capital of Sikkim, the annual festival of the worship of the god of Kangden-Dzod-Nga, Kangchenjunga—this mountain. The pageant took place in the presence of the Maharaja and Maharani before the Chief Magician's temple in the garden of their palace, with a retinue of brightly clad Lepcha guards.

The god is called Dzod-Nga, meaning " Five Treasures." He is the war god, and every year the ceremony must be held to placate him, and to foster the martial spirit of the nation, while the lamas invite Dzod-Nga to guard the faith of the State and to bring peace and security to the people.

Flashing sword dances are accompanied by the blare of lamas' trumpets, processions of temple gods, and other religious ceremonies.

In the dance of the Dorge-Gro-Dosjidros—the mystic step—the triumph of Truth over Evil is believed to be accomplished. This dance is held with loud cries, led by the Maharaja at his throne, and echoed in a chorus of thousands from his assembled subjects—" Ki-Kihubu! Ki-Kihubu! "

It is the voice, as is also the thunder in the heaven,
of the war god who consumes mountains of dead
as his food and drinks oceans of blood as draughts
and relishes the organs of the senses for dessert.
" Ki-Kihubu—I am the blood-drinking and destroy-
ing god! Glory to Maha-Kala! Should any love
his life, keep out of my way. Any wishing to die,
come into my presence. I will cut the red stream
of life—glory to Maha-Kala-Ki-Kihubu."

The dancers work themselves into a frenzy,
wounding each other with their swinging swords,
and imitate a fight between the followers of the war
god and his enemy. Heralds of the Sword chant
loudly :

" This blood-dripping sword is the despatcher of
lives. It is made of the substance of the thunder-
bolt, welded by a thousand wizard smiths. In the
summer it has been tempered in the white mountain
tops, in the winter it has been tempered in the ocean
beds. It has imbibed the heat of fire and the venom
of the ocean. It has been dipped in poisons. Its
edge has been ground on the man-slaughtering
boulder. When waved over the head it emits sparks
of fire. When lowered point downwards it drips
blood and fat. It is my dearest and most cherished
friend—My name is the Lightning-like Life Taker!
Ki-Kihubu ! "

All very ludicrous, and to the Western mind, when
the first impressions begin to pall, even rather tire-
some. But alone in these remote mountains, in the

icy depths of their night, those raucous cries came
echoing through my memory. This was the very
home of that mountain god. Giant shapes flung
themselves to the skies all round me. Who was I
to violate with impudent temerity these forbidden
solitudes? The wind howled, now miserably, now
angrily round our tiny tent. I shivered, and
although I told myself that it was the bitter cold, I
began to wonder, if—after all . . . !

CHAPTER III

WITHIN FORTY MILES OF THE GOAL

Next morning we shook ourselves up at an early hour; our blankets stiff with frozen dew. We had a hard march before us.

The pass looks like the work of a giant axe that has split a narrow cleft in the mountains, and left the bottom raw and splintered. Huge fingers of rock point vertically between cliffs on either side. When we reached the foot we found the debris of avalanches precipitated from above—the danger that had caused this pass to be abandoned by the Tibetans. Rocks fell as we climbed, and we met an exhausting obstacle in the loose shingle that slipped beneath our feet. Even the highest and loneliest Himalayan passes are crossed occasionally, as this one used to be, by shepherds, and in their migration in search of grass they perform amazing feats getting their yaks and sheep and goats, their families and foodstuffs across. The animals, each carrying a light load of tsampa and tea sewn into little wooden bags, balanced and strapped to each side, find their own way. The yaks are so sure-footed, on ice and rock, that they can go almost anywhere a man or goat can go. The shepherds

46

sing and whistle shrilly and hurl stones from their slings to urge and guide them.

But we were not yaks, and the men felt the burden of their loads, heavily laden as they were with our reserve food. One man complained of noises in the head ; Adhu's nose started to bleed. The air was dead—mountain climbers know this condition as " stagnant air "—but the men called it " La-druk," the Poison of the Pass. They say it is the evil breath of the Zhidag—the Spirit of the Mountains.

But on the top we found good air and the men became happy and began to sing mountain songs. They built cairns, tied strips of coloured rags to them, lifted their caps and cried, " Om mani padme hum." These cairns were to counter the evil spirits.

But their flags did not drive away the low spirits which began to assail me. When I looked down to the desolation below, I felt discouraged. Ahead was the unknown—a foodless, inhospitable, forbidding waste. Moreover the obstacle of the pass we had just crossed would lie like a barrier across our homeward tracks. We did not dare to look back to the lovely grassy meadows of Lhonak, lest they should lure us from our goal. We had to nerve ourselves to go forward to the north—to Tibet. We would have to find some shelter by the glacier to spend the night. Next day, we would look for the pilgrim's shrine of Chorten-Nyim, reported by the early native explorers as lying where the mountains drop to the plains.

The men became anxious for our safe descent to Tibet, for the prospect was indeed threatening. A staircase of rocky ledges conducted to the terraces of ice which formed the head of the glacier below. Where glaciers at their source break away from the rock walls of the mountains, they leave gaping cracks, sometimes invisible under snow crusts, and a great danger when descending passes. We had to make our way, cautiously avoiding immense cracks down which we could look, sometimes 50 feet, into dark recesses.

That night we sheltered in a nook by a glacial lake. In the mountains I think one can scarcely find a prettier sight than these glacial lakes. They are like pale blue translucent cups filled with emerald water.

A night spent on a glacier holds many sensations. The stars at night in the rare [air seem to be larger and brighter than you have ever known before. The slowly moving ice gives out weird noises as it rends itself, opening out new fissures with reports like pistol shots. Surface stones slip and gurgle down into the thinly frozen water of the lakes. Now and then louder noises, sometimes reaching a deafening crash, tell of rocks falling from above. The melted snow water, lodging in cracks during the day, freezes at night, and expands and loosens the rock. You will hear also what the natives name " the music of the wind." Ice pinnacles whistle shrilly as their sharp edges cut

the wind and the ice caverns moan deeply as it eddies in their hollows. Wrapped in your blanket, your breath freezing on its edge, uncomfortable on rough stones, your native companions—for you feel no colour bar when sleeping out in such conditions—huddle close. You are glad to have them near, as you wait for the dawn to come.

Morning showed no signs of life or vegetation. We found the way, avoiding boulders and crevasses, left the broken ice and walked to the side of the valley. After some miles we came unexpectedly to a little stone hut on a promontory where the valley closes to a neck. The hut was deserted. I expect it was the identical one mentioned by Sarat Chandra Das as the first Tibetan guard post ; but it was no longer inhabited by any Tibetan guard.

Adhu discovered the shrine by following the line of chortens which are put up to guide pilgrims from the north and are built on the hillocks. The shrine, a place of special sanctity, lies hidden in a secluded nook. Numbers of tame birds and blue pigeons inhabit the cliffs and are fed by the nuns who live at the shrine. The spot has a special beauty in its solitude and in its gaunt surroundings. The valleys converge with white tongues of glaciers protruding from the cavernous mouths of the mountains that stand behind dark and solid.

The shrine is circled by a well-worn pilgrim's path, marked with mendongs, and poles with flying prayer flags. As we approached we behaved as pil-

D

grims, lifted our hats, cried, " Om mani padme hum,"
and contributed stones to the foot of the chortens.

We entered and I took a dark corner to hide in
while Adhu conversed with the nuns. We found
that the chief nun and two others were quite blind,
which relieved me of some anxiety. There were
altogether seven nuns living at the shrine.

" Are you pilgrims ? " they asked.

" No, we are travellers from India."

" Make offering to our shrine that no misfortune
may overtake your journey. And take these
potions to bring strength and love to your lives,
for you Outer Men " (meaning men of earthly affairs)
" prize these things for the body more than those
things for the soul. Live more for the inner life,"
they said.

We made suitable offerings to the shrine, placed
grains of rice in the bowls by the butter lamps
beneath the god images ; accepted the pills and
love potions the nuns gave us. Then the nuns
brought out goat-bladders of yaks' milk and *chung*
from their bokkus and gave us to drink. Adhu
talked with them and obtained information for our
journey. The nuns said we were brave to come by
the snowy road ; they even said we might sleep
here, but we feared other people might arrive. We
thanked the nuns for the wise things they had told
us, to which they answered, " We know your dark-
ness " (ignorance) " and we will pray for you."
Then we took our departure.

Here at Chorten Nyim we were at the exit from the high mountains. To the north we contemplated the plateau of Tibet, the highest desert of the world. It has much of the character and appearance of an Arabian or an Arizona desert, with the same breadth and space of sandy, rocky soil, intersected with ranges of undulating hills, bare of trees ; but it has this difference, that the far horizons show snowy peaks.

In depressions between the hills, more like shallow basins than defined valleys, is seen the green of the marsh-lands along the banks of lakes and winding rivers. Beyond the grass-lands sandy wastes continue ruffled and blown into dunes by the wind. As in all deserts, there is shimmering sunshine and clear sky, yet the sky of Tibet seems to have a special blue all its own. As in other deserts, the day is hot and the night is cold. Here is experienced a difference of 50° between day and night. All is peace and breadth and solitude ; guarded by snowy mountain barriers that wall away the outer world and lend an impression of majestic loftiness to this peaceful plateau. We felt ourselves to be above the other world,—veritably on the roof of the world.

We continued due west, following a high level line over the spurs of the mountains, switchbacking over ridges and across deep glacier valleys. We could make little headway, and finally we were stopped altogether by deep canyons. We descended to the bottom of one by a funnel, but could not find

any way out beyond. We were obliged to turn back and take a lower level route by the plain, hiding ourselves and passing villages at night, making detours to avoid the dogs that, hearing every movement of men and animals within the distance of a mile, barked and howled. These Tibetan mastiffs, found in all the Dok-pa shepherds' encampments, are magnificent yet savage animals. Attacking, they show fangs like wolves, and their ferocious appearance is heightened by the immense scarlet ruffs of yak hair which the Tibetans place round their necks like Elizabethan collars. These dogs are prized for their ferocity, and the mark of their breeding is the depth of their bark. The Tibetans say their bark must ring like a well-made gong. Once I had to shoot one of these mastiffs that rushed out and bit one of my men badly.

We had now fairly well escaped the fortresses of Khamba Dzong and Tinki Dzong; and I wanted to bear into the valleys in the direction of Nepal, which promised more friendly concealment than the plains. But I was vague as to the way to the Langbu Pass, so we decided boldly to turn into a certain village that we saw in the opening of a valley leading south-west.

Our approach caused the keenest excitement, the barking of dogs and the barring of doors. Along the sky line of the roofs were the flying prayer flags and bunches of dried grass, and we noted peeping heads observing us from the apparently deserted

houses. Keeping on our way, and meeting people, we boldly insisted on being given a house to live in.

The people are forbidden by the lamas and Dzong-pens to furnish information to strangers ; but they do not do more than offer a passive resistance and answer " No " or " I do not know " to everything. They would, however, always give information in return for presents secretly conveyed, and at night time they would give us food in return for money. The Tibetan peasant himself is friendly, generous and hospitable, although with the same freedom that he gives his own things to you he will also make you a present of other people's things and take what he fancies of yours. In the spacious folds of his bokkus he stows away anything up to the size of a cooking pot.

A man and woman befriended us at this village, which we found was called Eunah, and gave us to eat and drink at their house. We climbed a wooden staircase to the living-room above the stable which always occupies the lower floor of a Tibetan house. There were no windows, but a circular hole in the ceiling let in light and let out the smoke of the yak-dung fire burning in the chula, or earthenware pot. There was also the dim light of the butter lamps burning before the family shrine. We sat round the fire on sheepskins and Tibetan woollen rugs and brought out our wooden tea bowls from our bokkus to drink buttered tea and eat tsampa.

I behaved just as one of my own men, except

that I conversed in the Indian language, using a few Tibetan words that I knew.

Our visit, although no doubt causing our presence in the country to be reported to the governors of the fortresses, served its purpose, in that we found out from the people the way to the Langbu Pass. We got the information out of two boys who said, " Go to Changmu to-morrow—bridge to cross— go little along the river to two chortens. Then go up between high stones and you will find yak paths."

This we did, passing the curious rock-hewn settle- ment of Changmu, consisting of about a hundred caves like huge pigeon-holes high up on the sheer face of a sandstone cliff. They were cave dwellings and we kept some distance away, not knowing what the hidden inhabitants would do. In Tibet there are many such caves, and they are said to be con- nected with passages leading out to the tops of the cliffs. They make splendid dwellings, protected from cold and heat and enemies alike.

We found the chortens the boys spoke of, and the yak paths that led into the mountains to the west. We breasted the bridge which separated us from the valley of the Langbu Pass. Below our feet was the winding valley of the Gye river. A track could be seen along the open red sandy hillsides. On we went, doing about 18 miles that day by my paceometer, and camped by the stream, where we found fuel and could light a fire.

By climbing 1,500 feet up the hillsides I observed that evening the position of the Langbu Pass, also that of another pass to the south, leading back over the main chain to Nepal and giving access probably to the Kambachen Valley somewhere near the foot of the Kangchen Glacier. This would make a back door from Lhonak to Southern Tibet through a corner of Nepal. There is still another pass that way, the Chabuk-la; but it is said to be very difficult.

Next day we struck out towards the Langbu Pass, crowned by the fine mountain called the Langbu Singha. The all-important question was: Could Everest be seen from the top of the pass ?

When I reached the top, I was staggered by a magnificent view of towering snow mountains. The centre peak of the range rose as a glittering spire of rock clothed with clinging ice and snow. Beyond rose a higher peak twisted like a hooked tooth, a precipice on the north side and a névé on the south. To the left of this again was a long-flat-ridged peak, fantastically corniced with overhanging ridges of ice.

What fine mountains ! But they were none of them Everest : they were too near. Everest was still about 60 miles away. These mountains were about 23,000 feet in height. I named them—Taringban (meaning " Long knife " in the Lepcha language) and Guma Raichu (meaning " Guma's tooth " in Tibetan).

Presently, while watching the panorama, the shifting of the clouds revealed other high mountain masses in the distance; and directly over the crest of Taringban appeared a sharp spire peak. This, through its magnetic bearing by my compass, proved itself to be none other than Mount Everest. A thousand feet of the summit was visible.

Although this fine panorama and the discovery of mountains hitherto unknown was in itself a reward, still it was also a disappointment, because it indicated an utter barrier. The only existing map showed the Kama Valley joining the Arun at the same place as the Tashirak River. I had planned to follow down the Tashirak Valley to reach the Kama Valley and then to go up this valley to Mount Everest. The maps were entirely wrong. This mountain range stood between me and Mount Everest; and the Tashirak River flowed south instead of west. I was opposed by an enormous mountain obstacle; and I felt it was impossible to overcome it. After remaining an hour on the top of the pass, during which time the men said copious prayers and built a chorten, to which they attached the usual strips of cloth, we went steeply down to the open meadows which surround the village of Guma; and there we found a shelter for the night among some dirty sheep pens and huts plastered with mud and dung. The people were not unfriendly.

We proceeded towards Tashirak in some trepida-

tion as to whether we would be stopped by the Dalai Lama's Rice Officer, who holds the toll bridge with a guard of soldiers. There was nothing for it but to go straight on and talk to him. He requested us not to cross, so we went away and made a camp on our side of the river some distance off. We struck camp, however, at about two o'clock in the morning, forded the river in the dark under terrible difficulties, and so lost two loads of our food. But I breathed again.

I hoped the valley would bend west towards the Arun. But it went on persistently south and we eventually found ourselves descending to forest lands with the valley becoming more and more narrow.

We met an encampment of Nepalese traders with their yaks carrying borax, salt, wool, skins and yak tails. They are enterprising, honest, engaging and handsome men and women, these Nepalese who spend their lives crossing the mountains, trading between Tibet and Nepal. They talked openly and pleasantly and told no lies in answer to my questions.

"This road does not go to Kharta," they said. "Down the river you will come to Hatia, which is in Nepal, and the Maharaja's guards live there to see that no strange people enter. Go up that valley," they said, pointing to a lateral valley to the west, "and you will find a Gompa (monastery) high up, from which you can see all mountains."

They spoke of a great mountain Kangchen Lemboo
Geudyong. Could this be Mount Everest? They
knew Kangchenjunga, which they called Kang-
chenzeunga. They spoke of another great moun-
tain which had a lake in its centre, which might
well be a reference to Makalu, the "Arm-chair
Peak," which has been observed from India to
have a curious cup-like formation near its summit.
Geographers think this is filled with a glacier.

These Nepalese invited me and my men to stay
in their camp, which we did for a little while, and
they replenished our supplies of mutton, butter,
ghee, salt and tea.

We regretfully parted from them; and struck
off to the westerly valley to reach the Monastery
they had spoken of, and to look across, as I hoped,
to Mount Everest.

We found a strongly fortified wall built across
the valley—a wall that had been made during the
wars between Nepal and Tibet. I little thought
how useful that wall would soon be in other ways.
Now we used it as a shelter against the wind where
we made our camp; pretty soon it was to protect
us against Tibetan bullets.

Next morning Adhu came to the tent to say that
a Tibetan Captain and guard sent to prevent us
following the upper road to Pherugh were watching
some little distance away. I went down with my
men and, forcing the Captain to dismount, asked
him what he meant by posting soldiers on us as if

we were common thieves. I found that he was the Captain of the Tashirak guard, and in the background was no less a personage than the Tinki Dzongpen himself and his followers.

They rode shaggy Tibetan ponies bridled in brass and silver and saddled in coloured numdahs. Each pony carried bulky slung leather saddle-bags and blankets; and from the general appearance of the party it was obvious they had travelled far. We learned later that the Dzongpen, hearing of our presence, had ridden 150 miles to meet us, covering the distance in three days.

An interview was arranged which lasted two hours, and was carried on for some time in rather a heated manner. The Dzongpen showed his surprise that we had been able to find our way into Tibet over the high pass, and was suspicious because we had chosen to come by such an unusual way.

" For what reason have you come to Tibet? At the time of the War " (the 1904 Mission to Lhasa) " many white men and men of India came, but since that time no one has entered the country."

They repeated again and again the same sentences: " No foreigners may come to Tibet. We do not know what you want, or for what reason you come."

I complained that I had received only discourtesy and opposition in Tibet, whereas all Tibetans coming to India were free to travel where they wished, and were received as welcome visitors.

This was, I protested, indeed a disgrace to Tibetan civilization and Tibetan culture.

The whole party became very excited at this juncture and all started to shout and talk together. The soldiers crowded round and unstrapped their matchlocks in a threatening manner. It was impossible to understand what they were shouting about or what plan they might be proposing. All I could make out was the Dzongpen saying : " Go back the way you came."

I argued, but he was insistent. Then I tried the Tibetan game. I temporized, told him I would think it over and give him a reply the following day. The discussion then took another turn. He dropped his blustering authoritative tone, and became delightfully courteous. He told me he would have to get permission from Lhasa for us to pass through his province, and he begged me by no means to travel on or it would cost him his head. So I consented to wait for instructions from his superior. But such a permission, in the unlikely event of his even seeking it, and in the unlikelier event of its being accorded, would take weeks to arrive. I knew they were only procrastinating. In a very few days the Dzongpen would inform me that Lhasa had refused, and that I was to quit Tibet immediately. I was tempted to steal away and push on with my hillmen. I was nettled, meeting this opposition when so near to my goal, and at the prospect of failure after so much effort.

I knew that his force of soldiers could not deter me. They were armed with an ancient variety of matchlocks, and at 30 yards range the charge of slugs they would fire would be harmless ; but the Dzongpen had, in the latter part of the interview at least, been so polite that I naturally hated to do anything that would cause him to be beheaded !

Happily, this idea of fighting the Dzongpen forces was quickly dismissed. Certainly it would be impolite, and moreover there seemed to be no need of it. He returned to the charge and again urged me to quit Tibet immediately.

But it was my turn to procrastinate. Delay might produce an opportunity to steal away unobserved. When he saw that I would give him no decided answer, he said he would not remain in that inhospitable gorge until I had made up my mind, but would go home. He ordered me to remain where I was. He would return on the following day for my decision.

He galloped down the ravine, his party stringing along behind him. I watched them, none too pleased with the turn of events, and well " on the boil." Life at high altitudes does not conduce to placidity and evenness of temper, and the arrogance of the soldiers, and their unconcealed smug satisfaction at having discovered and made us halt, had distinctly got on my nerves. One of the men remained behind longer than the rest. Finally he too started, but in passing he jostled his horse against me rudely.

I jumped ahead and seized his bridle. I meant to hold him and complain to the Dzongpen, but he struck me across the face with his whip and tore the bridle from my grasp. Highly enraged, I ran after him. He galloped for several hundred yards with me in pursuit. Then he dismounted and swung his clumsy matchlock into action.

I was fired on by that grotesque instrument ! It made enough noise for a cannon. Where the slugs went I could never tell—all over the place, I think. I slipped behind the ruins of the Tibetan wall. I placed a shot from my American rifle over his head, and he went off so fast, and made me laugh so much, that I did not think it worth while to follow it with another one.

Things seemed to be none the worse for this incident, save that my face smarted a bit from the blow of the whip ; but my men thought otherwise. They were tremendously excited and highly perturbed. With the exchange of fire they thought the whole of Tibet would descend on us. They absolutely refused to go on.

There was nothing to be done but to turn our backs on the approaches of Everest, the mysterious Lamasery and the valley of the mountain.

Within forty miles, and nearer at that time than any white man had been ! I leave you to imagine my chagrin and disappointment.

It took us six long weeks to get back to India.

CHAPTER IV

TIBET—THE FASCINATING

There is in this terrible country, which its inhabitants think the most beautiful in the world, an unforgettable fascination. Life in Tibet is life at its hardest, but the traveller always longs to get back to the wild grandeur of mountain and stretch of rocky plain. The Tibetan people—sunk in the most fantastic superstition—possess a character which charms by its gentleness and yet, like the placid glacial lakes of the country, mirrors things which affright and repel. You see things by turns; the prettiest and the most ghastly. Let me tell two episodes!

There is a large, beautiful lake high up among the lifted plains, and in the middle of it is the Island of Birds. This island refuge is the general mating and nesting place for the geese and ducks that migrate to India in the winter. For generations, possibly for centuries, it has been the custom of the Dalai Lamas at Lhasa to send a lama to the island during the breeding season. This lama, deputed year after year to the task, has the duty of feeding the birds. He lives there among them during his stay, and scatters grain for their sustenance.

He knows his birds as individuals and even has names for them. He calls them, they rest on his shoulders and he talks to them. Here is a Tibetan Saint Francis and the Birds, high among the Himalaya Mountains.

The second episode, not so pretty, also concerns birds. On a journey to Gyantse I once attended a Tibetan funeral. The people give their dead to the vultures, the only exceptions being the lamas and victims of infectious diseases. These are buried. Why the lamas are excepted I don't know. The people seem to regard the fate of being eaten by vultures, after death, as a desirable one. Those who die of infectious diseases are buried out of regard for the birds' health.

The dead man was placed on a high crag, where watchers waited beside him through the night. At dawn all the family, headed by lamas, gathered around him. They chanted prayers, beat gongs and blew on ceremonial trumpets while the light grew above the mountains. They were waiting for the vultures.

Soon a black spot appeared in the sky, followed by another and another. A vulture alighted on a rock a hundred feet or so away, and his fellows perched beside him. Meanwhile others were coming, and they gathered, a score of them in a chattering group. Their croaking and screeching combined eerily with the weird chanting of the mourners, the banging of cymbals and blaring of horns. They

made a hideous company, with their filthy feathers and naked necks, and the stench from them was unbearable. They were quite at home at this ceremony, whose import they seemed clearly to understand. They spread out in a half-circle, and began to hop closer.

Now came a most unseemly interruption and disturbance. Having got into the good graces of the local Tibetans, I had persuaded them to permit me to photograph their funeral rites. I stood watching, with my camera on the ground, waiting for a good moment to take a picture. The vultures seemed a fitting subject. I picked up the camera and focused it on them. At this unusual sight they screeched in wild alarm. There was a vast flapping and away they went, winging up into the sky.

The Tibetans were furious. I had frightened the sacred vultures, a most impious thing, and I had held up the funeral. Nothing could be done without the vultures.

I pacified the mourners as well as I could as they gathered chattering shrilly round me. Through my interpreter I assured them with fervour that I would keep my camera on the ground thereafter, and that the vultures would soon return. My reasonings finally convinced them and they returned to their prayers and music, squatting round the corpse and waiting.

The vultures did return, wheeled in the sky, then

E

circled closer for an inspection, and finally their hunger got the better of them. Once more they sat in a row, and with occasional hops drew nearer. When they were within 20 feet two butchers (they are called Ragyabas) approached the corpse. One had a hatchet and another a large wooden hammer. The body must be dismembered and the bones crushed, so that everything would go into the gullets of the vultures and nothing be left save bloodstains on the rocks.

A new set of visitors then arrived on the scene—ravens. They gathered in a circle at a respectful distance. They were most unwelcome guests. It is very bad luck for a Tibetan to have any bit of his corpse eaten by a raven.

Anxious to join in the feast, the ravens kept trying to come closer. A couple of Tibetans who had the duty of keeping them away threw stones at them with their slings, weapons with which the Tibetans are expert. Occasionally the squeal of a raven hit by a stone was added to the general din. At times hunger would nerve one of the smaller birds to a feat of desperation. He would wing his way high up in the sky and then swoop, darting swiftly down. Skimming among the vultures he would seize a morsel from them. On these occasions the uproar was dreadful. The Tibetans screamed with rage, and a shower of stones swept towards the swift gliding bird. There would be a loud screech when a misdirected stone

chanced to hit a native or a vulture. One had to
dodge nimbly to avoid the promiscuous missiles.

When the ceremony was over everybody adjourned
to the bottom of the hill. There a huge pot of
Tibetan *chung* was waiting, and the family passed
the rest of the day getting drunk. I drank nothing,
nor was I able to eat for a day or so. That grue-
some business had nauseated me, with a horror
which was mingled with pity. The disgust of the
sight clung to me. Perhaps I would have forgotten
it sooner, but a little bit of the pulped bloody flesh
had spurted out and splashed my face. I slashed
it off with my sleeve. The Tibetans treat a corpse
as a shell to be got rid of as completely and quickly
as possible since the soul has fled to another incar-
nation—to some other baby newly born or perhaps
to some animal shape. Tibetan religion demands
fantastic beliefs about reincarnation.

I once saw at the Palkor Choide, the Temple of
Gyantse, a painting—The Tibetan Wheel of Life.
It occupied a whole wall space near the massive
lacquer temple doors, which remain locked by an
enormous rusty iron padlock, a foot in size, held
to a more rusty iron chain, with hasps knocked
crookedly into the woodwork of the doorstep.
These " wheels of life " remind pious Tibetans of
their fate, and incidentally also of the power which
the lamas alone possess of helping the wandering
spirit along the upward path.

In the picture a cock, a pig, and a snake bite each

other's tails in a circle, whirling round and round. They are the three cardinal sins, lust, ignorance and hate. As long as a man possesses these sad defects he must continue endlessly to be born and reborn, to follow either the white road to perfection led by saintly lamas or the black road down, to the chains of hell's demons.

Holding the Wheel of Life in his talons is the fearful figure of the three-eyed, skull-crowned monster god of wisdom, Nyalwae Thubpa Cheegyal Mlyinzin, who controls the reincarnations. In hell he rules on his judgment throne, judging spirits brought before him by the good and wicked angels. Good deeds and bad deeds are weighed as pebbles and black and white stones in the balance.

In their picturing of hell, the lamasery artists express the terror of the demon torture that the lamas teach the people from infancy. Suppose the balance weighs down on the side of the black pebbles. The wretched soul is seized and carried off to either the hot or the cold hells—because Tibetans have hells both of flame and ice. He is fleshed by vultures and gnawed by wild dogs. Knives falling from trees pierce his body through and through as he is led off to have his skull sawed open, or is thrown by the fierce Cow-headed Demon Huggausten and the Stag-headed Monster into pots of burning oil, to emerge and continue existence as a skeleton with his flesh boiled off.

In the Tibetan hell punishment fits the crime.

The lama who has not read his holy book will be crushed under the weight of the sacred book " Gya-thomba " itself. Degraded people who have lived sordid lives will be condemned to the " Filthiest place in Hell," where they are devoured by vermin and worms, and monster reptiles with dragons' bodies and vulture-beaked heads will tunnel their carcasses. There is a fine punishment for liars. Their tongues are stretched to ten thousand times their size and then ploughed across by teams of yaks.

But from the torments of hell souls may yet arise to continue the cycle of reincarnation through the spirit world of purgatory, where pure gods encourage them with words of wisdom. Chen-zaizi, the God of Love ; Jumley-yung, the God of Knowledge ; and Chana-Dorje, the God of Inter-cession, live in the upper regions of purgatory among clouds and mountains ; but, below, Yadaktsupa, enthroned in his flaming chorten, herds the spirits called Yi-dwags or Preta, ever unhappy, repre-sented by Tibetan artists as giants with pot-bellies whose needle necks prevent them from satisfying their huge appetites.

How easy it becomes for the lama to terrify the poor Tibetan with threats of this tortured future!

Legends tell of a White Lion that is said to live on Everest. The milk of the White Lion, if it can ever be obtained by man, will give him a miraculous remedy for all ills of the body and mind. Only

one Dalai Lama, of all men, has ever obtained the
coveted milk, so tradition in Tibet narrates. When
the Mount Everest Expedition came to Tibet, the
people believed the Expedition's object was to
reach the summit of the mountain in order to obtain
the milk of this White Lion.

In the Wheel of Life picture, among the moun-
tains, you will also find the dreaded Sukpa—the
Legendary Hairy Man of the Mountains.

The Tibetan sees in his every misfortune a relent-
less fate pursuing him for the sins of his former life.
In animals he sees, reincarnated in a lower state,
the souls who once were men, descending along
the black path. Saintly lamas carry this belief of
reincarnation to such an extent that they become
unwilling to walk or move from the motionless
Buddha posture lest they take the life of some
minute insect beneath their feet. Others even
allow their clothing and the skins of their bodies to
offer perpetual hospitality to vermin.

The whole of life is looked upon as a burden, a
pain and a punishment. The hope of all Tibetans
is to escape the infernal cycle of reincarnation.
The highest state of earthly existence is typified in
the hermit lama in his cell in the mountains.

By the way, Tibetan artists, whenever they depict
a white man and woman among the inhabitants of
the human world, put them down with the lowest
stages of society, among the Ragyaba, the profes-
sional butcher scavengers, the breakers-up of the

72

SPECIMEN OF TIBETAN DESIGN. NO. III.

dead. The hermit lama, by long meditation and fasting, will one day obtain such purity of soul and knowledge that he will transport himself miraculously from this world to the region of the demigods and the " Gods-past-the-strife-of-war-waged-over-the-Wish-Giving-Tree " whose roots are in the department of the demi-gods, but whose fruit is in the kingdom of the gods.

The state of the gods is the highest of all states ; but from it a man may yet fall back to the darkest stages of hell before the final state of Nirvana and the presence of the Divine Buddha himself is reached.

The goddess of war is Baldan Llamo. She is depicted in monastery frescoes as a fierce goddess riding a mule with a saddle of human skin and reins of serpents. She uses a human skull as a cup to drink the blood of men. At the time of Queen Victoria's glory in India, when many pictures were published of the Queen on horseback among the troops, the Tibetans, to whom traders brought some of these pictures, declared her to be the reincarnation of the goddess Baldan Llamo. This curious story is well known.

If some one intending to go exploring in Tibet were to ask me for advice, I should say at once : Get on the good side of the lamas. The moment you arrive in the country set about cultivating the favours of the gentlemen who dwell in the monasteries.

During the Mount Everest Expeditions we got

along quite well with the red and the yellow gowned monks, and that, I should say, was one of the important elements in accounting for the measure of success we achieved. The Expedition's chiefs, Howard-Bury, Bruce and Norton, were all experienced Asiatic travellers, who knew how to establish friendship with Asiatic people.

The great armies of lamas are the absolute rulers of the land. Every Tibetan is required to give a third of his produce to the monasteries. The smallest details of life are considered religious, and are governed by the lamas. From the government of the Dalai Lama at Lhasa to the smallest village functionary, the lamas dominate everything.

They are shrewd fellows, and understand that outside influences, from China, Russia or India, would tend to weaken their dominion. For that reason they have followed a policy of excluding foreigners, in the process of which they have sedulously cultivated in the minds of their followers a mistrust of all strangers from other lands. They teach the Tibetans that Tibet is the most beautiful and opulent country in the world, the terrestrial paradise. There are three other countries, which adjoin Tibet—China, India, and Russia. They are not nearly so desirable as Tibet, therefore their people want to possess Tibet, most delightful of gardens. When foreigners come in, it means a conspiracy of the outlanders to seize Tibet.

But as a solemn fact, Tibet, in spite of its charm,

is unquestionably the most frightful and desolate
country in the whole world. No other land can be
so harsh and forbidding as that vast tableland raised
15,000 feet, where stone and ice and mountain seem
to conspire against all life. The people live in the
most extreme poverty and discomfort. It is so cold
and the land is so poor that the only crop they can
grow is barley. There is even a scarcity of air to
breathe. Yet the icy winds blow endlessly with a
biting velocity.

What an amazing life these Tibetan monks lead!—
a life of seclusion and peace. They are contented
and happy, devoted to their gods, revelling in the
multitude of their demons. They avoid intercourse
with other nations. They live in their mountains,
despising machinery, science, and all that is Western.
It is their ambition to live in isolation from the
outer world in their mountain monasteries, without
change or progress in the future as they have lived
in the past.

There are many fabulous stories of mysterious
powers, of trances, and of the lamas' ability to
leave their bodies and travel to other planes. They
claim to predict the future; and the casting of
horoscopes is one of their regular functions. But
they are very secretive about this and they are loth
to talk about it to white men. Perhaps if one lived
among them and gained their confidence fully they
would speak. My wife, who stayed at Chumbi, in
Southern Tibet, during 1924, for the special purpose

of studying the folk-lore and legends of Tibet, collected much fascinating material on this subject.

Leading such a rough life on their lofty plains, in a fearful climate and with a scarcity of food, you would expect the Tibetans to be a sad people. But they are some of the most cheerful and happy people in the world. They are always full of good coarse humour. They laugh and sing all day. Watch a gang of labourers at work, men and women, on a mud roof of a monastery, flattening it down with water and rammers—Tibetan mud, like the Indian, dries hard as a brick and makes a good roof or wall. For hours they will work, keeping in dance step and singing in chorus all the time. Then watch the villagers ploughing the barley fields. You will find men and women singing behind the yak and wooden plough. You will wonder perhaps why they plough in circles, narrowing to the corner of the field. That is to push the devil towards the corner and freeze him out of the field, then no harm can come to the barley! In another part of the field you may be attracted by other choruses of high-pitched songs where parties of women are digging. The digging is always done by two people with one wooden spade. One pushes the spade slowly by the handle and the other draws it by a rope. At 15,000 feet above the sea manual labour is tough and a strain on the heart. Besides, what does time matter in Tibet? When tending herds of grazing yaks, men and women sing and spin wool. From

the pure wool of the sheep and the hair of the yaks they weave the material to make the tents of the Dok-pa (the shepherds) and the bokkus, the loose blanket coats girdled at the waist, that the people wear—coats so voluminous that bags of tsampa, wooden bowls, cooking pots, bladders of milk, and prayer wheels may all find storage place therein. In the winter time over the woollen bokkus they will wear a raw-cured sheepskin coat, the wool inside and the leather outside. It stinks, but it is warm!

When a child is considered big enough to wear a bokkus one is woven for him. The material is immensely strong. As he grows older and taller, pieces are sewn in to keep him covered. When the native tailor says to the proud mother, " There's a fine suit that will wear for the little fellow's life-time,"—believe me, it is a real guarantee!

Tibetan mothers rely upon horoscopes entirely to decide about the marriages of their children. In Tibet they count the years in cycles of sixty by the names of animals, the earth, fire, wood, iron, etc. The year of the first Everest Expedition, 1921, was called the Iron Bird Year. Now if a boy born, say, in the Fire Year loves a girl born, say, in the Water Year, the lamas will forbid the marriage— the boy and girl would obviously not get on together.

From the day when born they tumble to the earth, until the day their dead bodies are hacked to pieces on the stone slab, they will never have a bath with water. They wash with oils and butter.

I have seen the babies getting these baths, and being besmeared from head to foot with yaks' butter by their fond mothers, who work the butter into every pore. It helps the children, who have a hard time in the struggle for life in their tender years, to stand the winter gales of the Tibetan plateau, with the thermometer at zero.

The mothers love and fondle their little ones, for it is difficult to rear them, but their fathers care little. Relationships on the father's side are not kept—the children do not know who their fathers are in polyandrous Tibet.

But it is only among the shepherd people that polyandry is practised and the woman marries all a man's brothers as well as himself. The Tibetan men and women live without jealousy in this peculiar way. When one husband, who has been grazing his herds in the hills or trading in a town, returns home he will not intrude on his brother husband if he finds the other's prayer beads hanging on the wife's door, but will go quietly away. Nor do they make much fuss or ceremony when getting married. The lamas consult their horoscopes and say " Yes " or " No." If " Yes," the man and woman light a fire together and so set up a home. But the richer people who live in single couples, without polygamy or polyandry, indulge in courtships and marriage festivals.

The Tibetan baby is in a curious position as regards his parents, who are looked upon only as

a " vehicle of reincarnation." From the parents
the reincarnated spirit obtains flesh and bones and
blood to make another step for himself on the cycle
of the endless Wheel of Life.

So the children are given only first names, usually
the names of deities. Sickness, accident, or bad
luck pursuing a child, is a sign that its patron deity
does not like the child. Lamas are called in to
perform a ceremony, and the child's name is altered,
perhaps simply to the name of the day of the week
on which it was born.

I spoke about a child " tumbling to the earth " ;
so I will explain the superstition and the manner of
child-birth in Tibet. The belief is that to be
near cattle at the time of child-birth will make
it as easy for the women as it is for the beasts.
A woman therefore will go down to the stables on
the ground floor of the house, alone, or with a single
friend, and will not tell anybody else, because another
superstition says that her delivery will be delayed
by exactly the same number of hours as there are
people who are aware of her condition.

If a family has more than one son, one of the boys
goes straight to a monastery to become a lama.
He goes when he is quite small. His head will be
shaved ; he will don maroon or yellow gowns ; he
will become a little embryo god.

You must not think that Tibetan ladies have no
charms, nor good looks. In Tibet, meeting mainly
shepherd women of the yak-hair tents on the windy

F

plains, or women of the mud houses of the villages, you form the opinion that all Tibetan women are ugly, with skins like crocodiles. These people have to live out in the glare of the sun and against the blasts of wind on the plateau, and they become rough and ugly. But though they are not pretty, there is charm in their spirit, their laughter and their hospitality. Step into their tents and drink tea and *chung* and yak's milk with them.

On the other hand, if you are fortunate enough to be introduced to the high ladies of the cities (Lhasa, Gyantse or Shigatse) you will be struck by their good looks, their dainty manners, their smiling faces, their soft silken clothes, their long parti-coloured woollen boots, their madonna-parted hair fluffed out to fall in masses over their shoulders and reach below the waist. In the province of Tsang, they lace a turquoise and coral-studded aureole into the hair; while at Lhasa they wear a crimson fillet, like a crown and ornamented with immense balls of coral and stone turquoises. Round their necks they carry the same stones, and massive turquoise and silver amulet boxes containing precious lama charms to ward off misfortune. They wear also massive rings and earrings which hang like jewelled plates, four inches long, from their ears. The men wear the same turquoise jewellery, also with a necklace. A Dzongpen, or high official, will carry his badge of rank in a single pendant earring of turquoise and gold—quite a beautiful thing.

Food in Tibet consists of yaks' meat, mutton,
(the people are allowed to kill domesticated animals)
and barley (tsampa or satu) coarsely ground in stone
mills and mixed with grit which aids digestion.
Tibetans have stomachs that rival a chicken's
gizzard. They make buttered tea of which they
partake of thirty cups a day. It is made of Chinese
brick tea, stewed with butter and salt. A first taste
of it will sicken a non-Tibetan. Hot, greasy, salty
slime it is. But the traveller can acquire the taste
and thrive upon it, as I did myself in journeys in
Tibet; it offends the Tibetans if you disdain it.
There is no escape by gulping it down quickly, for
a servant stands behind to fill the cup relentlessly.
A teacup must never be empty, neither must a
tuk-pa bowl.

General Bruce thought of a good excuse. He
said that as a penance—until he had reached the
end of his pilgrimage to the top of Mount Everest
—he had sworn to deny himself his life's delight—
Tibetan butter. He used to tell the Tibetans also
that it was the religion of white men—the tribe
called mountaineers—to climb to the tops of high
mountains in order to reach near heaven. On
Chomolungma they would reach nearer to heaven
than any man on earth.

Tuk-pa, unlike buttered tea, is a palatable dish
—a macaroni of imported white Indian flour, stewed
in mutton broth. It is fine. Again your bowl is
filled up by an ever-waiting attendant as quickly

as you empty it. I liked this dish so much that I
once took fourteen large bowls when entertained
by a Tibetan governor. Such behaviour, scanda-
lous in our society, is a compliment to your Tibetan
host—also to his cook. When you have reached
something like the tenth bowl—well over a gallon—
the cook will present himself to receive congratu-
lations. When you set eyes on him after you have
eaten of his tuk-pa you will see that he is as black
as coal and his hands and fingers and hair are matted
with greasy soot like coal tar. He cooks over a
yak-dung fire. Never mind, you have done the
right thing and pleased him.

One of the most charming traits of the Tibetans
is the way they give you " How do you do ? " They
do not shake hands. They do not know how to do
it. They cry " Tashidelhi, Tashidelhi," put out
their tongues, and press forward one ear. This is
a sign of submission. It signifies the offering of
the tongue and the ear to be cut off.

It is most important to know the social code of
the Dzongpens, and lamas' manners, and how to
welcome them and how to return the expressions
of politeness and goodwill they offer. You must
place the silken scarf of friendship, called the
" kada," on your host's shoulder, and he will do
likewise to you. When you part you must give
him the correct Tibetan " good-bye," which is
" Remain seated." He will say in answer to you,
" Go away slowly."

Once I stayed two days at a great monastery in the interior of Tibet, photographing devil dances. Having made friends with the chief, I was, on departure, escorted by his retinue along my road, mounted standard-bearers carrying a picture banner of the god of friendship. When we parted they raised their arms and cried, " Go with you luck."

Some travellers to Tibet have described the lamas as bigoted, debased, immoral, fanatical and cruel. I think the accusation wrong. In some of the Tibetan monasteries it is possible to find really cultured and genuine religious devotees of great intellectual and spiritual attainments. There are some black sheep, as in the priesthoods of all countries.

Tibetans have a quaint legend of the origin of their race. Before man or animals existed, the gods, they say, who lived in the spirit spheres on the tops of the mountains of Tibet, caused an incarnation in the form of a monkey to come to earth. This monkey met, in a cavern on Mount Bon, a demoness, named Drasrinmo, who at first sight formed a passion for the monkey. The offspring of their union, in men, animals, fishes, birds and insects, was so prolific that it stocked the world with all its living creatures.

So the Tibetans excuse their faults by saying that from the demoness they have inherited unalterably their savage passions, but from the monkey they have gained their wisdom. Inheritance, fate and

reincarnation provide logical and good enough reasons to the Tibetan for all that happens to him in life.

The hero of a little incident that happened during the Mission in 1904 led by Sir Francis Younghusband to Lhasa must have been suffering from a severe manifestation of this Drasrinmo-monkey complex.

A monk had ventured into the Mission's military camp, and was walking about, when suddenly he went mad and cut down an officer with his sword. He told the guards, who soon pinned him down, that he did it because the officer's hat was " an ugly thing." When he had knocked off the ugly hat, he saw the face underneath was uglier still, so he took a cut at that too ! A lover of beauty, and a fierce critic, evidently ! It is said that the officer, who recovered, grumbled more surlily about the explanation than he did about his wounds !

This was the country and these the people among whom we wished to penetrate with a scientific Expedition. Our object was one that could never be other than incomprehensible to them : to climb, for the pleasure of performing the feat, to the summit of a mountain considered inaccessible, a mountain moreover which they considered sacred to their gods and kept inviolate by their demons. The inert East, and the inquisitive impertinent West, were there to meet on the " Roof of the World."

CHAPTER V

DR. KELLAS'S PLAN

I had not been the only person with ideas for the penetration of forbidden Tibet in order to reach Mount Everest.

Before the War broke over Europe and claimed the energies of all, General Rawling, the celebrated Tibetan explorer, had planned to lead an expedition ; and his project had the approval of the Royal Geographical Society of London and of the Government of India. But Rawling, unfortunately, was killed in the early part of the War.

Much exploration and mountaineering had also been accomplished by Dr. Kellas, and I take this opportunity of telling something of his quiet, methodical, minutely detailed methods.

Kellas used to go every summer to the Himalaya for a vacation from his work at the Middlesex Hospital in London. The doctor, a Scotsman, was a pioneer in every sense. He established new records in Himalayan travel and climbing and in feats of physical endurance. Furthermore, he pioneered in ideas and methods.

He devised the plan of using the natural resources of the country—yaks and mountain ponies—for

transport on the lower heights, as the Tibetans do themselves, and he employed the Sherpas, one of the hardiest mountain tribes of the world, dwellers in the highest mountain valleys of the Himalaya, as porters. What General Bruce was to the Gurka, so Kellas was to the Sherpa. Kellas discovered the use of the Sherpas on high ascents. They are simple shepherd people, as hard as steel. They can run up mountains with immense loads on their backs, and then yodel their songs in pure delight, when the plainsman following them, panting and blue of lips, will fall exhausted to the ground. Kellas found them cheerful under all conditions, willing to undertake risks, and faithful. He made friends with these rough mountaineers, and with their help he conquered virgin peaks one after another with an ease and rapidity that astonished the world.

Kellas did not advertise; few people knew about him. He would emerge each year from his chemical research work at the hospital. He did not tell the newspapers when he set out to climb a mountain higher than any climber had ever tackled before. He just went unobserved. No peak could defy him. He conquered great Kangchejnhau, Chomiomo and Pauhunri. He walked up one side of this mountain, walked down the other and then round the base back to his camp for the night. It is what climbers technically call "traversing," a feat they attempt only after having first climbed each side.

Kellas would traverse nearly all his virgin mountains from one side to the other on his first ascent.

In the long gap between my own journey of 1913 and the Everest Expedition in 1921, I talked with Kellas whenever I had a chance about Everest, and he told me many things that have never been made known about his plans and [work concerning the mountain. He told me how he got his wonderful photographs of Everest's glacier from the Tibetan side. He had shown them to geographers, but would tell no one how he obtained the pictures. He had been among the mountains of Nepal west of Kangchenjunga, but not so far west as I had reached at Tashirak. He trained a native to photograph, and sent him to Kharta and the Arun Gorge to get the pictures of the valleys and the eastern glaciers of Everest.

I often used to talk with Kellas in his chemical laboratory at the hospital and discuss Everest. He told me one day of his secret knowledge of Kharta and the pass called the Tok Tok La over the same mountain barrier that had blocked my way on my journey to Tashirak. By the Tok Tok La he could reach Kharta, he said, where he knew of a hide-rope bridge by which to cross the Arun River and so reach the Langma La, used by the shepherds of the Kama Valley. He told me how he had worked out a plan to lay depots of food in uninhabited high valleys west of Kangchenjunga by means of his own trained Sherpas, and of his hopes of reaching

Kharta, crossing the river and going up to the eastern glaciers of Everest by the Kama Valley, escaping the watching Tibetans. It was a most elaborately detailed plan ; thought out to the last ounce of food and water. He was confident he could reach Everest, and after my journey of 1913 he asked me to go with him as soon as the War was finished and we could both get away. I said, " Most certainly I will." But nothing ever came of this, for the authorized Expeditions took the place of furtive private raids.

Everything discovered and mapped by the later Expeditions proved that Kellas's Kama Valley project would have worked out and would have brought us to the foot of Everest, and that probably we would have escaped the watching Tibetans.

It was a very great loss to me personally when my good friend Kellas died of dysentery at Khamba Dzong on the way to Everest with the 1921 Expedition.

His encyclopædic knowledge of the subject can be gauged from his contribution to the discussions when the time came for the first official Expedition, when ways and means were being debated. I quote some of his own words from the report of his speech to members of the Royal Geographical Society.

" There is a route which could be followed from Siliguri or Darjeeling to the north-west. Instead of going due north along the Tista, one could proceed north-west by various routes into the Tambar Valley. At the top of the Tambar Valley there is a good route which was followed by Sir Joseph Hooker

in 1849, when he reached the Wallanchoon Pass, a few miles to the south of Tashirak, which is, so far as I can learn, 45 miles in a straight line from Mount Everest, the Wallanchoon Pass being about 50 miles.

" There is another route. One could proceed from Khanwa Ghat on the Kosi River due north along the Arun to Hatia. The direct distance from Khanwa Ghat to Mount Everest is only 110 miles, and the length of this route would be much less than that of the others, approximately 160 to 170 miles in all. It would also be possible, starting from Khanwa Ghat, to attain the south side of Mount Everest ; the Hatia route takes one to the north side. About 30 miles north of Khanwa Ghat one can turn to the north-west along the Sun-Kosi River, and then, about 40 miles further on, proceed northwards up the Dudh-Kosi River. Part of the eastern headwaters of the latter stream drain the south side of Everest."

So he went on, describing other possible routes. It is sad to think that Death claimed him on the threshold of the first real attempt on the greatest mountain.

PART II
THE FIRST EXPLORATION
AND CLIMB

CHAPTER VI

FINDING THE WAY

When Peace came, it was my privilege to recall the attention of the Royal Geographical Society to Everest. At a meeting in London, on March 10, 1919, I gave an account of my journey in Tibet, and Sir Francis Younghusband revived the Everest project officially.

The discussion which ensued on the subject of the approaches to the mountain, in the event of the Tibetans permitting the visit of an exploring party, was a long one and attracted considerable attention.

The familiar manner with which successive speakers juggled with peaks and passes whose very names were unfamiliar, incomprehensible and astonishing, struck *Punch* as being comical. I make no apology for quoting here the apt parody it printed of the proceedings.

HIMALAYANS AT PLAY

(Suggested by the sequel to a recent Lecture)

" The Chairman, Sir Norman Everest, after congratulating the lecturer on his interesting address and beautiful photographs, observed that he remained unconvinced by his arguments in favour of approaching Mount Amaranth from the North. The climatic difficulties of that route were in his opinion insuperable, to say nothing of the hostility of the natives of the Ong-Kor Plateau and the Muzbakh Valley. He

still believed that the best mode of approach was from the
South-West, following the course of the Sissoo river to Todikat,
where an ample supply of yaks could be obtained, and thence
proceeding along the Dagyolong ridge to Tumlong.

" Sir Francis Oldmead said that he had seldom heard a
more interesting lecture or seen a finer collection of photo-
graphs. He must be allowed to demur, however, to the
lecturer's description of the heavy snowfall in the highlands
of Sandjakphu. During his visit to that district, as they
would see from the photographs which he would presently
show on the screen, he enjoyed uninterrupted sunshine ; nor
had he met with the slightest difficulty from the Pangolins
of Phagdub. As for the best approach to Mount Amaranth
he was convinced that the only feasible route was to work up
the Yulmag valley to the Chikkim frontier at Lor-lumi,
crossing the Pildash at Gonglam, and skirting the deep gorge
of the Spudgyal, ascend the Takpa glacier to Teshi Tsegpa.

" Professor Parbatt expressed his keen appreciation of the
vivid descriptions of Himalayan scenery given by the lecturer,
and the admirably-selected photographs which had enlivened
his address. He wished, however, that he could have furn-
ished more details as to his camp equipment. Had he, for
example, used Nummulitic beds for his party ? Then there
was the question of geoidal deformation, on which he had
remained unaccountably silent. As for the vital problem of
approaching Mount Amaranth, he ventured to differ from all
previous speakers. The Northern, South-western and Eastern
routes were all equally impracticable, as he would conclusively
demonstrate from the photographs he had brought with him.
But there were at least fourteen routes from the West, of
which he would confine himself to four. (1) Starting from
Yeh, the party might cross the Tablung-La pass to Gorkpa
Nor, and thence follow the Yombo to Chilgat, where they
would be only 25 miles from the foot of the western face of
Amaranth. (2) They could follow the old Buriat pack-road
to Amdo, diverge by the narrow defile of Koko-Pir-Panjal to
Tumbung, and thence make for Chapchu-Strong and Chyang-
Chub-Gyultshan. (3) They might start from Pongrot and
cross the Tok-Tok pass to Pilgatse. (4) They might con-
struct a tube from Darjiling to Grogma-Nop, and thence
proceed by aeroplane to the saddle of Makalu, or, better still,
to the summit of Amaranth itself. The last route was far the

shortest and quickest, but it involved a certain amount of preliminary expense.

" The Chairman having expressed his regret that Sir Marcon Tinway was not present to describe his experiments with man-lifting kites and trained albatrosses, the assembly dispersed after singing the Tibetan national anthem."

However the project of a properly equipped and duly authorized Expedition was launched.

Sir Francis Younghusband was the prime mover and the soul of the enterprise. Captain Farrar, the President of the Alpine Club, supported him actively and promised to find fit, skilled young men. He said, " I have two "—he referred to Mallory and Finch—" who will get to the top, I'll guarantee."

Thus the enterprise started, officially sponsored by the Council of the Royal Geographical Society. Lord Chelmsford, then Viceroy, received Colonel Howard-Bury in India as the Society's envoy and gave his support. Sir Charles Bell, C.I.E., the Political Officer for Tibetan Affairs and Political Resident in Sikkim, undertook the negotiations with the Dalai Lama at Lhasa.

Sir Charles Bell is one of the many splendid administrators in the service of the Indian Government who have spent long years of quiet, unadvertised, constructive work on the frontier of India, and have carried on British tradition and upheld British prestige. Sir Charles's work has been with Tibet and the fostering of mutual understanding and friendship between the Government of India and the mysterious god-king, the Dalai Lama of Tibet.

G

Sir Charles gained the confidence of the Tibetans through careful study of their national character and through his perfect knowledge of their difficult language—a knowledge that culminated in his writing a grammar of that amazingly intricate tongue after years of study of the wood-bound, hand-written religious and historical books in the libraries of their monasteries.

He is one of the few men who have won the confidence and friendship of the Dalai Lama. He received an invitation to visit the Sacred City in 1920. He stayed there a year ; and it was only through his personal intercession with the Dalai Lama that permission was obtained for the Everest Expedition to enter Tibet. Such permission could never have been gained by diplomatic correspondence between the Governments, but only by an Envoy welcomed as a favoured friend and guest of the god-king in his own palace, as Sir Charles was. Sir Charles broached the subject one day when alone with His Holiness in his private chamber in the Potala after His Holiness had dismissed all the Minister and Staff, and obtained the coveted permission for the explorers to enter Tibet.

When Sir Charles bade farewell, the Dalai Lama himself watched his departure from the roof of the Palace in view of all his subjects, summoned to give their guest of a year a ceremonial send-off. Special guards of honour escorted him on the long journey through the mountains back to India.

It was splendid! The exclusive lama-governed people who had hitherto shut themselves up in their mountain fastnesses and refused admission to foreigners were now to allow us to explore the great mountain in the heart of their sacred valleys.

For such a turn of events there might perhaps be found a political reason in addition to the potent friendship won by Sir Charles Bell. The Tibetans feared the advance of powerful neighbours in Mongolia, Russia and China. They had just emerged from a bloody war against the Chinese. They had conquered, had beheaded almost every Chinaman in Tibet, and their country was now their own; but they did not know when the Chinese might return to the fight. They felt, however, they had nothing to fear from India or the English. Sir Francis Younghusband had in 1904 shown the stern power of Britain, but also her justice and friendship, and had given confidence to the Tibetans that in India they had a just, strong and friendly neighbour. Claude White, the first Political Officer on the Sikkim-Tibet frontier, had kept up that friendship and developed trade intercourse; and Sir Charles Bell had cemented the confidence by his intimate personal friendship with the Dalai Lama.

So friendly had relations become with Tibet, that a regular postal service had been established between India and Lhasa over the Jelep Pass and the Chumbi Valley by Phari and Gyantse. The Indian Government maintained a post office at

Phari in Tibet and another at Gyantse, while the post office at Lhasa was under Tibetan control and they used their own quaint postage stamps. In 1924 a telegraph line to Lhasa was actually constructed by our engineers for the Dalai Lama, who wished to establish this connection with his friendly neighbour, India.

Mention of the telegraph reminds me of a story of Sir Francis Younghusband's little army which made its way across the ice-bound mountains and reached Lhasa in 1904. They laid a field telegraph line behind them for military purposes as they progressed; and strangely the Tibetans never interfered with or cut the line. There was a quaint reason. They had asked what the line was for; and Sir Francis told them that he had ventured into their land far from his own home. He had come to transact business and make friends, and when he had done this at Lhasa, he would return immediately with his soldiers, finding his way by the thread he had laid behind him. The Tibetans therefore never harmed the line. They were only too anxious for the Mission to quit Tibet.

In due course after Sir Charles Bell's intercession, the Tibetan Prime Minister issued a passport giving an invitation and safe-conduct for an Everest Expedition under the Great Red Seal of the Holy Rulers of Tibet, and dated in accordance with the Tibetan Calendar. A curious document, abbreviated it reads :

" Be it known to Officers and Headmen of Phari-
jong, Khampa, Tin-ki and Shekar that a party of
Sahibs will come to the Sacred Mountain Chomo-
lungma. . . . You shall render all help and safe-
guard them. . . . We have requested the Sahibs
to keep the laws of the country when they visit
Chomolungma and not to kill Birds and Animals
as the people will feel very sorry for this. . . . His
Holiness the Dalai Lama is now on great friendly
terms with the Government of India. . . .

" Despatched on the seventeenth day of the
eleventh month of the Iron Bird year."

It was of course the duty of the Expedition to
fulfil the conditions, and to respect the wishes of
the Tibetans to preserve the wild life, especially
not to kill creatures which to the Tibetans are the
incarnate spirits of their own people.

The road to Everest being at last open, in the
spring of 1921 the exploring Expedition set out.
Colonel Howard-Bury was the leader. Mr. Raeburn,
a veteran Alpine climber, Dr. Kellas, Mr. G. Leigh-
Mallory and Mr. Bullock formed the mountaineer-
ing party. Major Morshead and Captain Wheeler
were surveyors, and Dr. Wollaston naturalist and
medical officer. The Expedition completed its
personnel—interpreter, porters, and native cooks—
in India.

The plan was to make for the Tibetan side of the
mountain ; it was pretty certain that that would
be the only way to reach it. A wide sweep was to

be made across the plains of Tibet through unknown
country. Hope ran high and news of discoveries was
eagerly awaited, but Dr. Longstaff, the expert
explorer and climber, who to this day holds the
world's record, he having conquered the highest
individual mountain summit yet climbed—Mount
Trisul—startled everybody by saying, " They will
have a big enough job to find the mountain, let alone
doing anything else in this first year."

People laughed ; but it was true. Longstaff is a
pretty shrewd fellow ; and few men know more
than he does about travel and exploration among
mountains.

It took the Expedition a long time to untangle
the geography of the plains of Tibet and the be-
wildering valleys that lead up to Everest's northern
glaciers. They had to be guided largely by observa-
tion of the rivers, comparing their relative volumes
and guessing which were the parent streams and
which the tributaries, so that they could follow the
main streams to reach the principal glaciers.

At Khamba Dzong a great misfortune befell them.
Dr. Kellas, who had been ill for many days, died of
dysentery. He was buried in a simple grave on the
slopes of the fort, high up, so that his burial-place
might face the southern mountains—mountains
among which he had worked so hard and accom-
plished so much in previous years of pioneering
exploration. Is not such a grave the best an
explorer can desire ?

After passing the romantic monastery of Shekar,
the Expedition, guided by the now friendly Tibetans,
struck south-west on the last stage of the journey.
Morshead was making a map of 50,000 square miles
of this hitherto unknown country.

The journey led on through mountains and
valleys ever monotonously the same. The wind
all day and every day blew an incessant piercing
gale. There were many obstacles to be surmounted,
transverse mountain ranges, gorges and rivers.
There are few bridges over the Tibetan rivers.
The caravans ford the lesser streams as best they
can ; and the crossing of such fords by three to four
hundred laden animals was always an arduous and
sometimes a dangerous task.

Finally the party reached the Rongbuk Valley, the
main approach to Everest from the north side, led
there by Tibetans who told them about the Sacred
Monastery, the Valley of the Hermits and the Rong-
buk Lama, the living reincarnation of a god who
dwells in the snows of the great mountain and whom
pilgrims come to worship. The explorers said,
" Show us this monastery," and, holding as they
did the orders of the Dalai Lama that all were to
help them, they were led to the foot of Everest.
It was the first time white men had gazed upon it
from foot to summit. Mallory described the scene.

" We had mounted a thousand feet when we
stopped to wait for what we had come to see. As
the clouds rolled asunder before the heights, gradu-

ally, very gradually we saw the great mountain sides and glaciers and ridges, now one fragment, now another through the floating rifts, until, far higher in the sky than imagination dared to suggest, a prodigious white fang—an excrescence from the jaw of the world—the summit of Everest, appeared."

CHAPTER VII

THE EXPLORING EXPEDITION (1921)

They had come ; they had seen ; the next step was —— ?

They set to work and established a series of depots on the Rongbuk Glacier and members of the Expedition detached themselves in separate parties, pushing out as far as Tingri on the north and Kharta on the east. Mallory and Bullock—Raeburn falling seriously ill—undertook the technical exploration of the mountain to discover a possible ascent. They pushed far up the main Rongbuk Glacier and climbed a pass from which they could get a glimpse over the edge of the southern side of the mountain. They saw a terrifying prospect—barren glaciers and rocky precipices surely uninhabited and untrodden since the beginning of the world. They knew at once there was no hope for a venture on the south. The north side was the only favourable one to climbers.

The first of the hidden secrets of Everest was revealed. There had been advocates of an approach to the mountain by way of Nepal, but the Expedition had been forbidden to come that way. It was curious that Tibet the exclusive, Tibet the land

entirely independent of India, threw open the door, while Nepal, the ally of Great Britain, refused. Nevertheless this refusal mattered not at all, for when Mallory peered over the divide of Nepal and Tibet and looked down into glacier valleys, far more broken and more desolate than the Tibetan ones, he definitely determined that the Nepalese side offered no access to Everest's summit. He therefore devoted his entire energies to exploring a way on the Tibetan side.

In this exploration of 1921 Mallory made a very unfortunate mistake when he missed the entrance of the East Rongbuk Glacier. Later he discovered his mistake and found this glacier, but only after approaching by a totally different easterly direction across an outer range of mountains by a high pass, the Hlakpa-La, nearly 23,000 feet high. From the top of this pass he looked down to the valley he had missed and saw it leading down to the Rongbuk Main Glacier and Rongbuk Monastery where he had first been. From here, however, he also observed the North-East Ridge of Everest, an easy-looking ridge leading to the very summit, and the only practicable route by which the mountain may be climbed.

This ridge sweeps down at a moderate angle to a loop which is named the North Col (23,000 feet). It then sweeps up again to the summit of an outlying mountain—one of the sentinels of Everest—the North Peak (25,000 feet). The North Col itself is

a terrible-looking sheer wall, 1,000 feet in height, rising from the glacier basin below. This ice cliff must be first climbed by a party wishing to reach the North-East Ridge.

Mallory and his party reached the top of the Ice Cliff under extreme difficulty.

From the top of the Col he looked up, seeing every detail through his telescope, the North-East Ridge that leads up to the North-East shoulder, and then along the summit ridge to the final pinnacle or " pyramid " as we now call it. The way beyond was straightforward and not difficult ; but the wind was blowing so strongly, the whole party was so exhausted, being insufficiently acclimatized to the high altitudes, and the snow was so deep and soft, making progress ten times harder, that they could not go a step beyond the top of the North Col. They had reached 23,000 feet. They had made a splendid effort, and they had found that there was a way up the mountain. That was the great discovery Mallory made.

Encouraged by their achievement, they began their descent. Exhausted by the laborious crossing and recrossing of the Hlakpa-La, they rejoined the rest of the party which had collected under Colonel Howard-Bury at Kharta Village at the end of their circuit of the Tibetan side of the mountain.

The 1921 Expedition had accomplished its purpose and was a spectacular success. Its news at once threw the whole world into enthusiasm for the

coming assault on the last stronghold of Nature—
the highest mountain.

While recording and highly praising the success
of this Expedition, a review of its work in the light
of later experience may be permitted.

How Mallory missed discovering the East Rong-
buk Glacier is explained by his being deceived by
the small trickle of a stream that issues from the
valley. He thought the valley itself therefore
could only be a diminutive one. It bends to the
south, and one cannot see far up it. But it is a
special feature of Himalayan glaciers, owing to the
peculiar climatic conditions of the tropics, that often
the largest glaciers discharge only small streams.
Those, like the East Rongbuk, that expose large,
open surfaces discharge themselves by evaporation
and radiation in the tropical sunshine, and have less
water to spare to form glacier streams at their snouts.
Therefore they cannot be judged by their streams.
It was a pity that Mallory in this first exploration
did not have the co-operation of Kellas, who had
had such a wide experience of the Himalayan
Mountains, or of Longstaff, whose services were vital
but who unfortunately was in the Arctic. This was
Mallory's first visit. He was one of the foremost
Alpine men ; and of Alpine conditions his knowledge
was complete.

Wheeler, the Canadian Surveyor, who accompanied
the Expedition and who produced of Everest one
of the best photographic surveys ever yet made of

any mountain, found and mapped the whole of the East Rongbuk Valley, because the ordinary course of his work necessitated his walking up every valley he came to. Unfortunately he was working independently of the climbers Mallory and Bullock. The whole Expedition in pursuit of varied objects had divided themselves into separate parts.

It would have been a help if an aeroplane had been used for the first exploration of Everest. In 1921 there were many aviators available just after the War, and military and civil aviation authorities would surely have consented to co-operate in such an important work. It would have been quite easy—involving a flight of not more than five hours' duration—to fly " round " Everest from a landing ground on the plains of Bengal. This would have enabled aerial photographs of all the valleys and glaciers and approaches to be made so as to guide and shorten the work of those who would follow afterwards to climb and explore the mountain on foot.

Incidentally many people frequently inquire : " Why did you not go to Mount Everest by air ? " Well, it must be explained that in the first place it would be quite impossible at the present day for any flying machine to land and take off again on the top of Everest, although I, myself, am perfectly confident in predicting that some day a man will fly to the top and walk down it aided by breathing apparatus.

In the second place, flying was not the object of the Mount Everest Expeditions. They were undertaken purely for the sport of mountain climbing, were composed of mountain climbers and were sent out by a club sponsoring the sport and art of mountain climbing. To climb Everest, the greatest prize of the sport, is their object.

It is necessary, I think, to record that the mistake of missing the East Rongbuk Glacier seriously affected the work of the subsequent Expedition in 1922. The valley, although mapped by Wheeler, had not been explored by the mountaineers who should have done this on the first Expedition and then determined the exact locations for the glacier depots which the climbing Expedition would have to construct, following what is known as the " Polar method " of gradual approach by depot laying— the only method, as it is recognized now, by which the Himalayan giants may be conquered. The second Expedition on arrival had to do this exploration work and thus lost valuable time and exhausted the native porters and themselves. A reconnaissance party had to go ahead before adequate camps and depots were laid. In the early spring season there is so little time before the monsoon breaks, that every moment is needed for the actual business of climbing. There is no time to spare for exploring.

Again, because the 1921 Expedition met an unfavourable autumn, it became the established custom for Expeditions always to select the early

spring season. This is against the experience of all previous Himalayan mountaineers for the last fifty years. Kellas, profiting by his years of experience, had definitely established the season at the end of the monsoon to be better than the early spring. I think it was a pity the mountaineering section of the Expedition did not have Longstaff with them, and it was a real misfortune to the Everest Expeditions when poor Kellas died at Khamba Dzong. I, who knew Kellas so well, believe that if he had not died, Everest would have been conquered now, and by nothing other than this—the combination of Kellas's Himalayan knowledge and Mallory's dash.

Mallory's spirit and boldness and pluck and courage needed tempering by Kellas's knowledge and mountain wisdom. Kellas was hardly less powerful physically, except that he was older—and age tells on Everest—but Kellas and Mallory were the perfect pair to forge a way to the top.

Mallory was no ordinary man. Raeburn, the veteran climber before he fell a victim to the illness which unfortunately finished his climbing days, said that for sheer dash there was no one to touch this young climber. He applied himself to the task, which might have appalled most men by its danger and magnitude, with indomitable energy and will. When he found his mistake over the missing of the East Rongbuk approach to Everest, he got his caravan of exhausted porters and his companions

over the Hlakpa-La in soft snow, nearly tearing
their hearts out, and then encouraged them on still
further even to surmount the greater obstacle of the
terrible Ice Cliff.

With his physical strength he had a vivid imagin-
ation and a great heart. He seemed to live in a
realm remote from everyday life. It could be seen
that he had great imagination and ideals. He was
stubborn to a degree; and his ideas were perhaps
lacking in flexibility, but yet in another sense this
same rigidity contributed to the strength of that
determination which caused him to push through
with dauntless energy any enterprise he might take
up. In camp on the later Expeditions we often
used to tease him for fun for his " advanced views."
Some of these views on political and social questions
were indeed advanced. (You see, even in the camps
on Everest, as in every remote corner of the world,
men are wont to talk on politics for ever. . . .) He
was lofty as the peaks he loved.

He was always young at heart, and fond of a
game. In America, after his sensational climbs in
1922, a photographer caught him climbing a fire
escape at a New York skyscraper hotel, but not in
the manner the builders intended. He was going
up underneath the steps hand over hand, sometimes
upside down !

But yet he always preserved a certain aloofness.
If he had lived, after conquering the heights which
were his ambitions, no doubt he would with his

intellect and energy have accomplished fine things. Above all, he was a mountaineer. By that I do not mean so much a climber of crags, but a man who lives among mountains and loves them. On Everest he seemed to have centred all his ambition and energy. The mountain gripped him. Describing one of his climbs he said :

" The camp was made under the moraine about 17,000 feet up. It was a night of early moons. We went out into the keen air, mounting a little rise of stones and faintly crunching under our feet the granular atoms of fresh fallen snow. We were already aware of some unusual loveliness in the moment and the scenes. We were not kept waiting for the supreme effect. The curtain was withdrawn.

" Rising from the bright mists Everest above was imminent, vast, forceful—no fleeting apparition of elusive dream form ; nothing could have been more set and permanent—more terrific—more unconquerable."

How this mountain obsessed him ! He threw his whole body and soul into the fight against her. He seemed always as if he were measuring and calculating. Yet, in my own acquaintance with him, I always felt that some strange fatalism overshadowed his ambition. He was always trying to convince himself that he could beat the mountain, but at the same time he seemed to be conscious that the mountain held the mastery.

" The chances of a given party to reach the

summit in a given time are fifty to one against."
That was the expression, now become historic in
the story of Everest, which he used on the occasion
of the first public lecture he gave in London after
his return in 1921.

How the "personality," I might say, of this
mountain had impressed itself upon Mallory can
be traced in things he said from time to time. For
instance, in 1924, when he started up the Rongbuk
Glacier for the last time to make his biggest effort—
the effort from which he never returned—he said,
"We expect no mercy from Everest. . . . But
yet it will be well for her that she deign to take
notice of the little group that approaches stealthily
over her glaciers again, and that she shall observe
among the scattered remnants she has thrice put to
flight still a power to string her very nose-tip."

CHAPTER VIII

THE FIRST CLIMBING EXPEDITION (1922)

The summer of 1921 was the summer of " Fading Hopes," so the newspapers at home described the project of ascending Everest. The despatches describing the exploration of the northern, or Tibetan, and the Nepalese sides of the mountain, had given the impression to the world that Everest was unscalable. But hope was galvanized into life again when Mallory discovered the way up the North-East Ridge in the autumn at the very close of the Expedition's work. Despatches arrived describing the forcing of the Hlakpa-La under enormous difficulties and the ascent to the foot of the North-East Ridge by the North Col.

During the ensuing winter the clouds of gloom still hung over the project after Mallory's historic phrase " Fifty to one against." But war with the mountain was declared. A way up had been shown. There was justification for the sending of another Expedition. This was to be purely a climbing affair. Geography, map-making and preliminary exploration had been finished, although the mountaineering exploration of the East Rongbuk Glacier remained incomplete. The whole of the new effort

was to be concentrated on an assault of the mountain. Accordingly the Mount Everest Committee of the Royal Geographical Society and the Alpine Club set to work energetically to organize and equip a climbing expedition along the most thorough lines, without stint in equipment and including in its personnel the best climbers the Club could provide. The intricate details of organization and equipment were executed under the skilful direction of Mr. A. R. Hinks, the able and celebrated Secretary of the Geographical Society. The Expeditions indeed owe a large measure of their success to the organizing genius of Mr. Hinks. Mr. Spencer and Mr. Unna of the Alpine Club gave a tremendous amount of work to the technical climbing equipment and appliances.

Many riddles, however, still demanded answers. Though a way up had been indicated, could a human being reach the summit ? Was it in the power of the human being to do so ? Five and a half miles above the level of the sea with the temperature at zero, could life be sustained under the physical strain of climbing ? Men had been as high in balloons, but that entailed no exertion and they could wear all the cold-resisting clothes they wished.

Many experienced explorers, mountaineers and scientists recalled the classic Abruzzi Expedition— an expedition provided with the perfection of equipment and of personnel which had been defeated, by sheer lack of air to breathe, on an easy snow slope at 24,600 feet, with the goal, the summit of the Bride

Peak in Kashmir, only 400 feet above them. The consensus of opinion was that Everest could not be climbed by reason of its height. Yet there was a ray of hope in the prediction of one celebrated mountain expert, Clinton Dent, the writer of *Mountaineering* in the Badminton Series, who said : " I believe firmly it is humanly possible to ascend Everest. I feel sure that even in our time, perhaps, the truth of these views will receive material corroboration."

The problem of Everest was and remains principally one of weather and of breathing.

One effect of lack of oxygen is to tire the mind and produce mental debility even to the degree of loss of intelligence. Against this there is no remedy except oxygen gas. Should men unaided try to struggle against these drawbacks, or should they load themselves with the necessarily heavy apparatus and depend for their lives upon artificial breathing ? Here was a question causing endless discussion and controversy. Immediately people became divided into two schools—the Oxygen and the Non-Oxygen. Finally it was decided that both oxygen and non-oxygen attempts would be made. The best apparatus must forthwith be designed to combine lightness and portability with simplicity, reliability and ample gas capacity—no easy problem.

At what altitudes and at what sites should the depots be laid ? Here others interrupted, saying: " Not how high *should* but how high *could* depots be

carried, even by the powerful Sherpa porters ? "
They quoted the example of the Duke of Abruzzi,
and his guides who broke down at 24,600 feet. How
·then could the Everest Expedition get laden porters
beyond or even as far as that height, since the Duke's
party carried no loads at all ? There would remain
over 4,000 feet to climb—Impossible ! Nobody
could do it !

Should men ever succeed in carrying up the camps,
would the tents stand against the blizzards that
sweep across the face of the mountain and tear the
snow off the upper ridges, throwing it a thousand
feet into the air, as Mallory had observed ?

Would the ultra-violet light rays of the sun, so
intense at those altitudes in the tropics, strike the
men down with mountain lassitude and sickness ?

Could an expedition risk the dangers of the
treacherous Ice Cliff while the North Col, up which
the way led, threatened death from avalanches in
bad weather or when soft snow fell ?

Would the short season of the spring, no longer
than seven weeks, give sufficient time to complete
the work of laying depots and climbing before the
obliterating breath of the monsoon sweeps up
in the first week of June, to cover the mountain
with an impenetrable blanket and stop all work
dead ?

Lastly, and above all, could men tune their
minds to convince themselves that puny human
beings might dare to match their strength against

the strength and the defences of this mighty and last stronghold of Nature, and dare to win ?

The answer to this last query was : Yes. Men could steel themselves to the stupendous task. Sir Francis Younghusband said :

" The doom of Everest is sealed, for the simple and obvious reason that Man grows in wisdom and stature, but the span of mountains is fixed. Everest fights stoutly with her many terrible weapons. She is surrounded with unscalable rocks, which are her armour, but she fights blindly beneath her armour. She cannot learn from experience. She cannot rise to occasions ; whereas she is beset by an adversary who has all these advantages over her, for man's full cunning will find means to outwit the mountain's allies. Each fresh check he receives will only heighten his spirits and he will return undaunted to the battle. This doom can be seen relentlessly closing in upon Everest. Man is remorselessly overtaking her. Forty years ago he was very humble, and did not presume to think of anything higher than 21,000 feet. Twenty years ago he had reached 23,000 feet. Ten years ago he had attained nearly 25,000 feet. Arithmetic alone shows that 29,000 feet must follow and Everest be vanquished."

Scientific reasons for the Expedition there were in plenty, but these were never the chief motive. The chief motive, for instance, in Mallory's mind was just that it was the highest spot on earth—a last defence held by Nature against the advance of

human beings—a perpetual challenge to men to thwart their determination. When he went to America after the 1921 Expedition to tell the story and to lecture, he was asked why he wanted to reach the top of the highest mountain.

" Because it is there," he said.

The *New York Times*, which typifies the spirit of modern progress, remarked :

" It is the necessity of human nature that practical records should be broken ; and to affect the inability to understand why men are irresistibly attracted by the chance of doing something first or going somewhere first, is a waste of time. They are built that way, and to the very impulse that rules them the world is enormously indebted."

The personnel of the Expedition was selected with great care.

General the Hon. C. G. Bruce, C.B., the world-renowned Himalayan explorer, was to command. " The Very Best Man " is all that it is necessary to say to describe him. But for the benefit of those of my readers who are not normally interested in Himalayan exploration or in mountain climbing, and for whom this popular account of the story of Everest is principally intended, I would like to give a few more details of the personality of General Bruce and his mountain work as well as of that of the other members of the Expedition.

General Bruce's reputation had spread over India through his extraordinary feats of " Khud," hill-

climbing, which is a Himalayan Gurka sport of racing up and down steep mountains, generally before breakfast. The jolly Gurka soldier boys delight in this. Bruce loves his Gurkas, and they love him. He speaks their language and knows their customs. He can talk to them and tell them funny stories and can show them even the steps of their own national dances. He has a great mountain sense and a love of mountains; they raised his spirits and his desire to be up and at them. The little toy train that brings you from the plains to Darjeeling used to be too slow for him, and he would jump out and race up the hillside to make a short cut, while the train continued its curves of eight round the spurs. His excuse was to get fit and reduce his weight. It was really that his delight in the mountains was too much, and the train was too slow for him. There are many after-mess stories about him, some of which can be written down and some which cannot. He was immensely powerful. His favourite joke was to lie flat with head and feet bridging two tables, and a thirteen-stone man could not bend his spine.

For great altitudes such as would be reached on Everest, General Bruce's climbing days were over, unhappily; but an ascent to 16,000 feet or so the doctor said he could do. So he was to make his headquarters at the Base Camp where he could organize the line of communications on the glacier, and his personality would provide the dynamite

behind the Expedition to shoot it up the mountain.

His books *Twenty Years in the Himalayas* and *Kulu and Lahoul,* are the fruits of his knowledge of Himalayan travel during thirty-three years of life in India. There is no valley in the Hindu Kush eastward from Chitral and Gilgit through Garhwal, Kulu, and Lahoul, to Simla, Nanga-Parbat, and the Karakorams, that he does not know. He has climbed alone, and with Sir Francis Younghusband, Sir Martin Conway, Mumm, Norman Collie, Longstaff and Mummery, besides winning many campaign medals on frontier wars in India, Burmah and Waziristan.

He was the first man to propose a definite Expedition to Everest—that was in 1893—and the idea never left him, although his requests through Government sources for permission to go were never granted, and the Tibetans themselves would never permit an Expedition. In the War he commanded the 6th Gurkas, and was terribly wounded at the Dardanelles. He then went back to India to teach mountain warfare, scouting and hill fighting and Gurka training.

General Bruce's leadership of the Expedition brought the whole caravan of 400 animals and 100 men safe and sound over 350 miles of difficult country from India, to the foot of Mount Everest.

Second in command of the Expedition was Frank Strutt, who had done a great deal of climbing in the

Alps, the mainstay of the climbing party being Mallory, Norton, Somervell, Finch, Dr. Wakefield, Morshead and Geoffrey Bruce. Longstaff joined as doctor, Morris and Crawford as transportation officers, and I acted as official photographer.

Norton was destined to emerge as leader of the next 1924 Expedition after General Bruce fell ill.

Somervell was always one of the outstanding characters of the Expedition. While Mallory was a lithe, cat-like, speedy man on a mountain, Somervell represented the more solid type with tremendous staying and recuperative power. In fact, he gained for himself the reputation of being the quickest of all to recover from exhaustion after a climb ; Somervell was one of the most experienced members of the Fell and Rock Club and the Alpine Club. He had climbed every big mountain in the Alps, always without guides—with his climbing companion Beetham. As a man he was versatile, satirical, brilliantly witty and a great lover of books. He is an accomplished musician, and in Tibet he made a fascinating collection of Tibetan folk tunes, for use as illustrative music to the films I made. He owed much of his amazing recuperative and physical power as a mountaineer to his optimism, his exuberant energy and cheery temperament. He comes of a Kendal family of strong missionary tradition, his grandfather being the Home Director of the great China Inland Mission ; and he himself has now become a missionary in India. At Rugby he dis-

tinguished himself in science, secured a scholarship at Caius College, Cambridge, where he took a double first, and completed his medical and surgical training at University College, London. He was considered to be one of the rising men among London's young surgeons. He had a lightning decision and a sure, swift and never-faltering touch of the hand. After this 1922 Expedition to Everest he was travelling leisurely on his way home and he chanced to stay at the London Mission Hospital at Travancore in Southern India. It was there he determined to become a missionary. The Hospital, providing for an immense district, had only one surgeon and no modern appliances. " The sight of the appalling needs of these people in Southern India," he confessed, " changed the whole course of my life and I could not possibly do anything else but go to them." So he gave up his ambition to be a leading surgeon in London and joined the Mission Hospital, where he has now installed himself with modern X-ray and other appliances. A short while ago he was married, and his wife works with him at the Mission, making climbing expeditions in the Himalaya on such holidays as they can spare.

Another strikingly successful climber was Geoffrey Bruce, a cousin of the General. A distinguished young athlete, his original duty was first transportation and the handling of the Sherpas, but he became one of the men to go highest on the mountain.

Another distinguished member was G. I. Finch. Finch was an Australian. When a student at the University of Zurich, he was one of the big men at the Academic Alpine Club of Switzerland—a Club renowned for feats of endurance and for guideless climbing. As a guideless climber he mastered every important climb of the Alps, making the first ascent of some peaks. He was a man of strong character with a mechanical and scientific turn of mind, and, like many people of strongly positive natures, he had the quality of making strong friendships and, as a corollary, acute enmities. As a mountaineer he was one of the type who could concentrate on a tremendous nervous effort, and force a brilliant conclusion by sheer enthusiasm of purpose. On the entire journey across Tibet he carefully husbanded his strength, riding his pony practically the whole way, conserving his energies, as was his method, for one big effort. He made one big effort and created a record, although using oxygen gas, and exhausted himself utterly.

With this little army of fine men under a brilliant leader, the Expedition set out from Darjeeling with the good wishes of all for the accomplishment of the stupendous task ahead.

For me, as I rode forward, the enterprise presented a singular blend of remembrance and emotion, for I could look back upon an adventure started ten years before to which the experience came as a climax and completion.

CHAPTER IX

ON THE ROAD TO EVEREST AGAIN

I was on the road to Tibet again !

Darjeeling was always the starting-point of the Expeditions, which took the trade route of the Jelep Pass, 14,600 feet, the Chumbi Valley, and Phari, to Tibet. The road to Phari, frequented by the wool caravans, presents no difficulty at all. The scenery is pleasant, although incomparable to the Tista Valley.

Chumbi is a charming place of pine forests and verdant pasture lands. We were in Tibetan territory as soon as we crossed the boundary at the Jelep Pass, although still in the southern watershed of the Himalaya. Higher and higher we climbed through the rocky gorges of Gautsa.

There the new mint of the Tibetan Government has been built, where forest wood, the only fuel of the country, can be used to smelt the copper scrap brought from India. The discs to make Tibetan coins are punched by an enormous hand-operated lever stamp. The second highest official of Tibet resides here—or he does not. He takes long holidays, for this is a lonely spot, far from Lhasa, the only place where the high-born Tibetan will consent

to live. The official's duty is to watch the pressing
out of the discs from the copper sheets. Though
he may be the second highest official after the Prime
Minister himself, he is not trusted to make the discs
into coins. They must be carried to Lhasa and
there stamped into Tankas under the eyes of the
Dalai Lama himself.

There are whole mountain ranges of copper ore
in Tibet, but there is not a wheel to transport it,
nor fuel to smelt it except the forest wood carried
from Chumbi or India. What other valuable
minerals might be found in Tibet besides the gold
we already know of, we can hardly tell. For years
the Chinese took the alluvial gold from Rudok. It
was the chief supply of gold to the Chinese Empire ;
Tibetan prisoners dug and washed it for them.

Beyond Gautsa the trees are left behind. The
valley broadens out and the river dwindles to a
stream. The mountains become higher, although
the valley broadens. Grassy swards and marshes
appear. We have left behind the deep valleys, the
pine woods and the terraced châlet villages.

The basin valley of Phari amazes by the change
in the surroundings. To look ahead is to look into
a deserted world. Peerless mountains raise white
crests to the scintillating sky, blue as the waters
of the Mediterranean. The land seems empty of
people, but a paradise for birds and animals. It
is the home of the slow-moving, grunting yak, the
ox of Central Asia that lives up to 20,000 feet and dies

if brought down too quickly, even to 8,000 feet above
the sea! The yak's appearance and manner seem
to spell content, and the Tibetan uses " yak " as a
superlative to signify all that is good and excellent.
These animals remain always semi-wild, docile
perhaps with their Tibetan drivers, but capricious
and even dangerous with strangers.

Most yaks are pure black. Others may be brown,
others silvery grey, and a few are pure white. Their
long hair trails to the ground below their bodies.
Nature gave them this apron against the wind.
When they graze over the exposed plateau they
stand with their backs to the wind and their heads,
carried low, are screened by their immense tails.
Never tied together, they roam free and move along
leisurely a slow 2 miles an hour when travelling
laden in trading caravans. The drivers spin wool,
sling stones and whistle. The yaks understand.
This shrill musical whistle urges them forward.

The yak carries the Tibetans' burdens over the
roadless country ; it provides material for the
tents in which the shepherds live ; also for the
clothes they wear. It gives them meat and milk
and butter. It ploughs their barley fields. Tibetans
could not live without yaks. No wonder they use
the name to express all that is good and excellent.

In Tibet the Expedition used yaks for transport,
collecting an army of four hundred or so. The
animals all carried large bells round their necks, and
small bells tied in their tails. As the caravan went

forward a gay march music was provided by the jingle of a thousand deep-toned cowbells over-ridden by the tinkle of the smaller bells and the whistling and singing of the Tibetan drivers. Soon after starting each morning the caravan tailed out, perhaps 5 miles in length, and scattered itself over the plain.

Although as we entered the Phari Valley it seemed so bare, we knew that it concealed an extraordinary town. Said to be the highest town in the world, it is said also to be the dirtiest. Breathless from the altitude so suddenly reached ; tired, because it is a long way up from Chumbi ; we did not care whether it deserved its unsavoury reputation or not. We looked forward to getting there.

We had had our first encounter with the Tibetan wind. It is more than a wind. It is a thousand knife-points that pierce all and any clothes you may wear.

Suddenly, the low, solid fortress lines of Phari Jong shaped themselves out of the bare plain as we turned a spur to the left. Behind rises an over-hanging parapet of cliffs, 10,000 feet in height. It is the mountain Chomolhari, the Lily-white Mother of Snow, a sacred Tibetan mountain venerated by lamas and pilgrims and in whose cliffs there are said to be hermit dwellers—people who were once of the world but who now live communing with the gods.

Along a dusty open track following the telegraph poles, we rode into the little walled post over which

I

flies the Union Jack. The post with true British insularity lies by itself out on the plain and well away from the Tibetan town. This is the last post and telegraph office on the route. The line continues north to Gyantse and Lhasa, but the Expedition from here branched off to the West. From here it was that the despatches of the Expedition brought in by postal riders from Mount Everest were sent down to India.

Whenever on the Expeditions we visited this fascinatingly interesting highest of towns, no member of our party would venture in, except to visit the castle; never the town. It deserves its reputation, for it is dirty—indescribably dirty—but it is amazingly interesting. I wandered for many hours through Phari myself in 1922 and also in 1924. I visited the Jong and went into the highest Tibetan society, as guest of the Governor; I was a guest also in the hovel of a Ragyaba, the verminous scavenger butchers who break up the dead and who live in the filthiest part of the town. In the course of my wanderings here, under the handicap of my imperfect knowledge of the language, I collected many of the notes on the Tibetans and their quaint customs given in this book. I walked over the whole town on the mud roofs of the hovels, jumping across the stinking drains which are the streets themselves.

Climbing to the battlements of the Jong, the huge fortress that crowns the hill, one may look down

on the clustering hovels that make up the town below. The walls of the Jong protect the huddled people of this highest town in the world from the icy blasts of the northern winter wind. There are lots of dogs, always howling, on the roofs among the many prayer poles and flags. From holes in the flat roofs the curling wisps of blue smoke rise from the yak-dung fires in the morning and in the evening. The people eat only twice a day. Ten thousand people live beneath that panorama of flat-terraced roofs, thirty and forty people in each house with their cattle and mangy dogs, begrimed in dirt and yak-dung soot.

The houses, built of " Tibetan reinforced concrete" —mud—strengthened with the horns, hairs and skins of dead cattle—seem to be buried half-underground because of the offal and dung heaped outside the walls ; you go down a flight of steps into the house from the raised level of the refuse outside. Everything is coated with greasy soot from yak-dung fires. It hangs in cobwebs and festoons, brushing your face and interlacing in your hair unless you stoop very low. The little children play in the stinking pools of the street and pick the bones and horns of dead cattle that are thrown out to rot away. The ravens watch—hundreds of them—and the mangy dogs slink round the corners waiting to finish what the children leave. These are not the fine black mastiffs of the shepherd people, but cur dogs of the slums. The children are dressed in rags

and are matted in filth, but now and then when they
look up and laugh you will see that they are the
same jolly-spirited little beings that all Tibetan
children are, only they are grimier than any others
you have ever seen before.

Why Phari is so dirty nobody can quite explain.
Other towns—Khamba, Shekar and Gyantse—are
quite different.

In the castle live two twin Governors. They wear
gorgeous, flowing robes of Chinese silk, embellished
with splendid embroideries in green and mauve.
One wears a headdress that is nothing other than an
enormous purple lampshade. They hold the rank
of the Backward-sloping Peacock Feather and the
Order of the Crystal Button. They wear their
sleeves long, reaching almost to the ground and
hiding their long, carefully manicured nails. Such
are marks of their dignity. They sit in their castle
and extract taxes, for which there is no fixed scale
or rule, from the traders who collect here from India,
Bhutan, Nepal and Tibet.

The taxes are a matter of bargain. Lhasa fixes
with the local governors of districts the amount of
revenue they must send each year to the Central
Government. The Governor has a free hand to
collect this, and, receiving no pay himself, he lives
on the difference between what he can extract from
the people and what he is obliged to remit to Lhasa.
A good governor is a man of moderate personal
demands. A bad governor is one bent on getting

rich quick and retiring soon to reside at ease at Lhasa.

Formal visits are first exchanged between a traveller arriving and the Governor, and it is impolite to discuss business on these first visits; compliments only must be exchanged, together with ceremonial scarves and presents.

Phari was an important junction point for Everest Expeditions, because here the transport animals from India and the Chumbi Valley, usually mules, were exchanged for the transport animals of the plateau, yaks and donkeys.

After Phari, for day after day the onward-travelling caravan passed over the desolate elevated plateau, nowhere less than 14,000 feet above the sea and in some places 19,000 feet in height. Always we were plagued by the incessant wind. Day after day brought the same open landscape, plateau bounded by piled ranges of snow mountains stretching on endlessly.

At least five or six hours' marching in a straight line towards some landmark seemed to bring that landmark no nearer. Camps were laid by valley, lake or river. Here and there a Dok or shepherd's encampment was found, by the banks of glacier streams, where in spring and summer fresh green grass will sprout, good for yaks and sheep. The Dok-pa in the yak-hair tents lead a nomadic life, moving on from camping ground to camping ground with their beasts. The men spend the day on the

hillsides with the yaks and sheep while the women remain in the tents spinning wool and cooking over the gogra, yak-dung fires. These Dok-pa collect yaks' butter and cheese and exchange it in the towns for tsampa, barley, and tea.

Villages were few and far between. The people are collected for the most part in settlements under the protection of some castle or fortress monastery, built fantastically on pinnacles of rock or cliff faces rising vertically from the plain. Very wonderful buildings they are, these Dzongs and Gompas, built with all the skill of the Tibetans, who are some of the best architects of Asia.

Constructed of nothing more than mud and stones, yet what an aspect of solidity they present! They seem to have grown from the very rocks upon which they stand, so harmoniously do the lines of rock and building merge. The Tibetan is in this way a genuine artist. Look not only at his marvellous sense of line, but notice the lofty flights of his imagination, inspired by the majesty of his surroundings of immense spaces and heights and influenced by the superstition and fantastic ghost fears of his mind. He materializes these feelings into the shapes of the dream-castles he builds. Such is the castle of Khamba Dzong, that has stood upon its rock, 15,000 feet above the sea, even beyond the records of Tibetan history, and Shekar-Dzong, the " Monastery of the Shining Crystal," which no explorer before the Everest Expedition had ever

seen. Watch its lines and follow them upwards as they lead the eye to the needle crest of the mountain 17,000 feet above the sea !

In my photographic impressions of these two marvellous structures I have tried to convey their astounding character. They are Dream Towers of the air, and at times, caught in the light of dawn or of sunset, are unbelievably beautiful.

Shekar Dzong has a place in my memory too for quite another reason. We were entertained here on one of the Expeditions by the Governor, who received our party royally. He held games and dances and gave a banquet of twelve courses. As a mark of special honour—believe it or not, but it is true—we were allowed to partake of some old smoked vintage mutton, killed forty years before !

The Tibetans have their own peculiar system of cold storage !

CHAPTER X

THE RONGBUK MONASTERY

For weeks we had toiled through desolation of mountain and plateau. At last we sighted our goal and gazed spell-bound at the sheer cliffs of rock draped with ice which seemed to form part of the very heavens above us.

We stood at 16,000 feet above the sea. The valley, a mile wide, ran straight ahead for nearly twenty miles. At its farther end, stretching across, closing the valley, rearing its imposing head of granite and ice, was Everest. Some colossal architect, who built with peaks and valleys, seemed here to have wrought a dramatic prodigy—a hall of grandeur that led to the mountain.

A spectacle of astounding beauty and strangeness, for me it evoked singular remembrances and emotions ; I could look back ten years upon an adventure to which this experience came as a climax and completion.

Many stories had been heard, yet few believed, of this region of the Rongbuk, called Chamalung, " The Sanctuary of the Birds," where indeed all wild creatures, because they are considered to be the reincarnated spirits of former human lives, may

live unharmed and untouched. Who would there
be to hurt them ? There are no inhabitants save
the hermit monks who dwell in solitude and medita-
tion in the rock-hewn cells we saw dotted over the
hill-sides.

In the heart of this sacred valley these hermits
live their entire lives, gaining merit so that when they
die their souls may escape from the affrighting cycle
of reincarnation which they believe to be the inevit-
able and eternal sequel to the lives of ordinary men.
One can be oppressed with a sense of mystery in
this lifted hidden world, in the solitude and in the
impressive majesty of the surroundings.

There is one tremendous reputed saint, who has
been sealed up in a rock cell beneath Mount Everest,
dwelling in darkness for fifteen years, meditating,
sitting motionless years after year. Once a day
brother monks bring a cup of water and a handful
of barley meal to this self-isolated priest. I myself
watched, and saw, through a hole in the wall of the
hermit's cell, a hand steal out and take in the water
and the bread. Even the hand was muffled, because
not only must no one see him, but the very light
of day may not touch his skin.

On the left at the entrance of the valley lay the
Monastery. Certainly no architectural pains had
been expended on it. That, indeed, would have
been futile labour, with Everest straight down the
gigantic corridor. It was a collection of low flat
buildings, and in front stood an immense chorten,

a cupola-like monument built in terraces and crowned by emblems of the sun and moon, symbolizing the light of Buddha's teaching illuminating the world.

This is the highest monastery in the world—the Rongbuk Lamasery, where the venerable Rongbuk Lama, one of the holiest hermit monks of Tibet and the incarnation of the god Chongraysay, lives and contemplates. The monastery is the shrine dedicated to Everest ; and the lama is the High Priest of the Mountain, who communes with the Goddess Mother of the World. Here was the reality of that which had been merely vague legend from the time of the Pundit Explorers.

Our party, a handful of white men and a band of Tibetan and Nepalese carriers, advanced into this secret place with feelings of awe, the white men scarcely less than the natives.

According to Tibetan historical legend, the monastery was built or possibly rebuilt over 2,000 years ago. In a later time, a Chinese Princess of the Tsang dynasty that ruled China, then in one of the most exalted ages of her culture and civilization, had married the King of Tibet, Srong-Tsan-Gampo ; and she had persuaded her King to invite the Indian Buddhist saint, Padma Samblava, to teach the religion of Buddha to the people of Tibet, then possessed only of the Devil worship of Bom. Padma Samblava came miraculously across the Himalaya by the sky, and rested awhile at the monastery beneath Mount Everest to subjugate those evil

spirits—the Zhidag—that had opposed his saintly advent, conjuring up the anger of the storms and the poisons of the air against him, but without avail.

The chief of the Devil-worshipping Lamas, who dwelt in this monastery, challenged the Buddhist to prove which was the most powerful—the teachings of Buddha, or the ancient faith of the people. To decide the matter they would hold a race to the top of Mount Everest, each calling on his gods or devils. During the night the Bombo Lama, determined to steal a march on his adversary, started off in the dark, riding on his magical drum.

The disciples of the Buddhist came to wake him, crying anxiously that the Bombo Lama was already half-way up the mountain. But Padma Samblava said :

" Fear not, because just as soon as the sun's rays come, so shall I start."

When the sun appeared, he was conveyed, by a beam sitting in his chair, to the very top of the mountain. There he sat awhile, enthroned on the steeple of the world. When he descended he left the chair behind. The wicked Bombo Lama perished ; and the spirits of the mountain kept his drum. So now, when the rumble of rock avalanches is heard, the Tibetans say the spirits are beating the drum.

Tibetans always had difficulty in understanding why we had come, and why we wanted to climb the

mountain. They had no conception of the idea of sport, and were certain that the reasons we gave were lies. They decided that what we were really seeking was the magical chair which the Buddhist apostle had left on the mountain. They were convinced that the spirits of Everest would see to it that we did not get to the top. Probably they would even punish us severely for our impiety— beliefs which, I admit, after events seemed to bear out.

From the outer world we had found our way to this rallying-place of demons and deities along the pilgrim paths marked with chortens and Mani walls, structures that must be passed right-handed, and with religious lifting of the hat to the flying prayer flags that wing to heaven with every flutter of the wind the Mantra :

" Om mani padme hum "—" Hail ! jewel of the lotus flower ! "

For many pilgrims seek for merit here in this valley of the Rongbuk. These devout and simple people travel sometimes 2,000 miles, from China and Mongolia, and cover every inch of the way by measuring their length on the ground. They prostrate themselves on their faces, marking the soil with their fingers a little beyond their heads, arise and bring their toes to the mark they have made and fall again stretched full length on the ground, their arms extended, muttering an already million-times-repeated prayer.

Thus they spend their lives. They live upon the
hospitality of villagers and shepherds, who themselves
merit spiritual reward by giving hospitality to them.
There are other places of pilgrimage : the Holy Lake
of Manasarowar of South Central Tibet, where the
great Indus and the Brahmaputra rivers both rise
together, to flow, in exactly opposite directions, to
the gorges by which they break through the Hima-
laya to the Indian Ocean ; the shrine of Chorten
Nyim ; and others : but the pilgrimage to the
Rongbuk and Mount Everest is one of the most
sacred in Southern Tibet.

We Western men who had entered this strange
land were pilgrims, but, unlike the pilgrims who
came measuring their length on the ground, we
were pilgrims only of adventure. We had our
camp with our horses and our tents and our servants
and our machines. Our business was to fight the
mountain, not to worship it.

We visited the lamasery. In dramatic contrast
to all expectation, our visit was an intrusion into a
place of joy. I can describe it best as a mixture
of pious religion and uproarious laughter—and a
little dirt. Mystical peace and contemplation is
not entirely a solemnity. Divine service was
brightened by the music of drums with plentiful
food and buttered tea served by attendants. We
heard laughter on all sides from the boys, dozens
and dozens of them, little fellows with shaven heads
and slanting yellow eyes and long claws, clad in

robes of yellow and maroon. They played much as children in any land. One of them will by spells and incantations perhaps be found to be the reincarnation of a saint or god. There was laughter from the grown-up monks, too, who swarmed about. Laughter is universal in Tibet, especially when a white man comes round. The white man is a strange object to Tibetans. They kill themselves laughing at him. You can please yourself whether you feel humbled or not about it. Personally I think that it is the laughter of pleasure and wonder at meeting, a happy polite laugh that conceals no derision. They are indeed most cheerful and happy people, although they lead as hard a life as any of the human race.

Our way being opened by the passports and letters of friendship given our Expedition by the Dalai Lama of Lhasa, we were accepted as honoured guests, although the lamas were all a little appalled at our hardihood in proposing to brave the mysterious dangers of Everest.

One thing about the lamas that catches your immediate sympathy is their gentleness. On the whole they and the Tibetans at large are extremely kind. They are almost fantastically humane towards animals, especially wild creatures, although there is the inconsistency of their being harsh with their beasts of burden. This, however, is to be observed among all people throughout the world who depend upon pack-trains for their transportation.

They are cruel at times towards human beings, although much less so than the Chinese.

You might imagine that they would be theologically argumentative and inclined to proselytize, even to the point of trying to convert us. But they could seldom be persuaded to say anything about either their gods or their devils. A lama once, however, condescended to make a few confidences. It was not matter of idle disputation, but quite practical.

The hairy men, he explained, were most malignant. They lived high up on Everest, and at times came down and wrought havoc in the villages. They carried off women and yaks, and killed all men. I was a trifle annoyed at the solemn fantasy.

" But," I replied, " I want to meet the hairy men."

He could not understand that, but then he thought we were quite mad anyway.

The Tibetan monk believes in a most incredible collection of devils and takes his beliefs with the most matter-of-fact seriousness. Everywhere you go you see endless chortens erected to keep the evil spirits in the ground. If a Tibetan encounters a mishap, falls or breaks his leg, the explanation is that the goblin—they are called Yi-dag or Preta —has risen from the lower world within the earth at that point and has caused the trouble, whether it be the work of Srin-Po, who devours the limbs of men; or Srul-Po, a female demon who causes all the illnesses of children; or Brjed-Byed, who causes

forgetfulness; or Snyo-Byed, who causes people to go mad. Thereupon a chorten is erected to keep that spirit down; and the stonemasons carve phrases on the slabs. Passers-by add stones to the pile and mutter " Om mani padme hum " as they pass on by the left.

There is a fascinating legend of the monastery, which all good Tibetans believe in, that tells of the Nitikanji, or Snow Men. That is the name the lamas give them because they are dread beings who inhabit the snows. One must speak of them with great respect, otherwise they will bring bad luck and perhaps even come down and raid and kill, because they are known to kill men, carry off women, and to bite the necks of yaks and drink their blood. The ordinary Tibetan peasant calls these beings Sukpa, and tells of their strange rovings in the snow, of the long hair which falls over their eyes, so that if you are chased by the Sukpa you must run down-hill, then the long hair will get into his eyes and you can escape from him.

What are they ? Man, ape, bear ? Nobody can tell. But there must be some reason for this legend, because it is an accepted fact in these valleys of Tibet. An ape perhaps, that once strayed from the forests of India and found a home in the snow. The King of the Sukpas is supposed to live on the very top of Everest, whence he can look down on the world below, and choose upon which herd of grazing yaks he will descend. Yak-herds say that

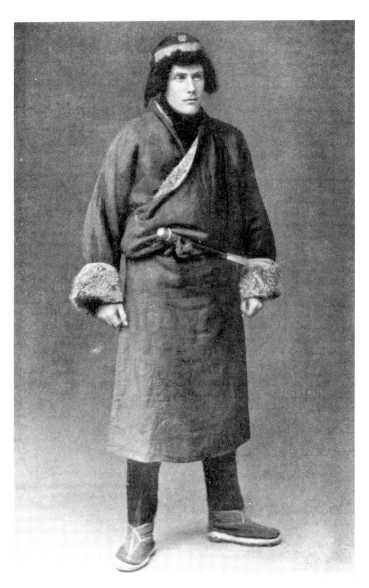

Captain Noel in Tibetan dress, 1913.

A Tibetan lama.

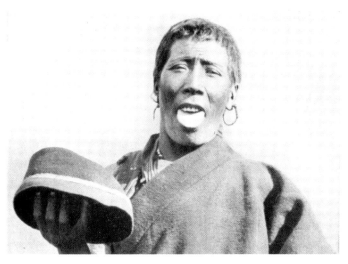

Tibetan method of salutation.

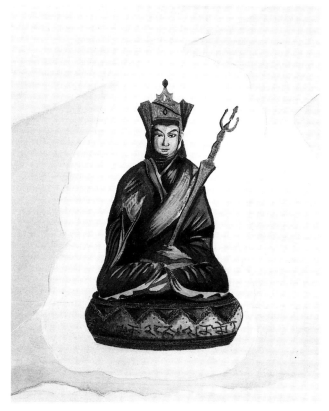

The holy lama who, according to Tibetan legend, ascended Everest on a sunbeam to the throne of Chomu Lung Ma – Goddess Mother of the World, the Tibetan name for the mountain. (From a painting by Maria Klokkou.)

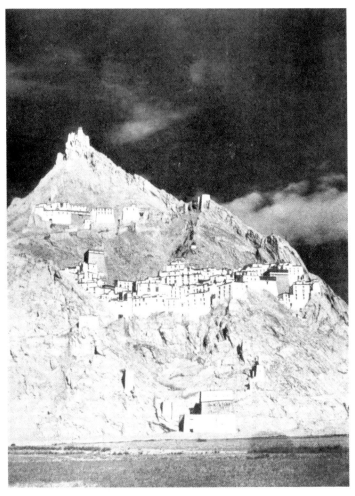

The Shining Crystal Monastery, Shekar.

The Rongbuk Monastery and Everest.

The Base Camp.

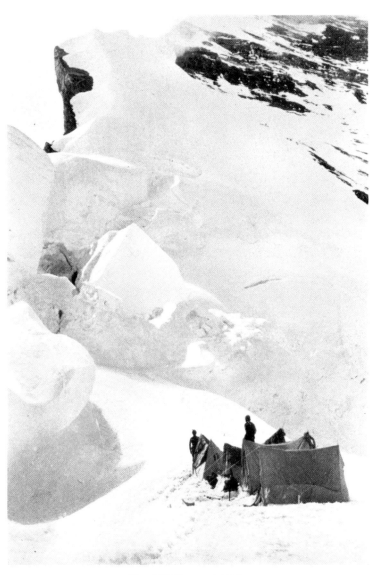

The Cliff Camp, 23,000 ft.

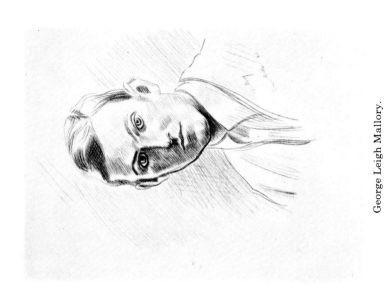

George Leigh Mallory.

The last note written at the 27,000 ft. bivouac.

the Sukpa can jump by huge bounds at a time, that
he is much taller than the tallest man, and that he
has a hard tail upon which he can sit. The men he
kills he will not eat. He just bites off the tips of
their fingers, toes and noses, and leaves them.

Before taking our departure from the monastery
we were allowed to visit the Chief Lama of the
Rongbuk, the great god-Lama, who is the god
Chongraysay reincarnate. He consented to give us
an audience.

We found ourselves trudging up a narrow dark
stairway to a shrine in the upper part of the monas-
tery buildings. A long deep trumpet note began
and continued on and on without a break, and the
sound of cymbals came clashing with a regular
rhythm. When any ceremony was under way a
party of trumpeters and cymbal-beaters on the roof
sounded a proclamation. The trumpeters held the
note sustained while the ritual proceeded, blowing
in relays so that the blare of the instruments over-
lapped unceasingly. We came into a small, simple
furnished room. A few holy pictures and inscrip-
tions in Chinese fashion were on the wall. Before
us we saw two lamas holding a screen of cloth. Our
Tibetan bearers, who had come with us, prostrated
themselves, with their faces pressed to the floor.
Behind that screen we understood was the saint.

We waited silently for a moment. The white
men were allowed to remain standing. Then the
two lamas slowly lowered their screen. A figure

K

sat with crossed knees in the Buddha posture. There were draperies of costly Chinese silks. The figure sat absolutely motionless and silent. Not a soul spoke a word, or even whispered in the room. Somehow we did not dare to interrupt the weird suspense. We stood with our hats in our hands. Outside on the roof the trumpets persisted in a monotonous unceasing blare as if announcing the occasion to remote Powers. Within the room there was an intoxicating smell from the juniper burning by the peacock's feathers in the urn before the figure.

Looking closely we saw the face of an elderly man of extraordinary personality. The Mongolian features had a singular cast of thought and beauty. It is said that each year he, himself, also retires for three months to the darkness of a hermit's cell.

He looked at us, but did not speak or move. Rather he seemed to look over us, through us. There was something vastly observant and yet impersonal in his gaze. The screen of cloth was raised and our audience was at an end and we filed out. Not a word had been spoken. I felt absolutely hypnotized myself. Then out in the sunlight and fresh air again on the way back to our tents we recovered ourselves, and somebody, I forget who it was now, said :

" Gee ! that chap is either the holiest saint or the greatest actor on earth."

It had been a meeting between the East and the West. We were pilgrims, but we had come to

wrestle, not with bogeys and demons, but against not less real and powerful opponents, against blizzards and tempests holding revel amid chasms and rocks, for a prize for which we perhaps would—as we actually did—have to pay a price of human lives.

Can I give you a better contrast between ourselves and the strange people we found living here, or give you a better proof that no physical obstacle of Nature, nor any immaterial obstacle of superstition, can ever beat the spirit of modern man, or prevent him winning any victory he may set himself to win—than by reminding you of a little incident that happened in 1922, when Captain Geoffrey Bruce, of the 6th Gurka Rifles, standing at the world's record altitude of 27,235 feet, forced to give up the struggle against the icy blasts blowing at a hundred miles an hour across the Himalaya, looked up to Everest above, and said :

" Just you wait, old thing, we will get you yet."

By that little incident alone the ultimate fate of Everest was sealed.

CHAPTER XI

TACKLING THE MOUNTAIN IN EARNEST

Five miles beyond the Rongbuk Monastery we came by good fortune to a patch of grass and a clear, fresh spring, at the tongue of the main Rongbuk Glacier, 16,400 feet up. Here, although we were still 15 miles away from the mountain, we built our Base Camp, for this was the farthest limit to which the yak-drivers could be induced to go.

We urged them forward. The junction of the East Rongbuk Glacier, 3 miles or so higher up the valley, would have been preferable for us, but the superstitious Tibetans refused absolutely to advance. Quite an ugly scene occurred when our men tried to prevent their throwing the baggage down at the foot of the glacier. Nothing would induce them to go beyond. They cried out that their yaks would die and devils would harm them. After a long parley, cut short by those who had already unloaded, and were taking their yaks away, we had to accept the situation. Eventually we made a comfortable place of it, pitching our tents on the grass. Then we started on the work of sorting stores and equipment and repacking that which was to go up the glacier. Nearly 20 miles up the turning, twisting valley,

General Bruce planned to make the Advanced Climbing Base.

In order that the reader may understand the system of Himalayan climbers in tackling giant mountains, I must explain the plan originally elaborated and named by Longstaff " The Polar method," by which the attack on Everest was to be made. We were to advance by stages, laying and stocking depots each one day's march apart. Along the glacier we measured a day's progress for laden porters at about 5 miles, involving an ascent of 1,000 to 1,500 feet. On the mountain we were to build depots at about 2,000 feet vertical intervals and continue these camps to the utmost limit which our porters could possibly reach. Each camp would have to be stocked with supplies and provided with a permanent party of porters, with one of General Bruce's Gurka soldiers as Camp Master. They were the connecting links. One party of porters receiving the stores brought up from below would shift them one stage up the glacier to the next depot, handing over to the men stationed there, until the equipment was all so moved up to the Advanced Climbing Base. No one, unless he had taken part in this work, could realize what labour these preparations entailed. It was all vital work too. No attempt to climb the mountain can be started until this chain of depots is established and working smoothly. The depots being completed and the highest carried to within 2,000 feet

of the summit at least—because it was estimated
that 2,000 feet would be the absolute maximum the
climbers could do in the last stage of the climb—
then the climbing parties were to move up from the
Base and acclimatize themselves by resting at the
depots for a period of some days at each as far as
the Advanced Base. Then they would go up the
step ladder of depots on the mountain, making their
desperate spring from the last depot to the summit.
Whether the summit could be reached or not, there-
fore, depended very largely upon the height to
which the porters could carry the highest depot.
We could not, before actually trying, determine
where this depot would be. It meant carrying
loads far beyond the previous world's record height.
There was no experience to guide us. Nobody
knew. Everyone must make their utmost effort.
That was all.

The problem of climbing Everest, besides being
one of the adaptation of the human body to altitude,
accomplished through gradual progress by this
Polar method, is also a problem of weather. In
the early season, which had always been selected
by the Expeditions up to now, there are only eight
weeks at the most of stable weather after the thaw
at the end of winter before the advent of the monsoon
in the first week of June. There is another period
of fine weather, but in uncertain spells, in the
autumn, from the middle of August, until the middle
of September when the monsoon clears up and the

weather becomes brilliantly fine. This period, which has been accepted as the best in the last fifty years of Himalayan travel, has never been used by the Everest Expeditions, although it was the idea of Sir Francis Younghusband that this 1922 Expedition would try both periods. If we failed in the spring, we were to stay on till the autumn. The accidental death of seven men which put an end to this Expedition prevented the carrying out of Sir Francis Younghusband's plan.

To climb Everest in the spring is to race against the monsoon. The period is short; the entire preparation as well as the climbing must be completed before the first week of June. In this there is the danger of the party exhausting itself faster than it acclimatizes, also the danger of confusion should any hitch occur in the preliminaries. Everything has to work to a carefully scheduled plan, and any accident, stores failing to arrive, porters falling sick, or unexpected bad weather, will upset the whole scheme. The men must be divided into groups, taking turns in the exhausting preparation work, pioneering the way by the Ice Cliff up which steps must be cut and ropes fixed, establishing the high depots on the top of the cliff and beyond up the North-East Ridge—forging a way for those who will make the last triumphant ascent. It is a matter of team work to a leader's scheduled plan. Against this mountain a party of two or three setting out on their own would make no headway. Final

advance is only possible when the ladder has been lifted and held in position by collaborators below.

In this Polar method of advance there is an essential psychological principle to be maintained. Each advance, each depot built, must be considered as ground won from the mountain. It must be consolidated and held, and no man must ever abandon an inch of ground won, or turn his back to the mountain once he has started the attack. A retreat has a disastrous moral effect. If the band of men are checked by unforeseen emergencies or bad weather, they must hold their ground and advance again as soon as opportunity permits. The battle is half lost once an assaulting party turns its back to the mountain. They must keep going forward until they win through. Also the health and morale of the native porters becomes tremendously important. These men are to be called upon to make a greater effort in weight-carrying than has ever been accomplished before in the world. It is upon their work in establishing the last depot within climbers' reach of the summit that the success or failure of the entire enterprise depends. Their strength and physical efficiency must be nursed, and they must be encouraged to make the enormous effort. When the highest possible depot is established, then the climbers form a party of the fittest among them to make the last dash to the top. The others must support them closely and be ready to go out in aid at once if they are late or missing.

Such is the ideal plan, but it was all new on Everest; and we could not tell how it would work out. We had to buy our experience.

Soon after we arrived at the site of the Main Base Camp, General Bruce organized and despatched a reconnaissance party consisting of four experienced senior members of the Expedition; this party had the advantage of having Longstaff with them, with all his valuable Himalayan knowledge. Their task was to explore the East Rongbuk Glacier as far as the snowfield at the foot of Everest, and to find sites for the depots. It will be remembered how Mallory reached the head of the glacier by crossing the Hlakpa La Pass from the Kharta Valley on the far eastern side, and how he had left the lower part of the valley unexplored. The reconnaissance party had therefore now to spend nearly ten days of precious time exploring this lower valley approach. They had a hard time, travelling light and sleeping out in the open in the intense cold of early April in temperatures falling to 20° below zero at nights; they accomplished fine work although they exhausted themselves and their porters. They chose a way up the left bank of the glacier, fixing sites for three depots. The first was to be at the snout of the East Rongbuk Glacier at 17,500 feet; the second, Frozen Lake Camp, at 19,500 feet, is a protected hollow by the banks of a little glacial lake at the mouth of a lateral valley to the west; the third, Snowfield Camp, at 21,000 feet, at the margin of the open

glacier basin at the head of the valley below the eastern ridge and face of Everest.

While the reconnaissance party was away, General Bruce completed the organization of a corps of fifty Tibetans, whom he persuaded to come for a short time from the last villages below the Rongbuk Monastery to help our men to move baggage, tents, equipment, oxygen cylinders and various apparatus up the glacier. These Tibetans consented to go as far as Camp 2, " Frozen Lake Camp," but they would not go any farther because of their fear of devils living in the snow and ice. They would not walk over snow or ice. Camp 2 could be reached by the moraine, avoiding the snow, so they were willing to go as far as that.

There was much busy work to be done in those days of preparation, sorting out stores and equipment to go up the glacier. High up only light Whymper and Meade tents would be used, but at the base we were lucky in having big comfortable tents to live in. Even so, after a few days of the awful wind that springs up with the regularity of a clock at ten o'clock in the morning and blows always from the west, we were obliged to shift our comfortable tents to face away.

This westerly wind has chilled itself thoroughly in its course down the whole range of the Himalaya over the tops of snowy peaks. When it reaches Mount Everest in its solitary position at the eastern end of the range, the current seems to stop to circle

round the mountain, held to the immense precipices as if by some magnetic force.

Inseparable from Everest is her " streamer." Mists evaporating from the Kangshung Glacier and snowy recesses rise up the southern precipice, are caught by the west wind and carried off horizontally, forming the great ever-changing, never-ceasing " steamer " drifting in heaving clouds from Everest's ridges twisted and torn from the westward—for some unknown reason ever from the westward. Personally I admired the streamer. It added to the pictorial photographic effects of the mountain. The climbers had different notions about it. It was an evil omen for them.

As an example, almost unbelievable, of the effect of Everest's wind, our scientists definitely determined that certain furrows and grooves and pitted surfaces we observed on the granite rocks were the direct effects of wind erosion. The same rocks on sheltered sides were smooth. It was no glacial action, but the very action of the wind.

During the days of waiting, the Base Camp grew into quite a comfortable village. The Tibetans made stone huts for themselves among the rocks, our cooks built a kitchen and tables and fireplaces of stone. They foraged for the scanty brushwood that grows in the springtime in the valley. The climbers trained themselves on rock climbs and excursions.

I busied myself with photography and the developing of the motion-picture film I had exposed to date.

I pitched a dark-room tent on the banks of the glacier river, and there got ready for the work of developing films at 16,000 feet above the sea, higher than the top of any mountain in Europe and miles higher than films had ever been worked before. If it be asked why the work should have been done up there, the answer is that I wanted to be able to check results as I went along, and to repeat any scene if necessary. A photographer has a terrible difficulty to overcome in the static electricity caused by the extremely dry atmosphere. This trouble may spoil any part of a film reel, and the testing of ends of reels is no indication of any trouble that may have happened to the middle parts.

I had four cameras, to ensure against the ever-present possibility of having one or more of them fall and break. With them went tripods, supplies of film and plates and developing tanks, a developing tent and other paraphernalia. All this was carried in specially made steel cases. It made quite a load to carry up the most difficult mountain trails in the world and finally to the dizzy heights—craggy slopes and glacial ice where the air was so thin that even simple walking caused me to pant and grow faint, and the heart pumped as though it were an internal trip-hammer ! Eventually with the help of my own Sherpas—valiant fellows—we got the cameras up to 23,000 feet. That is the altitude record for any motion-picture machine.

This phase of the Expedition was my own par-

ticular ordeal. I had been through some experience in photographic journeys in the Himalaya, but photographing the Mount Everest climb certainly lives in my memory as the most difficult task I have ever encountered. Its difficulty and labour became a nightmare. The plans for the Expedition embraced a day-to-day motion-picture record from the time we left India until we returned. During the first half of the journey to the approaches of Everest, mules carried the photographic baggage. After that we employed the yak. Now the yak is a quaint animal, a strange mixture of patient docility varied by lightning freaks of fancy. He carries great burdens very surefootedly at the rate of about a mile an hour, grazing a bit as he goes on. But he is capable of the most capricious wanderings if he is not treated exactly right. In riding him the yak driver covers the animal's eyes while the rider mounts from behind. This is important. If the yak sees the act of mounting he remembers it, and after an hour or so, perhaps, decides to reach back with his long horns, raise the happy rider from the saddle and send him flying a dozen feet or so. I tried the yak as a mount, but found the mule a better steed.

For photographic service the yak was out of the question. I had to be ready as we went along to get into action at a moment's notice. Events occurred quickly—there might be a curious group of natives to be photographed, or a mishap to our party, or a particular view which an oncoming mist

was obscuring. I had eight natives for assistants. In an emergency one unpacked a camera, another a tripod, a third made the connection with the batteries for the electrical operation of the machine. In two minutes the picture was under way. These things were much too complex for the yak's simple yet fantastic soul.

Up near the topmost heights discharges of static electricity became phenomenal. In that high, dry atmosphere everything is highly electrified. The ordinary motion-picture camera will not work there. Even the friction of the celluloid film against the complex guides sets up great discharges. The higher the altitude the more extraordinary this sparking becomes, and obviously if occurring inside the film box it is disastrous ; the film when developed shows lightning-like flashes on the picture.

In order that my pictures should not merely record a long series of these flashes, I, guided by past experience, had a camera made which in operation minimized friction. My films even then still showed flashes, but not enough to ruin them.

This constant fight with static electricity was continued while developing the negatives in the dark-room tent. Every contact of the fingers with the celluloid brought a spark. Holding the film flat between the fingers brought a disastrous display. I had to take the strips gingerly by the edges. That lessened the damage.

Washing and drying negatives was another ticklish

problem. The temperature was always below freezing at night. When the sun came up the condition was one of slight thaw. I developed at night and left the films to wash until morning. In order that the water in which they soaked might not freeze. an oil lamp was kept burning in the tent. It was impossible to dry film at night because of the freezing, and during the day the wind blew with unceasing violence, and carried quantities of dust and grit, which speckled a film in a disastrous way. But for two hours after the sun was up the air was quiet, and I used that daily tranquil time for drying. It was always a scramble to get the advantage of this temporary condition.

Thus I worked, not unhappily, against odds in my dark-room tent by the banks of the glacier river. Altogether there I developed during the progress of the Expedition 10,000 feet of film.

So the days passed until the reconnaissance party returned. The whole energy of the Expedition was then thrown into the work of building the glacier depots and moving up a stream of stores, equipment, tents, ropes, climbing gear, oxygen-breathing apparatus and steel cylinders of compressed oxygen gas. The camp was always astir. All were pressing forward. Everybody wanted to be in the vanguard ; to reach Snowfield Camp, and get a peep at the mountain from close quarters. I went up and down the line and had many opportunities of seeing the busy work of the climbers and porters.

CHAPTER XII

HOW CLIMBERS LIVE AT GREAT ALTITUDES

The daily task of the Sherpa porters was to go from camp to camp carrying forward the supplies, apparatus and provisions brought up by other parties of porters from below. Thus there was a human track-conveyer system established up the glacier, feeding the advanced climbing base and the high bivouacs from the Main Base Camp. The men lived on the glacier week after week doing this arduous work. They never complained, but remained as cheerful as young boys the whole time. We could hear them singing mountain songs, their voices echoing through the valley. Catching sight of one of the members of the party approaching they would shout their delight and run out and conduct him to the camp, where he would find a hot meal of a sort prepared within a few minutes' notice by the cooks.

The path followed from camp to camp, sometimes over the moraine, sometimes over the ice, becoming at length well defined by the many footsteps that passed. Between Frozen Lake and Snowfield Camps the glacier was twisted and broken into a belt some two miles wide of broken, splintered bergs of ice,

some towering to a hundred feet in height. Here
the men would strap steel spikes to the soles of their
boots and set out along one of the strangest paths
imaginable. They would find their way, turning
and twisting in every possible direction, past the
towers and pinnacles of ice, avoiding fissures fifty
feet deep, descending walls of ice a hundred feet in
depth, following old widened crevasses, climbing
ladders that we cut in the ice, guided by a line of
little flags we fixed to wooden pegs hammered to
the tops of ice-hillocks. These showed the way
when storms and mists concealed the more distant
landmarks and snow covered the foot-tracks. We
named this region " The Fairyland of Ice." Actu-
ally it had been a work of many days to discover
a path by which to penetrate the maze. Bergs and
cliffs and crevasses blocked the way a dozen times
to the first exploring party, and were circumvented
only by retracing steps and starting afresh from
some new direction.

It was truly a fairyland. The beauty lay in the
fantastic shapes of the ice formations, carved by
evaporation in the dry air of 20,000 feet and hol-
lowed by wind erosion. In the sunlight all was
dazzling whiteness ; but in the shaded hollows one
saw delicate transparent blue-green hues. And what
sunlight ! The brightest summer sunshine we know
at home would be mellow compared with this light
resembling the radiance of white-hot metal. The
air was sharp, freezing, rarefied, but the tropical

L

sun, almost vertical above, scorched the eyes into snow-blindness, and its ultra-violet rays, intensified by reflection from all directions, could strike men down helpless in the agony of mountain lassitude and mountain sickness if they were not properly protected. We usually tried to make the passage of this beautiful but deadly region in the early morning or late evening to escape the menace of the ultra-violet rays.

It was a marvel to see our Sherpas work. Probably nobody but the Sherpa could have done what they did. All their lives these men have lived in the highest mountains, accustomed from childhood to altitude and to the carrying of heavy loads. They inherit the cheerful spirit of the Nepalese plus the acclimatization to a rarefied atmosphere of the Tibetans, since the Sherpa race is an intermixture of Nepalese and Tibetan blood. Their villages lie in Nepal on the borders of Tibet on the south side of the Himalaya.

Sherpas are fighting people ; and no little trouble arose from their " scraps " with the Tibetans, whom they look down on and treat rather roughly. They fight among themselves, too. I remember one awful fight between two of our men. They battered each other unmercifully with fists and stones and bars of wood. Both were in hospital under our doctor ; but next morning we actually saw them doing up each other's bandages with the greatest care and mutual pity. They had exhausted their

steam ; the fight was over, and their happy natures
were restored.

At 16,000 feet they could carry loads of 50 to
60 lb. in weight. They carried 20 to 25 lb. weight
to a height of 25,000 feet, where white men could
hardly progress even when unburdened. These
supermen of our porters were nicknamed " The
Tigers." There is almost no limit to the powers of
these men in weight-carrying on mountains ; and
should they ever become animated by a sporting
desire to reach the top of the mountain, they could
undoubtedly do it more easily than any white man.
When they first saw our unsightly and awkward
oxygen tanks, they laughed heartily and said,
" The air in our country, sir, is quite good. Why
do you bring bottled air from England ? " But
later, when, at grips with the mountain, all were at
the end of their tether, we used to give the men the
gas to revive them. When they tasted it they
realized how wonderful it was and how it stilled the
heaving of the heart. Then often they would come
to us and say : " Sir, I—little sick to-day—please,
sir—I want a little ' English air '."

The men who succeeded best on the mountain, it
was interesting to note, were of the small, supple,
trim type. These did better than the big men.

One must remember that they were not in a true
sense picked men. They were recruited from men
seeking work in Darjeeling, and the life of the bazaar
and the town must inevitably have a deteriorating

influence on the spirit and physique of mountain-dwellers. As a general principle, it would be better to recruit the porters on any future occasion from the heart of their own country. This could be done with the good help of the ruler of Nepal by permitting some one to go to Solakumbu, or else by sending a native representative to inform the people of the objects of the Expedition and tell them that men were wanted. They could then come to Darjeeling specially to join the Expedition.

We noticed on the whole, exceptions apart, that the veterans of the former Expedition were not so successful as the fresh men. Their morale was not so good. They had become " old soldiers " and, knowing the ropes, some of them shifted their work on to the new men. Our common human nature ! Always the stumbling-block that stands in the way of achievement ! But on the whole the entire corps worked splendidly ; and one cannot praise their spirit too much, particularly when one realizes what losses and hardships they suffered and how at the end of this 1922 Expedition seven of them met a terrible death in the great disaster on the Ice Cliff. A proof of their spirit is that survivors, who even had relatives among the killed, volunteered again for the 1924 Expedition.

Bruce introduced a spirit of competition among the men. He promoted the " stars " into troop-leaders with promise of honours and extra pay. So the corps became a trained team, which is the goal

to be aimed at. They followed with the keenest interest the progress of the various climbs, and competed to be included in the parties to go highest. All, with the exception of the few " old soldiers," vied with each other to carry the heaviest loads. It was never necessary to tell any man, " To-day you will carry this " ; and to another, ' You will carry that.' Each man selected the heaviest he could bear. They felt that the eyes of the world were upon them ; and they knew that they would win glory when they returned to their homes in Darjeeling. They would all get good chits—mementos from the leader of the Expedition and perhaps medals which they could cherish all their lives. It was gratifying that when they did return to Darjeeling the residents received them with pride and hospitality, and made them feel that they had done great work. Who could say that these men were not real sportsmen ?

The Base Camp stood at the gateway of " The Dead World." Below was the region of life. Above was the region of rock and ice and snow. The kingdom of King Cold. To a real mountaineer—that is, to a lover of mountains—mountains are always living and friendly things. They always have a message to convey to him. He can never feel unhappy or lonely among them. People have often said to me concerning my journeys in the Himalaya : " What hardships and what horrors you have suffered ! " They never understand my

answer : " I never feel happier or fitter in my life than when up on the high glaciers ! " The seven weeks I spent on Everest's glaciers were seven of the best weeks of my travels that I shall ever remember.

Unless a man can feel at home and happy among the mountains, he has no right to call himself a mountaineer. Certainly he should never go on an expedition to the Himalaya. He should remain where there are railways and hotels, for there will be no railway to take him to Snowfield Camp at the head of the East Rongbuk beneath the walls of Everest, the highest camp in the world which men have ever built and lived in permanently. It was the snow-home of the Everest climbers for two solid months.

Scientific people, before the Expedition, predicted that human beings would not be able to live for long at such a height as 21,000 feet unless they came down frequently to lower elevations to rest. But we broke up this theory. When we first arrived at great altitudes our bodies were convulsed by violent panting, our hearts beat like hammers and our lungs heaved and rasped for breath, even when we so much as raised our arms to manipulate the ice axe to cut a step, to lift a rucksack to our backs, or to take one or two steps forward on a slope. Yet when we sat down and rested or slept at night motionless in our sleeping-bags, when there was no exertion, the panting would cease. We found after

acclimatization that we could sleep at any height. Actually in the Expedition of 1924 Norton and Somervell slept at a height of 27,000 feet.

This power of acclimatization was one of the important discoveries of the Expedition. It proved, what nobody previously imagined, that the human body is such a highly adaptable piece of mechanism, that it would even be perfectly feasible for a fit man to acclimatize himself by living two or three years on Everest and then walk to the summit.

One of the chief problems, then, in climbing Everest is to effect this necessary acclimatization as rapidly as possible. A party could of course be brought to Tibet to acclimatize during the winter, but most members would object to the tedium and discomfort.

Thus our task in the depot camps was to make ourselves comfortable and happy, so that we might acclimatize as quickly as possible. It was vital that we should enjoy ourselves and keep up our spirits, and the spirits of our native porters. Depression is one of the subtle ways by which the mountain fights us. It is one of her defences, that she makes us sick, tired, listless, quarrelsome with our companions and disinclined mentally to continue the fight. She exhausts our minds quite as much as she exhausts our bodies. At great altitudes mental capacity becomes dulled and memory hazy. This leads easily to nervous physical tremors upsetting heart, lungs and stomach, and over the mind falls

a worse cloud of mental confusion. We hardly know what is the matter at the time, although we realize it fully afterwards. Our very intelligence has been affected ! We have been suffocated as if by some subtle, invisible, odourless poison gas. We find ourselves returning to a primitive, elemental state. The only things that interest us are food and sleep and bodily comfort. The too frequent sight of our companions' faces annoys us. We quarrel with them over the most trivial details. Our appetites become capricious and demand a change of diet at every meal, and the sight of what is ordinarily a favourite dish here served three or four times in succession raises our temper to a storm. Here is a sad instance. We were all very fond of a certain type of sausage, and our cook had been feeding us a good deal on them. One day, I remember, when these were again served, one of our party (no names ! ! !) lost control of himself, shovelled the whole pan of frizzling Hamburgers into the cook's face, and pocketing a lump of cheese, went off to his tent repeating odd phrases in English, Hindustani and Tibetan. The blame was on the old mountain and her poisons. We each had to excuse one another's temper !

I used to take careful note of the climbers after their big climbs and watch the psychological effects of extreme altitude. In all cases they complained that their mental impressions when high up were vague. They all suffered from mental depression

and inertia. Finch was, for instance, the most ardent Kodak snapshotter I have ever met. He always had a Kodak slung on his shoulder, and photographed enthusiastically to right and left. He took something like 2,000 snapshots on the Expedition. When he made his great climb to the world's record of 27,250 feet with Bruce, he suffered so much, in spite of the fact that he was using oxygen, from this " mental stagnation " as he described it, that he did not even take his camera out of its case from the moment he left the Ice Cliff Camp to the time when, after reaching his highest, he returned again to camp. Now an ambition, which ranked with him equally to making a climbing record, was to get pictures of the upper parts of the mountain ; and the fact that he failed to get a single picture because, as he said, " he could not be bothered," was a striking example of the paralysing power of this mental lassitude. Even at the relatively low height to which I climbed on the mountain, 23,000 feet (a height which only a few men reached before, but which on Everest counted as nothing at all), I felt myself overpowered. This disinclination to do anything was of course the greatest enemy to my work. I had to fight hard to overcome it, because my motion-picture cameras were complicated and when making a film there are lots of things to think about—to say nothing of the terrible enemy—" static."

Doctors and scientists who have studied the

symptoms recorded by the Expedition during the ascent of Everest have formed a theory that they indicate a state of hyperthyroidism, caused by the abnormal interruption of the functions of the thyroid gland. Dr. Gale of Glasgow, the noted authority, said " the troubles were in many respects similar to the first signs of Thachardia." A symptom of disorder of the thyroid gland is a distaste for meat. That is what we felt to a large degree. We disliked our sausages and tinned meats in the high camps, although these were our favourite dishes in the journey across the plateau. We preferred cereals, Swiss milk, jam, biscuits and tea. I remember that when I stayed four days and four nights at Ice Cliff Camp at 23,000 feet, I ate no meat at all, and enjoyed a diet of Swiss milk mixed with strawberry jam. This may sound terrible, but it makes good food for such conditions. I considered it "tasty" (although it wouldn't be so to everyone), it has powerful nourishing and heat-sustaining properties, it required no cooking and caused no labour. In that alone it has a supreme merit. The torture and horror of "work" at high altitudes cannot be understood by those who have not suffered the conditions. If anything has to be done a man immediately cogitates : "Does it mean work? If so, I'll leave it—I cannot do it—let me remain still —while still I am all right. Moving will start that killing hammering and heaving of the heart and lungs again."

Of course, under the strain of altitude it is not only functions of gland, heart or lungs that are upset. Another disturbing influence is the effect of the ultra-violet rays. These are known to be beneficial to human beings at normal altitudes and are now used by doctors for curative purposes, but in these lofty regions we meet ultra-violet rays of short wave-length which are said, like X-rays, to have a baneful effect on the tissues of the body. French scientists have stated recently that the air on the top of Mont Blanc and Monte Rosa contains minute quantities of nitrogen which has undergone, through the action of light rays, certain minute atomic modification which causes it to become poisonous to the blood.

As regards the thyroid gland and its relation to altitude, Dr. Gale said that he would expect to find the best air pilots and members of future Everest Expeditions would be men of slow pulse, stolid countenance and quiet speech, whose thyroid gland condition shows a slight hyperthyroidism. Odell, Irvine and Somervell (particularly Odell), who proved themselves so marvellously successful on Everest, would seem to substantiate Dr. Gale's theory.

We disproved many established popular ideas. We found that whisky and particularly rum in moderate quantities were beneficial. A ration of rum should be issued every night in the glacier camps, to be taken as men turn into their sleeping-

bags for the night. This induces comfort and sleep.
Future expeditions should carry the rum in high
overproof concentration for transportation purposes
in small wooden casks.

Finch told me that cigarette-smoking added
greatly to his comfort, so it did also to the Sherpa
porters. I had brought with me 20,000 cigarettes
for my own photographic porters, knowing how
these men enjoy smoking. They smoked them all.
I got further supplies for them from an enterprising
Chinese trader who opened a little shop at the Base
Camp, selling out his stock in two days. He sold
us Chinese " Favourite Horse " cigarettes at two
rupees a thousand! He was pleased with his
business and regretted it would take him too long
to go and replenish his stock as he had come 1,000
miles from China with his twelve donkeys. How
he made his profit I don't know. He was a remark-
ably enterprising man.

When Finch was climbing at 26,000 feet he noticed
that unless he could distract his mind from worry
about his breathing of oxygen and let this become
an entirely subconscious process, he suffered. He
had thirty cigarettes with him. After smoking and
inhaling he discovered that it took his mind off the
question of breathing and made the act altogether
an involuntary process. Probably tobacco acts
indirectly as a counter-irritant of some kind or other
on the system under abnormal conditions. Cigar-
ettes were absolutely indispensable to the Sherpas.

Many people ask what a mountaineer's wardrobe is like. The great idea is to get something light and windproof. On Everest the wind is worse than the actual temperature, which does not go lower than about 30° below zero, no greater cold than the winter temperatures in parts of America. Climbing, you cannot bear the weight of furs. The freest and warmest anti-wind dress is camel-hair underclothing with plenty of air space next to the skin, topped with loose sweaters and woollen knitted jackets. Over the lot you wear a windproof blouse and trousers in the Arctic fashion. Headgear must provide protection from the ultra-violet sun-rays. The underclothes of camel hair serve also as pyjamas in your sleeping-bag, so that on rising in the morning the warm air next the body is not disturbed. You do not " tub " on the glacier ! This sleeping-suit is all you need inside your sleeping-bag at night. In the morning you have only to slip into your outer skins, after breaking away the little icicles that have collected round your beard. Then you get into your loose boots made with thick leather soles nailed on the rim and only stumpy nails on the sole because their iron has the property of conducting heat and cold between foot and ground. Your boots must be big enough to allow at least three thick woollen socks, and you will keep away frostbite if you carry spare dry socks to change in your back-sack. If the gale is raging outside the tent, you can slip on your windproof blouse and pull it down over the

windproof trousers which themselves are bound to your ankles by puttees leaving the knees loose and free, so there is no chink by which the wind can enter. Then with a wide-brimmed sunproof hat, with ear-flaps ready to pull down, snow spectacles, woollen gloves with outer leather covers hanging by a tape round your neck, and the skin of your face and beard covered with a thick layer of white grease to deflect ultra-violet rays, you will be equipped for the day.

Finch, who had a scientific brain, invented a wonderful green quilted eiderdown suit of aeroplane fabric, doped. Not a particle of wind could get through. Underneath he used to wear a suit of silk underclothes, then one of wool, then another, then a fourth of thicker wool, then a fifth of the thickest substance he could find—then he really began to dress in earnest, when he was to go up to the highest camp with the wind reaching a velocity of 100 miles an hour. For myself I always found two woollen jackets with the layer of camel hair beneath sufficient, but I did not go beyond 23,000 feet.

I cannot conclude this description of our life high up without trying to describe to you something of the romantic beauty of our surroundings at these glacier camps. This beauty was what always mastered me; and I strove to interpret it in my moving pictures. Many times I used to go out with my men carrying my cameras in the evening time

to photograph the amazing majestic, towering mountains, the fantastic ice pinnacles and formations, the ice funnels, the glacial lakelets, the rock mushrooms, where boulders balance themselves on stems of ice, and the enchanting effects of light and shade and cloud shadow on the ice worlds around our camps.

In the evening these solitudes wear their most entrancing aspect. The evening light beams play like quicksilver on the ice-bound slopes ; the shadows of the night gather in the ice caverns and recesses of the glacier below. But the delicate soft mists that form themselves out of nothing, float awhile, then evaporate, or are torn apart by the winds and scattered over the ridges, are more beautiful still. On the mountain ridges the corkscrews and whirls of fine powdered snow lift and sweep along the skyline, swamped sometimes by some bombshell of dense cloud which sweeps up and violently obliterates all.

Once at Frozen Lake Camp we were startled at night by the roar of a great rock avalanche—" the artillery of the mountains " we called it. The hillmen have a superstition that a rock falling near a camp and hurting nobody is a lucky omen. They say it is the spirits of the mountains, the Zhidag, who throw the rocks, and if they fail—well !

From Frozen Lake and Snowfield Camps Everest could be seen commanding the sky, filling the valley and dominating everything. What frightening

aspects the great mountain can display. Generally
her precipices are concealed by mists, but when they
clear she shows the never-ceasing anger of the awful
wind, blowing always from the west, veiling and
unveiling the topmost ridges with the smoke of
driven snow. We often used to look up at those
ridges and watch the snow being literally torn up
and flung a thousand feet into the air. " The worst
mountain in the world for wind," we would say to
each other. It was a grim thought for the climbers.
They knew they would be up against it in earnest
when the time came for the big assault, for there is
no escape from that hurricane of the west. It
never ceases, night or day, to rage round the summit.

I spent many long hours on the glaciers in the
evenings, trying to record in my motion picture
these amazing scenes. I tried so to compose my
pictures as to interpret, if possible, the soul-meaning
of these mountains. For me they really lived. I
was in love with their beauty just as much as I was
awed by their might and majesty and power.
Everest assumed an extraordinary living character,
a living thing of fascinating beauty, of fearful power.
Ever frowning down on us, she was angered, so it
seemed, that we should come to violate her sanc-
tuaries that never before had suffered the foot of
man.

The tropical sun has lowered itself behind the
mountains. There is no twilight. Evening jumps
to night. The mercury runs down as if you had

made a hole in the bulb. You must get back quickly to the camp, where everybody else has long since turned in to his sleeping-bag. Another day has passed and brought nearer the day of the great struggle for which we have been working and preparing.

CHAPTER XIII

COMBAT! ACHIEVEMENT! REPULSE!

Everything was ready for decisive conflict with the mountain. Snowfield Camp had become a well-established base for the start. It was decided that the first attempt would be made without oxygen, and Mallory, Norton, Somervell and Morshead, four of the hardiest and best men that the Alpine Club could send, were to make up the party.

The first task, which we really did not consider as part of the climbing but as one of the depot stages, was to climb the Ice Cliff. This, however, is one of the most dangerous parts of the whole ascent of the mountain. To anyone standing below, the Ice Cliff looms so terrifying, so sheer with its walls of ice a thousand feet high, so threatening with its yawning crevasses, that it looks too terrible a thing ever to propitiate. But it has to be done. It is the only way to the summit. The depot-laying parties had already climbed the cliff and made a permanent camp at the top with four light tents on the shelf of ice some 25 yards long and 10 yards wide. The men had to cut about two thousand footsteps in the ice, and fix over 300 feet of hand ropes, attached to wooden pegs driven into the ice, following a zig-

zag course to avoid the dangers of avalanches. We had to take the risk of these avalanches which we knew might crush us any moment. Steps were cut 2 feet deep through the snow into the hard ice beneath. The danger lay in the snow coating slipping away or " peeling." This was most likely to happen when the snow was new and soft, before the sun had played on it and bound it tight to the ice beneath.

Half-way up, at 22,000 feet, there was a nasty gaping ice crack 15 feet wide and about 70 feet deep, whose green jaws rimmed absolute blackness. It was crossed by a natural snow bridge which the climbers reinforced by shovelling on more snow and ramming it down. Ropes were hung across for the porters to cling to.

The climbers were to rest a night at Ice Cliff Depot, and thence to try and gain the top of the mountain in two days, building an intermediate camp about 25,000 or 26,000 feet. But nobody had experience of such heights. They were beyond the previous world's record and therefore plans were no more than hopes.

That evening Mallory and Somervell, roped together on account of the blasts of icy wind sweeping the top of the ridge, went out beyond the ledge where the camp was pitched to explore. They were breaking new ground now. The year before Mallory had not gone beyond the top of the Ice Cliff. They found the way barred by an enormous crevasse

impossible to cross without a ladder, and they had none. Turning back they found another opening, walking away from the mountain and then zigzagging back along the top of the crest of the Ice Cliff and so reaching the North-East Ridge. At the Crest which overlooks both glaciers, the Main Rongbuk and the East Rongbuk, they were nearly blown off their legs by the wind. But the evening was rosy and clear and promised fairly well for the morrow.

They returned to camp and found everything satisfactory—every man fit, and food had been prepared. Everybody ate heartily. Cooking was most difficult at this camp because water boiled at a very reduced temperature in the rarefied air. At this height the hand may be dipped quickly into boiling water without being scalded. Food will therefore not cook properly and it is difficult even to make tea leaves draw. One lives mainly upon " sloppy " foods, foods with plenty of sugar to cause heat. Dried figs and plums are good, but they tend to create thirst. Lemon drops, peppermint lollies, chocolate and dried fruits were some of the principal articles of diet of the party on the last stage of the climb. In fact, Mallory used a ration mostly of sugar, calling it " quick fuel."

Ice Cliff Camp was a not uncomfortable and even a cosy spot, protected as it was from the blasts of the west wind by huge ice blocks that stood insecurely towering some 70 feet above the tents, serving as a windbreak.

Next day, the 20th, the camp was astir at five o'clock. This was the day that was to bring the breaking of the Abruzzi world's height record of 24,600 feet made on the Bride Peak of Kashmir.

Four of the porters, suffering from mountain sickness, had to be left behind ; but with five other sturdy and fit men the party got away at seven o'clock along the new zigzag track up into the gale that was tearing over the top of the pass and sweeping the ridge. Here step-cutting had to be done in places. Mallory cut 300 feet of steps. Up and up they went ; going well. They passed the record height. They reached 25,000 feet.

They then bore off the ridge to escape the wind and to find a platform large enough to allow two tents to be erected on the precipitous mountain side. As they were doing this building work, Morshead's rucksack, laid aside, slipped from the rock and started down the slope. They saw it go bounding down the precipice to land on the glacier 4,000 feet below. Failing to find any flat place, they built two platforms with slabs of rock for the tents. The world's record height broken, they were now actually to spend a night higher than men had ever reached before. They were in anything but tiptop condition. Morshead was in a really serious state from frostbite and exhaustion. Norton was frostbitten, and Mallory's fingers also suffered a slight frost-bite.

Let Mallory describe the night :

" It was bitterly cold and snowing hard. We crawled into our sleeping-bags after securing the tent guy ropes, lashing the tents down, and huddled together, tired out, to obtain as much rest as we could before tackling that terrific climb above us. A storm arose and we had to fight for our lives, realizing that once the wind got our little shelters into its ruthless grip they must inevitably be hurled with us inside them down to the glacier thousands of feet below. By one o'clock in the morning the gale had reached its maximum. The wild flapping of the canvas made a noise like machine-gun fire, so deafening was it that we could hardly hear ourselves speak. During the lulls we took it in turn to go outside to tighten up the slackened guy ropes. It was impossible to work in the open for more than three or four minutes at a stretch, so profound was the exhaustion induced by this brief exposure to the awful wind."

At eight o'clock, the earliest time that any start could be made, no one was feeling well. They all suffered from lethargy and headache owing to the rough, wakeful night. Morshead was done. He said : " I think I won't come with you, boys—I shall only keep you back, you go ahead and leave me—I'll be quite all right." So tucking him up in his sleeping-bag and leaving food and water by him, Mallory, Somervell and Norton got away up the ridge. The air was so rarefied that only a step-by-step progress could be made. They were roped.

The men took it in turns to lead, because the greatest strain falls on the leader who makes the steps and sets the pace for the others. Mallory did a good deal of the leading. He had a marvellous process, said to be a secret of his own, worked out in Alpine climbs, of deep breathing in conjunction with his gait and upward swing while climbing. It is said that he could pass the air deeper through his lungs, and get more oxygen out of it, than others know how to. But he would never tell us his method of breathing. It was his secret.

Step by step they climbed, higher and higher. They were working along the line of the ridge leading up to the North-East Shoulder, 27,000 feet. From there the ridge turns to the right and leads on by a gentle slope and then by a series of steps to the final pyramid and the summit. The way ahead was visible almost all the time.

At about 2.15 p.m. they reached the head of the rocks a little way beneath the North-East Shoulder, a height of 26,800 feet. They saw the top of the shoulder clearly above them. Although capable of continuing they decided to stop here and return, because the summit was absolutely out of the question. It was a day's journey ahead at the speed—the utmost possible—they were going at. They were cutting only a step at a time. At every step they had to lean forward, doubled over their ice axes—and take five or six gasping breaths.

To reach the summit it would clearly be necessary

to establish one higher camp somewhere near the position they were in now. This was impossible, as they had not the equipment. They had food only for the day. Furthermore they were gravely anxious about Morshead, left at the 25,000-feet camp. They turned back.

They found Morshead's condition so serious that it was considered necessary to get him down that night to the lower camp on the Ice Cliff. It was already late and it would mean finishing the descent in the dark; but they thought it was necessary, so the whole party, with Morshead supported by each in turn, went down under tremendous difficulties. Some of Morshead's fingers were entirely frost-bitten; Norton was frost-bitten in his ear—he eventually lost a bit of it.

Bad weather overtook them. Sinister grey clouds, flickering with lightning, surrounded them, the lightning illuminating the glistening ice slopes. Night was overtaking them, and all the men became reduced to absolute exhaustion. It was touch-and-go whether they would reach the Ice Cliff Camp in the dark. They had a considerable amount of step-cutting to do, and Morshead had to be supported at every step.

Nearing the Ice Cliff they came to an enormous crevasse, and by their lanterns had to find a way down. The first man had to leap 15 feet into snow, not knowing if it would hold as he landed. Then the last candle in the lantern burnt out; and they

continued the descent, falling and slipping. Eventually they reached the camp at eleven o'clock at night. They found the sick porters had left and taken the cooking pots with them, so they fell into their tents to sleep with no more than the cold stores they found in the camp.

Next day the battered party descended the Ice Cliff safely. They were surprised to meet Finch and Geoffrey Bruce coming up with oxygen cylinders. I myself was with Finch and Bruce. I went with them to the top of the Ice Cliff and stayed there recording their climb by telephotography. I remained in the camp four days and nights.

Finch and Bruce were working on an entirely independent plan of Finch's. Finch had his own porters and planned to make his camp higher on the ridge and follow a line across the northern precipice cutting off the North-East Shoulder which Mallory's party had steered for. Finch and Bruce used oxygen to ascend the Ice Cliff. This gave them an opportunity to test the apparatus thoroughly. Oxygen had a most marvellous effect: it reduced a climber to the equivalent of an elevation of 15,000 feet above the sea. Each of our cylinders lasted about one and a half hours. When empty the cylinder, which weighed about 5 lb., was thrown away to save the weight. Of course a large number of spare cylinders had to be carried, and this, together with the weight of the apparatus, was its drawback. Still, on the whole, it was found that the

ability to breathe which the gas gave outweighed
the disadvantages of weight. But there was another
factor to consider—the dependability of the appar-
atus. Its failure, if relying wholly upon it, might
mean death. The 1922 apparatus was in quite an
experimental stage.

Finch and Bruce and I spent the night at Ice
Cliff Camp. It was my first night at this height;
and I did not sleep at all. Finch and Bruce had a
very poor night too. The next morning they were
very much exhausted, and we all sat about in the
snow for nearly two hours in a sort of dazed con-
dition, incapable of action. My camera was in my
tent. To get it out of its box and take a photo-
graph of the men or the camp was a thing that filled
me with horror. I felt overcome by a sort of mental
coma. Finch felt the same, and so did Bruce. They
sat about for a long time doing nothing. Eventually
we made some breakfast, but performing every action
at a ridiculously slow speed. I felt so done up that
I went to my oxygen apparatus, opened the tap
wide and took a quarter of an hour's heavy breathing
of oxygen. This had a most marvellous effect. I
became another being. I woke up and took notice.
regained full strength and felt quite myself again.
Finch also took oxygen and finally we finished
breakfast and aroused the porters who, lying in
their tents, were in a very lethargic condition.

The weather was fine. Finch and Bruce got off
at a very late hour with their porters. I watched

them with my telescope and managed to take some long-distance photographs of them, an enormous exertion only made possible by breathing oxygen all the time I was doing it. I saw them going, very, very slowly, up the North-East Ridge. When they passed over the snow, I observed them distinctly at a distance of about one mile. The long-distance motion pictures I took showed them quite clearly. After this I felt so done that I went to my tent and stayed there without eating anything beyond some tinned milk and jam during the rest of the day and the whole of the following night.

Next morning I got up with difficulty, and spent most of the day attending to Songlu, my faithful Sherpa servant, who had been always with me, and had been Kellas's faithful servant too. Songlu was an elderly man, and he reached this high point under enormous strain. He collapsed at the top. His condition was so serious that I thought he was going to die. I could not get him to take any food at all. His lips were deep blue and his face the colour of death. His heart seemed not to beat at all. Eventually he took a little food and afterwards vomited it over his blankets. Two other of my photographic porters were also suffering from mountain sickness, but I had two fit men.

Finch and Bruce had meanwhile gone up the Ridge. They reached 25,000 feet, where they built their high camp, and that evening they sent down the porters. These men told me that the weather

was very bad up there, but that the sahibs were well.

Next day I felt much better (acclimatization again !), and, without the aid of oxygen, I was able to get busy with my apparatus, do complicated manipulations of the electric batteries, and focus the camera on the upper ridge where I hoped to photograph Finch and Bruce climbing, but I saw nothing. Clouds covered the upper part of the mountain ; the weather was bad and snow was falling. I covered the camera with a waterproof sheet, tied down, because it was such a difficult operation to get the camera and its supporting tripods firmly into position that, once fixed, I wanted to keep it so. I expected that Finch and Bruce would make their climb and be back in our camp that night, but they did not come.

Next day I became anxious about them, and sent up a party of native porters to their camp with supplies of food and hot soups which I cooked and put into thermos bottles. These splendid porters found Finch and Bruce in the tents, where they had remained all day because of the bad weather. They were glad to receive the supplies and again sent the porters back to Ice Cliff Camp.

The next day Finch and Bruce set out with Tejbir, one of the Gurkas who carried the spare oxygen cylinders. Tejbir did not use oxygen. They struck across the Northern Precipice, going along the sloping ledges of rock which form a frail and tricky

foothold, and steered straight towards the summit of the mountain. They passed the record of Mallory's non-oxygen party first by 100 feet, then 200 feet, and then 300 feet. Tejbir, however, broke down completely, and Finch and Bruce took over some of the oxygen cylinders that he was carrying and sent him back to the camp to wait for them. They were going steadily and reached a ledge when suddenly Finch, who was leading, heard Bruce give a frightened cry : " Finch, I am getting no oxygen ! "

Finch immediately went to his companion, who had sunk to his knees on the rocks. It took Finch a few moments to descend the precipitous rock ledge to reach his companion, and he arrived only just in time to grasp him by the shoulder as he was falling. Collapsing he might have slipped over the precipice. Finch pushed his back against a rock, and, opening the tap of his own oxygen apparatus to allow a greater flow of gas to strengthen him, he unloosened Bruce's apparatus. Bruce was rapidly sinking and breathed only in gasps. Finch shared his own oxygen delivery tube alternately with him while he made a quick survey of the apparatus to see what was wrong. He was well trained in the use of his machine, and knew exactly every part of it and how to test it. Running his fingers over the cylinders down the pipes to the pressure and flow meters, he found them all working. Some time went by, and still he could not find out what was the matter. Deprived of a large amount of his own oxygen by

giving it to his companion, and under the strain and excitement of the moment, he himself started to give out and became dizzy. But fortunately he suddenly located the trouble in the tube of the flow meter, and a happy idea struck him. He had in his pocket a little spare T-shaped glass tube and some spare rubber pipe. He spliced this joint into his own oxygen tube and thus enabled both men to draw continuously from the same apparatus. It meant turning on the apparatus to the maximum-flow rate of delivery and using also the by-pass valve, fitted to the machine for use in emergency. This enabled both men to revive; and Finch was able to replace the damaged part in Bruce's apparatus.

Again they persistently set out in a bold attempt to continue the climb. After a very short distance Bruce's condition became serious, and he collapsed. Yet so great was his spirit that when Finch, realizing that it was impossible for them to go on, decided to return, Bruce expressed his utter disappointment at the abandonment of their hopes. Fearing another accident to the oxygen apparatus, they made their way down as quickly as they could.

At the lower camp I had been experiencing grave anxiety for the two men. They were a day and night beyond their schedule time, and in the evening I burned at intervals out in the open all my spare unexposed motion-picture film. This made brilliant illumination, and I hoped by it to signal to the men

on the mountain that we were hanging on to this camp.

Happily they rejoined me in safety and we all descended to Snowfield Camp below. Finch was exhausted and went soon after to the Base Camp, where his condition grew worse, and he became really ill. At this time Morshead was suffering terribly from his frost-bite, and Longstaff considered his condition so serious that he decided to take him back to India immediately. So it was planned for Longstaff and Morshead to leave.

There was still a short period left before the monsoon, and it was decided after a considerable amount of discussion that another attempt should be made in which Mallory, Somervell and Crawford would participate. Finch at first was also to join this party, but he broke down completely, and then it was he decided to go back with Dr. Longstaff and Morshead to India, Strutt also joining the party.

I went up the glacier again from the Base Camp with Mallory, Somervell and Crawford, who were to make this renewed attempt, but with a very forlorn hope. It was on this attempt that a terrible accident occurred, a calamity of which I was an eye-witness.

At Snowfield Camp, collecting every available fit porter (there were not many of them), they set out to climb the Ice Cliff and camp that night at the top. The porters were carrying oxygen apparatus, but the climbers were not using it. They intended

it only as a reserve for the greater heights. I planned to go to the top of the cliff again, but when we reached its foot the snow was so soft and thick that my exhausted porters were unable to get the photographic apparatus up. After we had climbed about 150 feet they broke down, and I decided therefore to return and try to obtain my picture by long-distance photography. I had a number of camera stations on the glacier below from which I could observe ; and lenses to keep the men in view at anything up to 2½ miles.

I had made my way back to Snowfield Camp and was there having a meal with Dr. Wakefield. We could see the figures of the others very, very slowly crawling up the face of the Ice Cliff.

Every five minutes or so we would look up and watch their progress, step by step. It was now well on in the afternoon, and they were only a third of the way up the Ice Cliff. They were evidently having a terrible time in the soft snow. The next time Wakefield and I looked up to see how they were getting on, we saw they had vanished. There were no black figures on the face of the cliff. Instead we saw the white, glistening surface broken into a broad ribbon widening out as it descended. I looked at Wakefield, and he looked at me and said, " Good God, they are gone ! " " What does it mean, man ? " I cried. " Avalanche," he replied.

We were so stunned that for a moment we could not think of doing anything. Then I got out my

telescope and saw the whole surface of the cliff torn away, and huge blocks of ice and snow lying confused on the surface. There was no trace of any human being. We called to the porters, pointed to the cliff, and told them what had happened. They became terribly excited and started to talk among each other and to cry. But we got them going and I ordered Songlu and one of the cooks in the camp immediately to heat liquid foods and put them in bottles. Then we got blankets and clothes and warm things from the camp reserve, expecting that we might have to spend the night in the open before we could get back. Evening was already coming on. We did not know whether we would find any-body alive.

With every available porter carrying the utmost he could in food and blankets, we struggled forward to reach the scene of the disaster. Wakefield and I took oxygen apparatus to help us get there as quickly as possible. Going to the utmost of our strength and speed, panting and blowing and slipping, we floundered in the soft snow. I remember, every time I slipped, I stopped for breath with my heart hammering. The thought of the men we were trying to reach, the realization that every moment we stopped to rest was a vital moment lost in saving their lives, made the torture worse. Perhaps they were buried in the snow, dying. At the foot of the abrupt ascent of the Ice Cliff we were forced from sheer exhaustion to sit awhile to gather strength.

N

Round us were gigantic snowballs some 10 feet in diameter that the avalanche had rolled to the bottom of the slope. Above we could see its tracks, the broken, rasped surface of the slope. But there was no trace of the men. Were they all engulfed? We started to climb and after we got some way up we caught sight of some huddled, motionless figures. They were squatting at the very edge of a sheer ice wall about 80 feet high. The avalanche had carried them to the edge, and they dared not move lest they should slip over. Where were the others? There had been fifteen porters altogether in the party with Mallory, Somervell and Crawford. Where were they?

Then we heard voices. We climbed higher up the slope, and found Mallory digging with his ice axe down in the jaws of the great crevasse at the foot of the ice wall. It had been an enormous crevasse, but now it was almost filled by the avalanche of snow.

Mallory told us all he knew himself. As they were going up roped in three separate parties, Mallory, Somervell and Crawford ahead, leading and step-cutting for the porters who followed, they suddenly heard a rending, tearing split. Their feet went from underneath them; and they were carried head over heels down the slope for about 150 feet and buried. Although severely shaken, they were able to dig themselves out, and looking below them they saw that some of the porters had been carried

to the edge of the abrupt fall. The others had disappeared and they could only surmise that they had gone over the edge. The porters had been lower down the slope, and so had been overwhelmed by the greater volume and force of the avalanche. They had been swept down with such force that some of the ropes between them had been snapped like threads of cotton. The men lowest on the slope had been carried over the edge into the crevasse. Some had fallen into the jaw of the crevasse and were buried deep in the soft snow. Others had shot over the gaping jaw and had hit the hard lips of ice. They, we found afterwards, had been instantly killed, their heads and bones and bodies smashed.

We called upon the men we had brought out from the camp to aid us to find these fellows. These men were mostly blood relations, brothers and cousins of those who had vanished. But here, at the scene of the disaster, demoralization seized them and they would not stir. " What was the use ? " they said. They must all be dead. The spirits had struck at them. Survivors would only be braving the spirits' wrath by going to help them.

These Sherpas were not reared in the Tibetan superstitions, and had only just come into contact with them. But Tibetan ideas had permeated them.

We Europeans went to the place where the men had fallen, and then occurred the saddest episode

of this tragedy. Five we found dead, shattered on the hard ice. But near by was the crevasse filled with soft snow. Two ropes, such as joined the men together, led to this crevasse and disappeared in the snow. We pulled, but could not budge the ropes. We dug into the fluffy stuff. Five feet down Mallory struck a boot, and, digging further, pulled a man out. He was unconscious, but, although buried for over two hours, he regained consciousness and later completely recovered. Eventually this man took part in the next Expedition in 1924!

Another man was reached by digging along the strand of rope and the ice axe struck his boots. He had dived head-first into the snow. When dug out he was found to be stone dead. The rope round him went deeper into the snow. Mallory tugged at it. The other missing man was on that rope somewhere deeper down, but we could dig no more. In the thin air we were prostrate. We had to leave the man in the crevasse. He must have plunged head-first down, we do not know how deep.

I remember, when we decided to leave him, I looked back at that taut rope going on down into the jammed snow. Somewhere at its end the man lay buried. It was heartrending to leave, but we knew further effort was hopeless.

Our task of getting the survivors down from their precarious position on the edge of the wall, though seemingly impossible, was eventually accomplished successfully. The men had completely lost their

COMBAT! ACHIEVEMENT! REPULSE! 197

nerve and were crying and shaking like babies.
Mallory and Somervell got them across and round
the ice wall one by one, and then Crawford and
Wakefield and I revived them with the hot food
and drinks we had in our flasks. It was pitiable to
see their condition and their grief. They asked us
where the others were, because some of the survivors
had lost their brothers. They went to the crushed
bodies and took their amulets and other religious
family tokens from their necks. We asked the men
if they wanted us to bring the bodies back. But
they did not wish it, and so we covered them with
snow, and left them.

Their fatalistic attitude did not astonish us. The
same thing affects even Europeans in those parts.
In wild countries the cast of the native mind seems
not obviously but in subtle ways to mould your
own. You begin to feel subconsciously the fears
that they feel, and to you also, in the deep recesses
of your mind, the mountain becomes possessed of
a fearsome spirit. At high altitudes these things
come even more strongly upon you. With lethargy
of body comes that which is worse, lethargy of
mind. Strongly held confidence goes and doubt and
pessimism emerge from dark recesses of the soul.
The spirit of the mountain, the adversary, bears
down with dull relentless antagonism. That is what
has to be contended with, and is what our men
struggled against when they were near the last
summit of Everest.

The disaster put an abrupt end to our work. The
men had fought mighty hard and won a brilliant
victory by their record achievements, but the
mountain still remained supreme—unconquered.
She had battered us and smashed us. Morshead,
who eventually lost the end joints of his frost-
bitten fingers ; Strutt, unfit ; Finch, exhausted—
had already left for home. With our porters shaken
by their own losses and with the surviving climbers
all exhausted, General Bruce felt it impossible to
remain in Tibet during the monsoon and renew the
struggle in the autumn. We had shot our bolt.

The First Climbing Expedition turned its steps
away from the mountain—homewards.

Back at the Rongbuk Monastery, before finally
quitting the valley, we paid another visit to the
Great Lama. He blessed the surviving men, and
prayed for them. The lamas, who before had said,
" The mountain will destroy you," then told of
other powers the mountain possesses ; how she
opens fissures in her side at will, and against such
powers men have no strength.

Veterans of the Geographical Society and Alpine
Club are, of course, not troubled by such beliefs ;
the same superstition has been met before on Mount
Ararat and the Mountains of the Moon in Africa ;
but the lamas painted a new fresco, half historic,
half prophetic, as is their manner in such things, on
the portal walls of this Monastery. This extra-
ordinary picture shows the angered Deity of the

Mountain surrounded by weird, wildly dancing
Demons, White Lions, Barking Dogs and Hairy
Men, and at the foot, speared through and through,
lies the naked body of the white man who dared to
violate the ice-bound tempest-guarded sanctuary of
Chomolungma—Goddess Mother of the World.

BOOK III

THE SECOND CLIMBING EXPEDITION

CHAPTER XIV

THE SECOND CLIMBING EXPEDITION (1924)

Notwithstanding the tragedy of 1922, it was the unanimous and urgent wish of the Geographical Society and Alpine Club, and of all members of the Expeditions, to renew the attack. After the 1921 Exploring Expedition doubts and fears had prevailed. Now prospects were brighter. A brilliant record had been made. Our knowledge of human capacities had been advanced. We had gained experience of what acclimatization can do, although its utmost limits still remained in doubt. Profiting by this experience we would try again. There remained unconquered barely two thousand feet. Would not a great effort take us to the summit ?

The year 1923 went by, every moment of it busily spent in planning and equipping the new Expedition. The motion-picture record of 1922 was circulated throughout the country and the Continent to enlist public interest. Funds were plentiful. The best equipment was to be collected ; and a new, highly expensive oxygen apparatus was to be tried. Again Mr. Hinks and Mr. Spencer applied their executive genius to carrying into effect the plans of the Organizing Committee.

Although the main object of the Expedition was mountaineering, geographical work was also to be done. It was intended to extend the exploration of the gorges beyond the snowfields and glaciers of the Rongbuk that curve away to the west and which possibly make this glacier the longest in the world. No one has ever reached the upper end.

Geology was forbidden. The Tibetans earnestly begged us not to break the soil, nor loosen rocks. This, they said, the geologists of the former Expeditions had done and so had let the devils out of the ground. If this happened again the barley crops would be ruined and disease and misfortune would ravage the land.

It takes about twelve months to make preparations for an elaborate Expedition such as this was to be. Everything must be thought out to the smallest detail. Owing to the weather problem, times, distances and dates of arrival had to be worked out accurately. Better tents, and better packing of provisions in cases of correct porter weight, clearly labelled to the depot camp for which they were destined, had to be provided. Norton devised a splendid mess tent, which gave us much comfort in the plateau journey and at the Base Camp. Solid spirit fuel " meta " was imported from Switzerland with special cookers. It is undoubtedly the best fuel for high altitudes.

Another new item of equipment was a portable sectional ladder for crossing crevasses. In 1922

climbers leaving Ice Cliff Camp had to follow that devious route which first took them away from the mountain and then zigzagged back to the North-East Ridge, because the direct road was blocked by a gaping crevasse. The new plan was to cross this crevasse by means of a bridge ladder and thus shorten the way. The bridge was made of hollow wood spars 18 feet long and the total weight was only 80 lb. It was strong enough to support a weight of 300 lb. A derrick was provided for lowering this ladder across a gap. This hollow light timber construction is of immense strength and is used for yacht masts and in aircraft. Almost any form of curve or taper can be made. The wood is a Pacific Coast spruce of even growth and the ply is made with thin sheets bent breadth-wise, glued and pinned. This splendid wood was also used to form hollow spar pitons, tipped with metal, to be hammered into ice and make fastenings for ropes in difficult positions in the ascent of the Ice Cliff.

The party was to be self-contained, able to deal with any casualties and act with complete independence. This meant the provisioning of one hundred and twenty men who would move over the plains of Tibet, when Tibetan supernumeraries were added, as a small army of five hundred men, yaks and mules, carrying stores for six months. Less fodder is required for yaks than might be imagined. They are accustomed to scarcity and can thrive on what thin grass is found by the banks of rivers in Tibet.

The good health of such a party is of course the essential care of the leader and the doctor. The whole personnel has to be treated like a group of athletes in training. We have come to look upon the journey of 400 miles or so through the forests of the Himalaya and across the plains of Tibet as a form of training by which climbers, porters, Tibetan servants and animals get into perfect physical condition and each learns his job, his part in the Expedition's work, so as to form a team to carry out the highly organized cut-and-dried plan to schedule time.

We were to have with us again the leading warriors of the previous onslaught, except Finch; but Mallory was the only one who had been on all the previous Expeditions. He was now thirty-six years old, married, with two little children. He had been a master at Charterhouse and had only recently been appointed a lecturer at Cambridge University when the call came to join the new Expedition. At first he said he could not spare the time, and refused, but he was all enthusiasm and determination to realize this ambition of his life. His wife shared his ambition and eventually he decided to come. General Bruce described his work in 1922—when he led his party without oxygen to the world's record height of 26,800 feet, and, in the task of saving Morshead, descended the mountain by the light of a candle in a lantern—as " one of the greatest feats of human endurance in any field of activity."

The climbing party was reinforced by the introduction of fresh young blood. We had the celebrated climber, Bentley Beetham, Somervell's companion of the Alps; Odell, Hazard and young Irvine.

Somebody said, after the 1922 Expedition, that a soldering iron in expert hands would have beaten Everest. The constant breakdown of the fragile oxygen parts had left only two machines reliable when Finch made the final climb. Now we had lots of mechanics with us, Irvine, Odell and Hazard all being skilled.

Notable among the new men was Andrew Irvine, a magnificent specimen of a young athlete who had rowed as No. 3 in the winning 'Varsity crew. He sacrificed his place in the Oxford boat that year to go to Everest. The authorities of his College granted him leave and sent him, confident that he would do big things. Physically he was immensely powerful. He was of a cheerful and modest disposition. General Bruce described him as " The Experiment " because of his youth—he was only twenty-two years old— and because he had but little mountaineering experience. He was selected because he had done such fine work on two Oxford University Arctic Expeditions, and everybody said, " Send him to Everest." The Selection Committee knew it was a risk because of his extreme youth and small knowledge of mountains, but his other qualifications were good. He was ready to face anything

to reach the 29,002-feet mark, and " to expect no mercy from Everest."

Hingston joined us as doctor. He was a distinguished traveller-naturalist with much Asiatic experience. Shebbeare, chief of the Bengal Forest Service, was transport officer, one of the best men possible to find for this work, a linguist and experienced in animal and porter transport. My privilege was to act again as photographic historian.

It is easy to accept cheerfully such a task as the Geographical Society gave me ; many others would gladly have jumped at the opportunity. Yet, apart from the magnitude of the work on its technical side, when it is realized that woven into the picture must be not only the spirit of romance and adventure, but also a feeling of the power and majesty of mountains, of the intangible atmosphere of mysticism of Tibet, and above all, a " something " which would make the spectator feel the immensity of this struggle of man against Nature, I began to doubt whether my physical strength—to say nothing of such imagination and artistic ability as I could call upon—would not fall short. The æsthetic standard the theme imperiously demanded called for effects both subtle and stupendous. To dabble fatuously in trivialities in face of Everest's grandeur would be sacrilege.

How should I treat the subject ? Film experts in a business-like manner said cheerfully : " Without a love interest the picture will be a certain failure."

They asked : Could we not bring out actors and actresses and make a romance in the snow ?

Must one vulgarize a subject like this to make it popular ? Everybody seemed to think so, but I could not believe it myself. The picture would have to be far more than a day-to-day pictorial chronicle. Such chronicles, in themselves unimpeachably truthful, do not always convey true impressions.

My pictures of the 1922 Expedition had been intended to amuse, and did amuse, people for a couple of hours, showing truthfully one aspect and depicting a jolly rollicking sporting adventure.

But they did not reveal all—how could they ? Bernard Shaw came to see them at the Philharmonic Hall, London, and said afterwards : " The Everest Expedition was a picnic in Connemara surprised by a snow storm." Never mind. When I fly to Mount Everest in an airship, I am going to invite Bernard Shaw to come with me for a little aerial picnic.

In this new picture the first task was to convey the fascination of those secluded, lofty, divinely beautiful mountains of Tibet. Then the supreme mountain herself must tell of the impressive, strange, implacable, majestic character she possesses; a character which causes the pagan priests of the Rongbuk to worship her as a sacred living creature and to name her beautifully " Goddess Mother of the World." Not to add those impressions to the chronicle of events would be to leave the story half

o

untold. It was my desire to convey a series of impressions leading to the one dominant impression —that climax of sensation that we ourselves experienced among Everest's virgin snowfields, fighting to the last ounce of our strength against her power, snatching victories, creating records ; being hurled back ; an unforgettable impression of power, beauty, grandeur and the insignificance of man. If I could convey this feeling to others and enable them to share what we ourselves had felt, then I would succeed in my task.

Did I succeed ? It is not for me to say, but it has been a gratification to me that many who have seen my film, " The Epic of Everest," have felt this atmosphere which I strove to convey.

Experience gained on the previous Expedition was applied to overcome difficulties encountered both in the field and in the laboratory side of the work. I had the most up-to-date photographic outfit with a specially constructed frictionless, electrically-driven camera. In the field my aim was to make myself independent and mobile, so that I could be well ahead, or, if I remained behind to get a " shot," could catch up again. The cameras were carried in watertight steel boxes painted white to reflect the sun. The boxes were packed to open sideways, so that at a moment's notice a camera could be taken out and placed on its tripod with everything ready in position. I had two sturdy Tibetan ponies. My interpreter, Cheddup, had another. I had two mule

men—Tashi, an adventurous Chinese muleteer who had trekked the mountain passes many times and had lived among the Kam-pa, the brigands of the Tibetan Chinese border, and Lobsang, a sturdy Sherpa with a great love of a horse. Both men became such expert assistants that I had only to blow my whistle when I wanted to " shoot " a scene and they would have the camera out of its box and levelled on its tripod within thirty seconds.

Thus as we marched across Tibet we obtained spectacular pictures of the army of men and animals crossing stupendous passes and bleak plateaux, recorded little scenes of interest in the fording of rivers, the meeting of Tibetan shepherds and caravans, and incidents of camp life. I planned so that when Everest was reached the mules would remain at the last village and be put out to graze, while eight specially selected porters would take on the work, transferring the cameras into specially made shoulder-boxes and following as far as laden men could in the footsteps of the climbers. When the men could not carry the cameras any higher, I would fall back on telephotography.

The lens equipment had been improved and provided with additional steadying supports, and now it was possible to get a clear picture of the moving figures of the climbers against a white background, even at a great distance. The picture I wanted, and which I could get if the weather were good, was that of the men breasting the summit of

the mountain. In 1922 I had found a view-point from which it was possible to focus clearly on the final pyramid. The summit is capped with snow, and I anticipated photographing the men as they reached the top by the eastern face of the Ridge. The distance was three miles. Nothing could be seen under the focussing glass, but the picture would be accurately " found " by the directing telescope. An electric drive operated the camera without vibration. The longest distance picture I actually got was that of Mallory and Irvine at 26,000 feet at 2 miles range. Above that point I never saw them, the mist concealed them.

In actuality work such as this, as compared to studio set production, there are many difficulties. In photographing the high climbing I had to fit my plans and wait on the climbers. I could not ask them to modify their plans or " act " for me. I had to be on the spot whenever I could and photograph what might come by chance. This meant hours of patience, hours on the watch. But such scenes are more convincing than any acted episodes because they are stark reality.

Such scenes must be caught immediately because they will not be repeated. It is not work that the ordinary " Pro " could do. The operator has to have the heart for it. There is no money in it. He must do it for the love of it. I considered it a privilege to undertake this work for the Expedition, although some members of the Organizing Com-

mittee and even some members of the Expedition
itself seemed rather to resent the presence of the
cinematograph. Still on the whole I got on
famously with all; and I do not think my camera
worried anybody. I remember Mallory told me once
in a laughing way that I had converted him. He told
me that on the first visit in 1921 he once said to
Bullock: " Thank God, there is no cinematograph
with us." But now he quite liked me and my picture-
making toys. When the time came for him to make
that great climb from which he never returned he dis-
cussed his route minutely with me, and told me where
to look for him with my telephoto lens on the final
pyramid. I told him that I would get him, if the
light were right, even 3 miles away. The night
before he was killed he wrote me—what was perhaps
the last note he ever wrote in his life—a little letter,
reminding me where to look for him the next
morning at eight o'clock, and he sent the note down
from his camp at 27,000 feet by one of the returning
porters. I have kept that little crumpled note ever
since; and I give a picture of it in this book. I
wish everybody would realize better the real service
the motion picture can do for a work of this kind.
It can do in a sense more than writing can. It was
my aim to democratize the work of the Expedition
by disseminating as much information about it to
the world through my pictures as I could, and to
make a clean, unexaggerated screen drama to show
those at home what otherwise they would hardly

be able to realize—the heroic struggle of this little band of men daring death in Nature's last hidden stronghold.

The production of the film was made possible by the public-spirited support and generosity of Mr. Archibald Nettlefold, Mr. Charles Merz, the celebrated engineer, Lord Salveson of the Scottish Geographical Society, H.H. the Agha Khan, Colonel V. A. Haddick, Professor Chalmers Mitchell, and others; while many firms—Messrs. Newman-Sinclair, Wellington and Ward, Burroughs Wellcome, and others—assisted in the provision of the equipment.

In the field the film was carried by despatch riders travelling 50 miles a day on relays of ponies down to Darjeeling, where it was developed, prepared and edited, while special news portions showing the progress of the Expedition were despatched immediately to Europe to be distributed in the *Pathé Pictorial News* to motion-picture theatres throughout the world, so that the man in the street, who perhaps would not chance to see the official reports of the Geographical Society, could follow the work of the Expedition.

Colonel Haddick, who is well known in India, came out with my photographic party, to travel with us and afterwards tour India recounting the official story of the Expedition and showing the pictures; and his work was much appreciated by residents of Indian stations. He lectured also to some of the Indian Princes.

The Everest Expedition was an adventure to appeal to young people all over the world, so I had a special pictorial postage stamp designed and printed and invited boys and girls to write to me for them. I had over forty thousand applications. Replies to all were mailed by the Expedition in Tibet, sent to the Indian frontier post office, franked, in addition to the Indian Government postage stamp, with the Everest Expedition stamp. They were sent to all parts of the world, even to Japan, Siam, South Africa and Western America. Some failed to arrive, as instances occurred where village postmen, and others, through whose hands they passed, kept the souvenir for themselves. Francis Helps designed the stamp, a bold design of the mountain in blue, surrounded by a Tibetan key and Swastika border with the words Sikkim, Tibet, Nepal, the States surrounding Everest. We had a special franking post-mark—" Rongbuk Glacier Main Base Camp, 17,000 feet above the sea."

On assembly at Darjeeling in early March, 1924, we were greeted by all our old Sherpa porters, who wanted to join us again despite the catastrophe of 1922. Many other men also offered their services. The General and Dr. Hingston held a careful inspection of them, but often as one old favourite after another presented himself and saluted, the General would slap him on the back and pass him quickly by the doctor. " Why, here is old Chemshar again.

Fine ! Of course he must come—and there is——"
So all the old men were collected again, not that they
were not all the best and fittest of fellows. Then
followed a gathering and entertainment in their
honour by the Buddhists' Society and Hillmen's
Association, a Gurka dance, and Lord Lytton,
Governor of Bengal, and Lady Lytton, received the
whole Expedition at Madan's Hall.

We were to start about the 20th of March. Every-
thing was ready. Again we were to use the early
period of the springtime. I do not know why, but
it had become an established custom that the
Expedition should start in March and try to climb
the mountain in the seven or eight weeks of the
spring season, between the thaw at the end of winter
and the break of the monsoon. 1922 had shown
that this spring season is not really a long enough
period to do both the preparation work and the
climbing. It means that everything must be cut-
and-dried and organized each day to a schedule.
Should anything go wrong, the whole machine will
be thrown out of gear—and this year what a lot of
throwing out of gear there was to be ! We boasted
to ourselves of our better plans, of how stores
labelled for various prearranged camps, each box
a correct porter's load, had only to be dumped at
each camp, then tents erected and the camps would
be complete. But it didn't all work out so nicely.
Unforeseen events and the weather upset the depot-
laying plans. On future Expeditions the main

depot-laying must be done a season ahead and independently of the climbing.

The few days spent at Darjeeling before the start were busy days for me. I had to organize my own photographic field party, and to send off the artist's party of four to Gangtok in Sikkim, led by my wife, who had come out with me to study the folk-lore and legend of the mountain peoples of the Himalaya and Tibet. With the help of Jetti, her faithful and splendid little Tibetan maid, she collected a surprising wealth of fascinating stories. Francis Helps, the artist and an old friend of ours, was with them. He had come to paint portraits of the hill people and the Tibetans, the first time a valuable collection of portraits of these people had been made. He met much difficulty and religious scruple and could not get his models to sit more than once or twice. But being a rapid painter, he produced forty large canvases and as many pencil sketches during five months. This party crossed the Natu Pass, 14,600 feet, to Chumbi in Tibet ; and there my wife with faithful Jetti explored the monasteries with their old musty libraries, and visited the lamas and the fascinating story-telling witches who live in the Chumbi Mountains.

At Darjeeling, before leaving, I had also to arrange details for the base photographic party under Arthur Pereira, F.R.P.S., the well-known photographic technician. He was to build a laboratory to develop and also print the motion pictures I was

to make on Everest. The only plot of ground Pereira could get was a jungle-covered mountain slope at a horrible angle. However, he found a contractor and coolies, cut into the hill, banked it and ran up a house, 60 feet by 40 feet, of cement, stone, wood and tin.

The little railway station was crowded out with Pereira's enormous packing-cases, containing developing tanks, drying apparatus and washing wheels, a motor generator for developing his own steady supply of printing current, chemicals, etc. Pereira had everything organized to the last tool and screw.

The porter corps was now completed and equipped and the Expedition started for Tibet. For the third time men set out to the assault of the bastions of the world's highest mountain. We made an imposing array—porters, animals, riding ponies, cooks, interpreters, and hundreds of loads of burden.

We started a happy and jovial party with a great send-off from Darjeeling. General Bruce himself wrote : " Everything has gone smoothly, we are fully equipped and as keen as mustard to be off ; for with all its hardships there is fun in it." That was typical of the man. At Kalimpong at the Mission Station he reviewed a large colony of Anglo-Indian Boy Scouts and Girl Guides, and read them a letter Baden-Powell himself had sent them. Everybody was immensely struck by the general happiness of our party.

But a set-back soon came; the sudden illness of General Bruce. At Phari we had divided, the main party crossing the Phari Plain by the Donka-La across the wind-swept heights at 19,000 feet; while General Bruce, with Dr. Hingston and Macdonald, the son of the British Trade Agent at Chumbi, took the longer detour by the Dochen Lake, at a lower elevation with consequently less exposure to wind and cold. The beautiful silvery mountain, Chomolhari, stands in the background behind the huge expanse of water of the Dochen Lake.

General Bruce had caught a chill on the bleak Phari Plain. This sudden arrival at the Phari Plain in the blizzard time of April was always a severe strain on us. The chill brought on a severe return of malaria, which the General unfortunately had in his blood through long years in India. He very nearly died at Tuna, but Dr. Hingston got him back to Phari. He was carried by porters the whole way. Hingston had to take him back to India and then follow up and join us at the Base Camp later on.

General Bruce's illness meant the loss—a severe one—of the moral stimulus characteristic of our established and accepted leader. Bruce has a cheerful, magnetic spirit that he can diffuse into men under him and hold them together. We called it " the Bruce spirit." He could make a party of men, some strangers to each other meeting for the first time, work as a team. He could teach each one to subordinate personal interests and ambitions

to the larger interests of the whole. There is always a danger that differences and jealousies will arise in a party thrown on top of each other in a confined camp life, and enduring the hardships of travel. We had to learn to put up with each other's peculiarities, and to subordinate jealousies, while still keeping up a healthy family rivalry and competition to become a prizewinner and go highest on Everest—I speak of the men of the climbing party.

Moreover, General Bruce had an extraordinary influence over the Sherpas, upon whom we depended so vitally. He would talk every day with the men, win them, and fire them with high spirit and enthusiasm.

When we had the misfortune to lose General Bruce we found in Norton and Geoffrey Bruce two successors who understood the natives and could also hold and enthuse them. Colonel Norton, a distinguished soldier with the D.S.O. and Military Cross, with a brilliant staff and fighting record in the European War, a mountaineer of tried capacity, became our sound and careful leader.

CHAPTER XV

HOW WE MET A DEFEAT

Once again we stood before Mount Everest at the Rongbuk Lamasery. Again we were to witness the fantastic ceremonies of the lamas and listen to the haunting sound of their long trumpets that echo in the evenings from the temple roof through the desolation around. The Rongbuk Lama was in retirement in a hermit's cell at the time of our arrival; but we met his representative and gave him presents, including a load of cement, a thing that he had particularly asked us in 1922 to bring him should we return. It seemed an absurdly material thing to procure for one who claimed such intimate dealings with the spirit world! Then came one of the things which make this Everest adventure so different from an ordinary prosaic mountaineering exploit. We witnessed a "devil dance." The priests were blowing gigantic horns, beautifully made in copper and silver. They had other trumpets made of human thigh bones, and drums made of human skulls with drum-heads of human skin. In the centre of the dancing-place, the courtyard of the monastery, a human protagonist fought and was symbolically slain by grotesque monsters. The dance

of the Cemetery Ghouls followed. Evil Spirits, skeletons wearing hideous masks, danced over the effigy of a dead body, fighting Good Spirits for the possession of the corpse. Out of the monastery windows leaped a troop of demons, fantastically clad, flinging themselves into the struggle for possession of the poor little white soul about to be reincarnated and embark on a new weary life in the world. The drums and gongs and cymbals rolled, rumbled and clashed, while droning notes from the horns blown on the temple roof resounded incessantly. A long procession of gowned monks preceded by cymbal-players and drummers and thigh-bone trumpeters paraded round the monastery courtyard carrying grotesque idols. With fear and reverence the assembled crowd of poor, superstitious, devil-ridden peasants bowed to the ground and touched their foreheads, repeating the prayer " Om mani padme hum." With sonorous voices the lamas chanted and scattered rice grains over the pilgrims who came to receive blessings. To us they extended a blessing also, although they gave us a not-too-cheerful send-off. They said, " Chomolungma, the awful and mighty Goddess Mother, will never allow any white man to climb her sacred heights. The demons of the snows will destroy you utterly."

They told us a curious story. After we had left at the end of the last Expedition, Tibetan villagers from valleys miles away went to our camps in the snow, although they were forbidden to do so by the

lamas, to see what they could find. They told how
they met several Sukpas living at the camps we had
abandoned, and terrified out of their wits, they ran
back to the monastery, where they prayed at the
Chief Lama's feet and promised never to disobey
him again.

One of the lamas, an old man with a gnarled face
and only two teeth in his head, shuffled over the
courtyard wrapped in his maroon gown, and led
me to the temple entrance, where on an inner wall,
so dark that at first I could not distinguish it, he
showed me a freshly executed painting. Looking
at it carefully I saw it was a picture of the speared
white man lying below Mount Everest surrounded
by guard dogs and Sukpas and horned demons. I
got my interpreter Cheddup to explain it; and I
took photographs and tracings of it. It was a
curious picture.

We arrived two days ahead of schedule time at
the Base Camp, and started on the depot-laying
work in all earnestness. Mallory and Beetham took
charge of the Alpine equipment and the provisions
for the high camps; Odell and Irvine, the oxygen
apparatus; Somervell, the scientific and medical
stores; Hazard, the mess; and Shebbeare and
Geoffrey Bruce the large convoy of one hundred
and fifty Tibetans we had collected from the last
villages to come and help us on the first stage beyond
the Base Camp. There were both men and women
in the gang. They built little shelters for themselves

out of stones, as we had no tents to give them. One-third of them deserted, but the others stayed with us and worked splendidly, receiving of course rations and pay.

What powerful people they were! The women could carry loads equally with the men. One of them carried a 40-lb. load, with her baby on the top of it, and she was always one of the first back to the camp after completing her daily journey from the Base to No. 1 Depot. Then she would devote the rest of her time to the care of her smiling child. These local Tibetans had no equipment such as our Sherpas had. They had only their woollen coats and skin boots and not even blankets. At night time they would untie their girdles and wrap themselves in their loose bokkus. Curled up like balls they huddled together to sleep. I have even seen them sleep like this blanketed by deep snow! Outwardly they did not seem to mind, but no human being could possibly suffer such exposure without being affected. It told on them, making them apathetic. They became careless whether they cooked their food or not, and this, in its turn, naturally affected their physique. These men, if their superstitions were overcome, and if they were efficiently organized, properly clothed and equipped, would make splendid high-going porters for another Everest expedition. My belief is that the wildest and roughest men, who have never at any time been in contact with whites or lived in civilized parts, but

who are recruited direct from mountain lands, will always make the best material for a porter corps. I would never take a Darjeeling man again. I would get my men raw from the mountains. I persuaded some of these Tibetans to come with me when some of my men fell ill. Two of them did as well and even better than my Sherpas in getting my cameras up to the top of the North Col.

This year we were soon to learn that our luck with the weather was all out. We encountered blizzards of a severity unknown for thirty years in the Himalaya. The thermometer fell to 30° below zero. The snow drove into and through our meagre tents, and the natives suffered particularly, as it piled itself in their shelters and put out their fires. Most nights they had to turn into their blankets hungry or with only such cold food as they might get.

Bad weather swept over the whole Himalaya range during May, 1924, from Kashmir to the east; meteorologists ascribed it to a cold current from the north-west. Such conditions were abnormal, but remembering the experiences in the Himalaya of numbers of travellers and explorers, I feel confident in saying that the early spring period is always uncertain. The after-monsoon period is uncertain too; but it is always the more reliable. These storms were quite unconnected with the monsoon, although some of our party who were inexperienced of the Himalaya thought that they signified its early advent, but they were wrong.

P

On May 6 the mountain, fighting us at her outposts with all her strength, inflicted a severe defeat upon us—a defeat that we did not fully realize at the time, but a defeat which had a vast influence on the final issue.

The snow beyond Frozen Lake Camp was soft and heavy. The struggling porters fell exhausted and a certain convoy found difficulty in reaching Snowfield Camp. Mallory gave orders that they might dump their loads at the head of the trough when emerging from the ice pinnacles about 2 miles below Snowfield Camp. This was, in the circumstances, unavoidable; but it broke the transport system. Thereafter the convoy parties started to choose their own sites for dumping, and stores became scattered all along the line. From that day the whole transportation system crumpled. Men straggled and dribbled back to No. 2 Depot in a dejected and exhausted state to seek what refuge they could in their meagre tents, battered and torn by the increasing gale. We tried to build stone walls and patch the torn tents with waterproof sheets and blankets, but it was too late. Stores and fuel failed to arrive from the lower base. Stores labelled and sealed for higher depots were broken into. The chain of supply was thrown into confusion. The reaction upon the strength and the health of the porters showed itself. They were frost-bitten and lethargic. Demoralization set in.

One day, while we were buried in snow at Frozen

Lake Camp, Mallory surprised us all. He appeared suddenly in the camp before breakfast, having walked down the glacier from Snowfield Camp, starting at dawn. With his dauntless energy he had been struggling to hold the porters together and to reorganize the broken transportation system. He had a terrible story to tell of Snowfield Camp. Everything there was at a standstill. The men were done—incapable of any work. The mountain above, whenever parting clouds revealed her, was smoking angrily with driven mist and snow. The gale was tearing over her ridges a hundred miles an hour, madly flinging the snow a thousand feet into the air. Odell and Hazard had tried the Ice Cliff, but had not been able to go far and had dumped the ropes and pickets on the cliff and returned.

On the 12th May there was a council of war at No. 2 Depot, with Norton, Mallory, Geoffrey Bruce and Shebbeare present, when it was decided to abandon the depots and retreat to the Base. One of the porters had fallen into a crevasse at the entrance to the ice pinnacles and had broken his leg.

Bruce did great work in putting heart into the porters. He had practically to man-handle the exhausted, hungry, frost-bitten men out of their shelters to strike the tents and lay them down. There was a certain joy and relief at the prospect of a respite from this hell we had been living in, but still we walked away from our mountain crest-fallen because of our defeat. My own photographic

porters, concentrated at Frozen Lake Camp, had succeeded in bringing up and establishing our own heavy double-lined, tunnel-entrance tent with sewn-in waterproof floor. It was proof against the storm. I left it with my film supply safely till our return.

Under the conditions, our camps being quite incapable of withstanding such continuous bad weather, there was no alternative but retreat.

In a struggle between man and mountain, such as this—as in any other battle, for that matter—the moral effect of turning away from the enemy, after having once challenged and opened the fight, is fatal. Turn your back on Everest and it will be difficult to summon again that necessary sense of mental mastery, without which hope dies. Nobody can understand the grim reality of this unless he has taken part or witnessed the fight himself. I felt it and realized it. There is a hackneyed axiom about the ratio of moral to physical forces in war.

Should we then have stuck to our ground and tried to weather the storm in our too meagre tents ? No. To have stayed on would have put our whole porter corps, and ourselves also, completely out of action. Already two natives were dying. Norton as leader, was right, of course, in abandoning the depots and bringing us all down to the Base.

But what I wish to convey is that the organization of any future Expedition should be more fully on the Polar method, and permanent depots must be made on ground won during the advance, where

men can take proper shelter in bad weather without losing physical and moral efficiency or giving way a single inch to the mountain.[1]

I had returned to the Base while the camps were being evacuated ; and one evening was making a slow-exposure sunset picture of Everest from the hill above the Base Camp when I saw a procession coming slowly down, carrying some stretcher-like object. I expected it was one of the many sick men. Not knowing, I shouted to them while still at a distance to clear the foreground of my picture, but they took no notice. I little realized at the moment what the procession was. They were carrying the dead body of Naik Shamshar, one of the Gurkas, who had died at No. 1 Depot that day of hæmorrhage of the brain. He was a splendid young man in his prime, and one of General Bruce's favourites. In losing him Norton said we were losing a friend and loyal assistant. Next day his companions buried him across the river, performing their own Nepalese ceremonies. So we lost two men. The second was a victim to frost-bite. His legs went dead as far as his hips. Hingston tried hard to save him, but failed.

At the Base Camp, vegetation was springing up and it was very much warmer than up on the glacier. Hope revived despite the serious loss of time.

[1] The building of a proper hut to house the Expedition at the head of the East Rongbuk Glacier is fully discussed in the Appendix, page 285.

I suggested one day in the mess that if we could get the Rongbuk lama to bless our men it might have a good effect in cheering them and restoring their confidence and morale. The Holy Lama consented to do this ; and we all went down to the monastery for the visit and ceremony. The Grand Lama received us in state, leaving his hermitage for the purpose. It took him and the other monks two days to dress themselves and prepare for the ceremonies.

We ranged ourselves on cushioned seats on either side, with the Grand Lama seated on a dais, attended by other lamas holding peacocks' feathers and incense pots. Our interpreter, a Tibetan who had lived in Darjeeling, approached the Grand Lama in a reverent manner, putting his hands together, and bowing down prayed to him. He paid our respects and we exchanged messages and ceremonial scarves of friendship. After this we each went before the lama and received a blessing by being touched upon the head with some saintly relic contained in a silver charm-box held in his hand. Each of our men followed in turn, presented a scarf, bowed down and received the blessing.

Then followed much feasting, and drinking of *chung*. We—to please the lamas, not ourselves— had to drink their buttered tea. Those of us who found a difficulty in keeping it down went outside and got rid of it, returning paler of face. But on the whole the ceremony was an enormous success. The

men after this blessing took courage again. The
interpreter told me later that the lama said while
blessing us, " Great Chomolungma, the Goddess
Mother, is guarded by the spirits of our ancient
religion. I will intercede with the gods for you.
Your turning back brings pleasure to the demons.
They have forced you back, and will force you back
again."

This lamasery of the Rongbuk held an irresistible
fascination for me, and finding myself here once more,
I renewed my explorations in the rooms and libraries
and temples.

Books in Tibet are sacred. It is a strange thing
that in a country where practically none outside the
lamas and the ruling classes can read, we should
find some of the most beautiful books in the world ;
moreover books are plentiful. The principal work,
the *Bkahgyur*, the great code of the Scriptures of
the Tibetan Lamas, is a " book " in 108 volumes,
each of 1,000 pages, and contains 1,083 distinct
works, translations from Sanskrit and Chinese texts.

Our booksellers would stand aghast if called upon
to handle in the course of trade many copies of this
work, for each of the volumes weighs about 10 lb.,
and forms a tome 26 inches long, 8 inches broad,
and 8 inches deep. The large monasteries possess
full sets of this code. To transport the volumes a
dozen yaks are required, and the carved wood blocks
from which it is printed—movable type being un-
known—require rows of buildings as a warehouse.

On the authority of Waddell's work on Lamaism, this book is printed at two places only in Tibet, at Narthang, in Western Tibet, where a great printing-press exists, and a later edition at Derge, in Eastern Tibet. Another edition is printed in Bhotan ; there is also a Mongolian edition, and a Pekin one. This Pekin edition has sold for £600. A copy was once exchanged for 7,000 oxen by the Buriats, and the same tribe paid 1,200 silver roubles for a complete copy with Commentaries.

The larger proportion of Tibetan books is in manuscript. The *Bkahgyur* was first printed only about two hundred years ago. These manuscripts are written on paper made from the inner bark of a shrub. Small abstracts from the Tibetan Scriptures used by wealthy devotees are written in letters of silver and gold on a board consisting of several sheets pasted together and varnished.

There is a very celebrated library at Sakkya, about 150 miles north of Mount Everest, which contains unique treasures of Sanskrit and Tibetan literature, with enormous pages wonderfully decorated. Books are regarded as sacred and are honoured by the burning of incense, and fragments bearing holy words are treasured reverently.

We spent over a week at the Base Camp waiting for a turn of the weather, and I was fortunate in having so much time to explore and photograph the Monastery and make friends with the lamas. We enjoyed and profited by every minute of our rest.

During these days I extended an invitation to
Mallory to live in my large comfortable photographic
tent, as we were short of tents at the Base, so many
having been sent up the glacier, and I had oppor-
tunities of observing his restless energy and ambition.
He seemed to be ill at ease ; always scheming and
planning. It was obvious to me he felt this set-back
more acutely than any of us. He was a highly strung
man.

One night I said to him, " Mallory, tell me your
secret of breathing. It's a great story." " No,"
he said. " When I've got to the top of the old
mountain, and there is nothing higher left to climb
in the world, I'll tell." With that he blew out the
candle and rolled over to sleep in his bed.

During these comfortable but anxious days of
waiting, Hingston, our doctor naturalist, was one
of the busiest of our party. He kept us fascinated
in the mess by telling us of his studies of animal
and insect life among Everest's snows. Hingston
was an Irishman, studious, brilliant, and witty.
He had a delightful nature that everyone admired
and loved. But at times we didn't love him. He
had an abominable blood-testing machine and a
mercury tube which he used to get us to blow. We
had to blow until we were positively blue in the
face to try and raise a column of heavy mercury
several feet up his horrible tube—there was a mark
to reach, and, if we could not reach it, it meant we
were no use for Everest. I got out of it because I

was the photographer and not of the climbing party.

Somervell also had his own scientific device by which he tested our breath to see the relative amounts of oxygen and carbon dioxide ; and he would cork up samples of our " high-altitude breath " to carry home. He told us that great scientific knowledge would be drawn from this.

Hingston, who is the author of an authoritative work on Indian birds, had made a wonderful collection of beetles and butterflies, caught round our camp even at this immense elevation. He learned that beetles, with their heads tucked under them and their legs curled round them, hibernated the long winter under the stones in this very valley to enjoy the brief summer. For six months they lie asleep in the crannies of the rocks. If awakened before summer has come, they become paralysed and insensible. He told us also that he found colonies of ants underground, torpid and asleep even in the springtime. They wake up and enjoy a short spell of life when the summer comes. He found also wasps who inhabit tunnels they cut for themselves underground. On sunny summer days these insect creatures come out, but they are very slow in all things they do and have not the vigour of those found at lower altitudes.

Hingston's most interesting observations were how these animals and insects adapt themselves to meet the conditions of life among Everest's snows. For instance, the butterflies found up here have short,

compact wings and seem specially made so that they
can fly about and not be hurt by the force of the
mountain winds. He also found grasshoppers, who
go in the summer as high as 18,000 feet in this valley.
They have no colour and are very small and difficult
to find, looking exactly like the rocks. The very
highest-living insect that Hingston met was a tiny
Attid spider. It was one of my porters at my
22,000-feet photographic station, above Snowfield
Camp, who first found him. We lost him in the

THE ATTID SPIDER
much magnified) found on Everest at 22,000 feet.

descent, he was so small. But I told Hingston
about him, and we turned out a party of natives to
search for others, and found several.

Hingston told us he knew of a grey hunting
spider who lives here in the ice, and of the Carabid
Beetle, another insect whose eggs are to be found on
the banks of glacial lakes. While he made a collec-
tion in the mountains, his Lepcha collector Romoo
had been left behind in the Sikkim forests, armed
with a collector's gun and skinning knife and pre-
servative. When we returned to Chumbi, Romoo
met us ; and Hingston was delighted with the
beautiful collection of birdskins he had made.

These were brought home and given to the Natural History Museum, South Kensington, London.

Round the Base Camp we found the tracks of many burhel. They look more like wild sheep, but are really of the goat tribe. Living here in this sanctuary of the Rongbuk, where they are fed by the lamas, they have become quite tame. They would come quite close to our tents, and Beetham, while convalescing from an attack of sciatica, went out with his reflex camera and took pictures of them within a few yards. It was amusing yet inspiring to watch him at this work. Despite his painful leg, which he had to lift along step by step, he roamed over the hillsides to get snapshots of the burhel, the choughs and the pigeons. At one time he laid a salt trail, and so brought the burhel right down to our camp.

The burhel ascend to 18,000 feet. You see many of them along the shelf of the Main Rongbuk Glacier. They feed on the sparse grass and live near the pools of water that collect in the spring. In winter they are forced to descend to the vicinity of the Rongbuk Monastery. It is then, through scarcity of food, that they go to the hermits' cells and take food from the lamas' hands. The choughs inhabiting this valley were our persistent friends. They followed us eventually to 27,000 feet, where Mallory and Irvine built their highest bivouac, and therefore reached the highest altitude of any birds yet observed by man. They were our liveliest neighbours too. Indeed, two choughs actually built a nest in the

cliffs above Snowfield Camp at 21,500 feet. We could not reach the nest because it was high on a ledge, but we were certain they had made a nest there. I think they laid their eggs too and hatched them before we left the glacier at the conclusion of the Expedition. When we were abandoning Snowfield Camp I remember thinking of these birds. They were so tame and friendly and so often came near my tent, I broke open one of the abandoned store boxes that contained good things for birds to eat, and left the contents scattered on the stones of the moraine. The food would last them, I hoped, until their young birds grew strong enough to fly.

Why should animals and insects and birds choose to come and dwell in such barren wastes ? Possibly they may be attracted by the sanctuary they find here. Yet what an intense and uncertain struggle mere existence means at those heights ! Birds and animals seem to realize it and come together in sympathy. The wild goats go to the hermits' caves to be fed. They lose entirely their fear of man. The goats in their turn are friendly to the birds, who have a harder life, buffeted by the storms. The choughs fly down and rest on the wild goats' backs, and the goats quite contentedly allow them to eat the insects in their hair. The birds build their nests in cracks in the cliffs where they can get protection from the wind. The tiny little pikos that live up here burrow into the ground, where they find an even temperature. Under the rocks they make

stores of seeds and other things to eat during the winter. The birds have the hardest time of all. They are always at grips with the elements. They cannot hibernate in the ground like the insects and beetles and little mammals. These find in the ground a cosy home because, curiously enough, a foot underground the temperature remains quite even. The blasts of the wind never penetrate their shelters. We did observe sometimes that birds got into holes in the rocks, and also into ground burrows made by hares. Hingston told us that he once found a lark's nest on the Tibetan Plateau where the birds had actually built a wall of pebbles on the windward side of their nest !

The little round plump mouse-hares, no bigger than large mice and found in numbers in Tibet, are particularly kind to these small birds. The mouse-hares store up in their burrows hoards of seeds and grains ; and seem to allow the smaller birds to share their store. They actually leave a proportion, as much as they can spare, outside their holes for the birds. The birds pay them back by warning them of their common enemy, the hawks, who watch above and swoop down. Both the little mouse-hares and the birds who commune with them have a protective colouring that harmonizes exactly with the kind of sandy ground where the mouse-hares burrow.

I make particular mention of these things, and of Hingston's clever observations, because they lead to one important theory vital in the study of Mount

Everest—the theory of adaptation and acclimatization. If animals, birds, and insects can adapt themselves, so also can human beings. The Tibetans build their houses and their monasteries to the limit of cultivable soil and grow barley, the highest-growing cereal in the world. In summer they go even higher, up to 18,000 and 19,000 feet, to graze their yaks upon the thin grass that grows among the rocks below the mountain snow. They have become inured to the conditions and immune to the effects of the rarefied air. Does not this give proof of the theory of acclimatization? Again, who would think that a bird would build its nest at 21,500 feet above sea level? This ability of life to adapt itself to circumstances becomes the basic principle in planning the conquest of Everest. I am convinced from what I have observed in the Everest Expeditions that there is no limit to the acclimatization of human beings to altitude, under right conditions.

I am confident in believing that if ever in future years shelter rest-huts are built in stages up the mountain, the ascent of Mount Everest will be as possible as that of Mont Blanc is at the present day.

CHAPTER XVI

A SECOND GREAT VICTORY

Some days after the Lama's blessing, there was a distinct improvement in the weather, and Norton called another Climbers' Council of War. Our time had been badly cut into. Most of the month of May had gone and now there was not a single moment to be lost. Further days would be occupied by the renewed ascent of the glacier before we could get to work on the mountain. It was then that we realized that the Base Camp was too far from the mountain, 20 miles away. To have the Base at the very foot of the mountain is imperative on future Expeditions.

The word was: Forward! and Quick! As an example of determination, reflecting as it did the general spirit of the climbers, I will quote Mallory's own words: "This retreat is only a temporary setback. Action is only suspended. The issue must shortly be decided. The next time we walk up the Rongbuk Glacier will be the last. We have counted our wounded. We know how much to strike off the strength of our little army. We will gather our resources and advance to the last assault."

So the advance was again sounded. We reached

Snowfield Camp, having practically to rebuild and restock it. Then Mallory tackled the Ice Cliff. It was his intention to find a new way up it and avoid the site of the disaster of 1922. Any new way would necessarily be a more difficult way and would need more engineering and more step-cutting, even if safer from avalanches. From below he looked up at the confused mass of broken blocks of glistening ice. Here and there were shadows where the ice overhung, and, at places, other shadows of a deeper blue, meaning fissures or caverns. Mallory determined to force a way up through the jaws of the great central crevasse. He had been in the disaster of 1922. He had been blooded to the awful avalanche danger. Now he applied his utmost cunning and skill to thwarting it.

I watched him and his companions hacking their way up the ice wall, step by step, with all the skill of accomplished ice-climbers. I could see them, little black dots clinging to the face of the sheer wall. It seemed as if they could not see what was above them, because they were heading directly for the great transverse cavern. They reached it and disappeared into its dark recesses. Hours went by and I began to feel alarmed. Then suddenly somebody pointed out little black figures squatting on the slope above the cavern. They had gone in through the mouth and come out on the upper lip! It was amazing. Longstaff, talking of this wonderful feat of mountain-craft and the cutting of steps

Q

up what we afterwards named the " Chimney," a
vertical crack just wide enough to let a man squeeze
up it, said : " Talk about pulling the whiskers of
Death, these folk climbed in between the chinks
of his closed teeth. They accomplished the
impossible."

The Chimney was a crack about 60 feet high.
With their feet in the precarious steps they cut with
their axes, and with their hands and fingers clinging
to ledges, they worked their way up. At the top
they hammered in a wooden peg and attached a
long rope which they dropped down for men to hang
on to. Later Irvine improvised a 60-foot rope ladder,
by splicing climbing-rope and tent-pegs, which was
also fixed in the Chimney. By this engineering
work and the steps also being widened, it was made
later quite safe for laden porters. By this Chimney
route, we avoided entirely the dangerous slopes of
1922, where avalanches always threatened. The
track continued horizontally along the lip of the
crevasse and then zigzagged back to the " Tra-
verse," the last steep ascent to the ledge on the
cliff-top where the camp was set.

Mallory and Bruce made a preliminary climb on
the 1st of June with eight porters, including Dorji
Pasang, one of the men who reached the highest
camp in 1922. On that Expedition he had been
one of my photographic men, but had been detached
from my work to serve the climbers as one of the
" Tigers." Now in 1924 he was commandeered for

the climbers again. Dorji was a magnificent speci-
men of a Sherpa, but this year he failed to repeat his
former records.

Mallory and Bruce reached only to 25,000 feet.
Their porters failed and dropped out one by one.
Then renewed storms broke over the mountain.
They were forced to give up the attempt and return,
collecting their straggling porters.

After this setback there swept over us another
period of truly evil weather. Certainly this year
we were " up against it."

In the rush to get the high camps established
in the short time left, parties of porters were sent
up the Ice Cliff on every possible day with stores.
We were so placed that whenever new snow fell
on the cliff no one could go up or down, even by
the Chimney route, for some days until the snow
had hardened. One night a heavy snowfall thus
cut off all communication up or down the cliff, and
worse still, marooned four of the porters who
happened to be at the top alone; no sahib with
them.

The days passed. The cliff was daily recon-
noitred, but found too dangerous. On the fourth
day, the snow still being in a treacherous condition,
it became absolutely a matter of life and death to
reach the men and get them down ; and the rescue
that was effected by Norton, Mallory and Somervell
became one of the most thrilling episodes of this
drama of 1924 ; this epic of records, of victories,

of defeats, of disasters, of tragedies. These three intrepid men started for the cliff to rescue the four marooned natives. They knew, and we who remained at the camp knew as they started, that it was touch-and-go with their lives. For this reason Bruce was left behind. He wanted to go with them. But—somebody might have to assume the duties of the leader of the Expedition and bring the remnants of the caravans back to India. It was more likely than not that Norton, our leader, and his two companions would be killed. Still those natives had to be got down. I told all my own porters to stand by. I had pretty distinct visions of having to take part in an Ice Cliff search party similar to the tragic one of 1922.

Step by step the three men plodded their way over the crevasses of the glacier, bridged by snow but hollow beneath their feet. They were roped and took all precautions. Reaching the actual foot of the cliff and starting the ascent, the tremendous work began. They slipped back at every pace almost as much as they climbed. The danger lay in one of these little slips developing into a slide of the whole snow surface. Once started, it would, with an overwhelming sweep and deafening roar, develop into an avalanche of hundreds of tons in weight. By their icecraft and careful step-cutting and zigzagging, but yet mainly by luck, they avoided this happening. With extraordinary pluck and by making superhuman efforts they gradually reached

higher and higher until they passed the Chimney and reached the foot of the Traverse. We watched them the whole time from below.

One must try to realize their state of mind. Wearied and hampered in breathing, the body protests and the brain becomes dulled. Yet they needed their utmost presence of mind and skill in mountain-craft to win through. Those unfortunate fellows marooned at the upper ledge could never be abandoned. Sahibs and natives were one single party. Those natives had worked hard and faithfully for us. Norton, Mallory and Somervell were risking their lives to save them.

How hard Everest fights! This trouble seemed something more than chance or ill-luck. It was more like the fight of the very mountain herself.

At the Traverse Norton and Mallory took up a strong position behind a solid projection of ice, and paid out the rope to Somervell, who went ahead. Slowly, step by step, Somervell cut through the snow with his axe and made holes for his feet in the more solid ice beneath. Evening was coming on. A slanting ray of light illuminated the final slope, and by it I saw the men quite clearly through my telescope. I focused the camera on them. The distance was $1\frac{1}{4}$ miles in a straight line, but the high-power lens cut a circle which included clearly the whole scene on the topmost ledge of the cliff. The traverse was almost sheer. Normally there were hand ropes fixed and steps cut across it, but

now these were all obliterated. Somervell had to
cut the steps anew.

My telescope showed me the tiny distraught
native figures moving on the topmost ledge where the
camp was. They came out one by one and looked
down towards Somervell below. They ran back-
wards and forwards in a confused manner; and I
could not understand what they were doing. Some-
times they would come out and squat down on the
edge, and then suddenly get up and run back to the
tents. I expected them to stay at the edge to hear
Somervell's instructions, and perhaps, if they had
ice axes, to start cutting their way down towards
him, but no. They were behaving in a very strange
manner and running about without reason.

Watching through my telescope, I saw Somervell
stop. He had reached only half-way across the
Traverse and was now starting to descend. My
heart sank. Had he found it too difficult to get
across and given up? Would the men have to
be abandoned? I continued alternately to watch
through the telescope and to operate the camera.
I could not understand the actions, although I
continued to photograph them. Later, when they
all got safely back to us, Somervell narrated what
had happened. He had reached the end of his rope
held by Norton and Mallory in their safe position.
He dared not go beyond his rope end, so he jammed
his ice axe into the snow, untied himself and tied
the rope end to the axe, so as to provide a hold for

the men. He himself went down to lighten the weight on the slipping snow. Then by shouting instructions he got the men across to his rope one by one. I saw all this happening and recorded it completely in the motion pictures, although I could not understand the action at the time. The slanting setting rays of the sun were creeping beyond the Traverse; shadows crept up and obscured the scene; I got a dark picture, but clear enough to show the figures descending. They all got down, although one started a snow slide of some 25 feet, which might—but fortunately did not—have started a general avalanche and swept the whole lot from the face of the cliff.

The motion pictures of this rescue, photographed in the fading light, but yet clearly, at $1\frac{1}{4}$ miles range, are most interesting to anyone understanding the geography of the Ice Cliff and understanding mountaineering. But to the ordinary eye they are not so spectacular, because the figures are so small, lost in a maze of ice blocks and glistening snow surfaces.

It took rescuers and rescued many hours to descend to the glacier below, and they were lost to view as the night came on. We went out from our camp with a supporting party, my own porters carrying three gallons of hot soup I had had made, together with blankets and dry gloves and other things. We carried lanterns and made our way laboriously through the snow in the footsteps which the men had made that morning. We had toiled

through the darkness for about one and a half hours when, in reply to our frequent calls, we heard answering shouts. They had seen the welcoming twinkle of our lanterns. When we met, the whole lot of them sank down in the snow. They were absolutely done ! The porters were like drunken men, not knowing what was happening. Norton, Somervell and Mallory hardly spoke. We got out our hot food to give them. One of the porters vomited as quickly as we put the stuff to his mouth and the others we had to prop up with our knees. They were lying in a state of collapse. Norton was strong, leaning on his axe, but Mallory was in a very bad state. Somervell was the most cheerful, and after a drink he started to make jokes in his usual buoyant way—a wonderful fellow, Somervell. We continued together down the glacier to the camp, where the cooks had prepared a good meal for all.

Later Somervell described the state he had found the men in. They were crying like little children. They had completely lost their nerve. Alone for four days, they had exhausted their food, and for the last twenty-four hours had had nothing to eat. They were obsessed with fears of the demons of the mountain. They told us they had heard the barking of the phantom guard dogs of Chomolungma at night, and that they were terrified. They never expected to be rescued. The accident of 1922 was a haunting memory to all of us who had been on the former Expedition, and a particularly haunting

memory to the porters, because it was seven of their
kin who had been killed. These men would never
have dared to attempt the descent alone. Their
sahibs had to come to save them, otherwise surely
they would have perished.

They were completely knocked out by the adven-
ture. Hingston got them down to the Base; but
they were not fit for another stroke of work for the
rest of the Expedition. In fact, during the next days
there was a general exodus from Snowfield Camp
of everybody who was not up to the mark. It
developed into a sort of renewed retreat. Mallory
remained a great deal in his tent and sleeping-bag.
He looked ill and in my opinion he was "an unfit
man " when, some days later, he started for the
mountain with Irvine to make his last effort and
to meet Death. Further, it is my own idea
(although I may be quite wrong, as I am not myself
a mountain climber, nor am I an expert in such
matters), presuming, as is generally accepted, that
his death was due to exposure in the night before
he and his companion could regain their 27,000-
feet camp, that Mallory's end began *from this time.*
His strength was sapped. *He made his last climb on
his nerves.*

Owing to the complete upset of all prearranged
plans by the repeated storms and bad weather, it
was now decided to make the first big effort, im-
mediately the weather permitted, without oxygen.
The original plan was for the first big climb to be

an oxygen-aided attempt. This, however, would mean more porterage work, and, owing to the exhaustion of the porters and in order to give time for others resting at the Base to recoup, it was necessary to reduce transportation as much as possible.

It was decided that Norton and Somervell would make the non-oxygen attempt, while Mallory would rest and Irvine would tune up the oxygen apparatus, which was faulty and giving much trouble. Odell, Hazard and Bruce would be in support, while I, in this emergency, had the honour of being counted in the second line of reserve for support work. I had my photographic head-quarters permanently established at Snowfield Camp. Beetham was unfortunately entirely out of action owing to sciatica. He returned from the camp to take care of the Base while Hingston moved up to the front line to be in readiness to render medical aid. Irvine worked all day and every day at adjustments to the apparatus. He got three machines ready that he could rely upon. He altered them entirely from the design the makers provided.

Norton and Somervell now got away on their stupendous, smashing effort that, without oxygen, was to break Finch's oxygen record of 1922.

My care was to get the picture of the climb. Distance was not so great a consideration, because with the high-power lens I could be at 2 miles distance. Even at 3 miles, against a suitable back-

ground, I could still photograph the movement of the climbers. The view-point was the most important consideration. In 1922 I had photographed the high climbing from the Cliff Camp ; but from there I got a foreshortened perspective. Now above Snowfield Camp rises a wall of rock, one of the buttresses of the eastern ridge of the North Peak ; and if I could get high enough up it, I could get an uninterrupted view across the head of the East Rongbuk Glacier on to the Ice Cliff, the North-East Ridge and the North Face of Everest. I climbed with my men carrying the cameras, spare steadying tripods, electric batteries for the motor drive and stores of food and blankets to keep us warm during long hours we expected of waiting and watching. We reached 22,000 feet. There I found a splendid promontory ledge of rock. I could see the camp on the snow plain a thousand feet below. I named this ledge " Eagle's Nest Point," although of course there were no eagles here at all. I could look south-east over the Rapui Pass to the Kama Valley, out of whose seas of mist the great mountain spires of Makalu projected. The topmost point of Everest was 3 miles away in a straight line. From here with my long lens I got the best picture ever yet obtained of the final peak. It made a prodigious sight as I looked—a forbidding pyramid of grey and white with rugged sides. In the marvellously thin and clear air it stood bleak and menacing. It became my task to train my camera on that cone,

and for hour after hour to scan it with my finder
telescope in search of microscopic figures that might
move over patches of white background—where
exactly I could not tell.

My men had made a great effort in carrying the
machines so high up the loose, fragile rock slabs
along which we passed from ledge to ledge while
stones whizzed past us falling from above. Stones
are always falling on this cliff. One of the men felt
the strain of the weight-carrying, and bled at the
nose. He complained of a maddening buzzing of
the head and a pressure of the temples. It was the
" Poison of the Pass " again ! I let him stay curled
up in a blanket while I put another man on watch
with the telescope to scan the North-East Ridge and
northern face of the mountain for any movement of
Norton and Somervell. On the camera was a six-
times finder telescope coinciding for view with the
optical axis of the camera lens, so that any object
seen in the finder telescope was known to be also
in the field of view of the camera.

For many long hours we watched. As a reward
I got one single picture, where I caught the move-
ment of a line of black figures, no bigger than dots,
against the snow high up on the North-East Ridge
at 25,000 feet, just near the place where they left
the ridge to turn round to the sheltered side where
Windy Ridge Camp is placed. I measured the
distance later from Wheeler's accurate photographic
survey, and found it to be 3,000 yards—1¾ miles.

The motion picture when projected shows clearly a moving line of figures straggling across the slope. I was happy indeed to get that picture. For me it was a prize—the longest distance photograph ever obtained in the world. This record was to be broken later by my second picture of Mallory and Irvine's climb, when I got them at 26,400 feet at 2 miles range.

After this I lost sight of Norton and Somervell. Next day they climbed 1,500 feet and built their highest bivouac at 26,500 feet, just below the North-East Shoulder. Next day brought them their victory in the breaking of the height record, although they missed the very top. Up and up, higher and yet higher to 28,000 feet they went. Then heart and lungs found their limit. Slower and slower they went—only step by step now. The cone looked so close—a thousand feet above—only 300 yards, but 300 miles to men at the last stage of human power and effort, as they were. Somervell's words describing his own state were, "Tired and breathless and the very epitome of human limitations."

Norton's pulse, normally slow and regular, was beating rapidly and irregularly. Suddenly Somervell, who had been weakening and going very slow, only one step forward to six to seven gasping breaths, stopped. He leaned over his axe, then dropped to the rock and cried, " I cannot go any farther. You go on ! " His pulse was beating at the rate of 120 to the minute. Norton himself was

feeling a nervous trembling, which seemed like a violent fever. He went on slowly, but he too was so exhausted that in one whole hour of struggling forward he ascended only 80 feet above the spot where Somervell remained. Although only 900 feet above him, he saw that the task of reaching the summit was impossible for him. He gave up and made his way back to his companion.

Somervell's exhaustion was caused through his throat drying and by the violent coughing thus set up, which he was powerless to prevent. The dry atmosphere and consequent thirst is one of the most serious problems on Everest. The air is bone dry, and the rapid, convulsive breathing still further dries up the throat. Of course it is impossible to carry more than the minimum of drinking water. The porters lost a great deal of energy and strength by their never-ceasing coughing. It was the one contingency for which we were entirely unprepared with remedies. Any future Expedition should pay the most careful attention to this and provide for every member of the party a daily ration of some suitable medicine for the throat. Somervell at one moment very nearly died in a paroxysm of coughing. He said that his throat closed. He could not breathe. He started to lose his senses and everything became black before him. Then, lying down, one terrific sustained, violent effort of coughing seemed to clear him. Should he have collapsed, Norton in his own weakened state could not have

got him down to their camp. It is not generally
known or appreciated how near to disaster both
these men were. Without this disability to Somer-
vell, it is quite likely that both men would have
reached well up on the final pyramid if not to the
top of Everest.

They began the descent of the mountain, resting
at Ice Cliff Camp.

But their adventures were not at an end. Norton
developed snow-blindness. Dr. Hingston went up
to the camp to attend to him. The doctor, although
not a mountain climber himself (and this was his
first experience of the redoubtable Ice Cliff), per-
formed an heroic feat. He got Norton down the
Chimney, guiding Norton's feet with his own hands
into every step—a masterpiece of courage, devotion,
and skill and perseverance.

It is impossible to imagine men in a more complete
stage of exhaustion than these were in when they
reached Snowfield Camp. They had climbed to the
rarefied heights of 28,000 feet, to an atmosphere
hitherto believed to be too thin to permit human life
to be sustained. We were proud of them, and all
congratulated them. Hingston hurried them into
their sleeping-bags.

Norton's snow-blindness, a terribly painful but
mercifully a temporary disability, had been caused
by his removing his Crookes glasses while on the
upper rocks. He did not realize that even rocks
would reflect enough of the baneful infra-red rays

that are the cause of this blindness. They found that the whole atmosphere is impregnated at those immense altitudes by the baneful rays. Norton's eyes became blood-red, and ached terribly. Temporarily he was " totally blind."

As an instance of Somervell's amazing resource, despite his disability, he, at the highest point he reached, summoned the energy to get out his little vest-pocket Kodak and take one of the most remarkable photographs that have ever been taken in the world. He photographed the summit of Everest from 28,000 feet with Norton in the foreground going forward. Somervell kindly gave me the picture, of which he made several duplicate exposures, to complete my photographic record.

With the previous theories of many scientists now upset that mountain climbers could not reach such heights under strain of exertion (although balloonists and flyers have been as high sitting still and breathing oxygen), what conclusion can one draw from this record performance of Norton and Somervell? We can say, as Norton was the first to say, that the summit of Everest is possible for man to reach by his own efforts without artificial breathing. The question of whether oxygen should or should not be used will always arise. With an improved oxygen apparatus, together with better equipped and higher base camps and with longer periods of acclimatization, the summit of Everest will one day without a doubt become within the reach of the

ordinary strong mountaineer, and with oxygen even within the reach of adventurous tourists of the future.

But the first conquest of this mountain means the waging of a whole campaign with separate battles. Somervell and Norton had won an important one —one that must inevitably influence final triumph.

R

CHAPTER XVII

THE CULMINATING TRAGEDY

As Mallory had written, " The die is cast.
Again and for the last time we advance up the
Rongbuk Glacier for victory or for final defeat."

Norton and Somervell had shot their bolts.
Mallory and Irvine now took up the fight, aided by
oxygen. Norton said : " There is no doubt Mallory
knows he is leading a forlorn hope."

I had an opportunity of observing Mallory closely,
as I was at Snowfield Camp during this time, and I
formed the positive opinion that physically he had
become an unfit man. His bitter but suppressed
disappointment over the continual setbacks and the
ill luck of the weather this year, was manifest, but
so also was his burning ambition. It was his spirit
that was sending him again to the attack. He had
his teeth in the job and he meant business. He was
throwing his last ounce of strength into this fight.

Only two men were to make the assault. Mallory,
of course, was to be the leader. It was his theory
that two make the best climbing party ; further-
more, the high-going porters were so reduced that
camp equipment for two climbers at the most could
be carried. For companion there were only two to

choose from—Irvine and Odell, because these two were the oxygen experts. Mallory chose Irvine, with Odell and Hazard in support at the higher camps. Irvine had virtually taken charge of the oxygen apparatus. He had been working hard during Norton and Somervell's climb and had completed two sets, with a third in reserve. He was anxious and worried about the machines ; and, I think, the anxiety told heavily on him because he also was far from being in good condition. He breathed heavily and with labour. We all noticed it.

Odell stood altitude, and acclimatized perhaps better than anybody else on the Expedition. He was never ill, never seemed tired ; always kept an even, placid temperament unruffled by any event whatsoever. Geology kept him happy the day long. He wandered up and down the North-East Ridge and across the face of Everest, reaching 25,000 and 26,000 feet apparently without particular effort. He remained longer than any up at Ice Cliff Camp. He had been slower than any other of the men to acclimatize, but eventually he appeared to become inured to a greater degree than any other. For an Everest climber he seems to be the perfection of type.

Many people now consider it was a pity Mallory did not take him on his final spurt, making his party one of three instead of two. But the reasons against that course have been given—the difficulties of the transportation of camp equipment for a third man

to Highest Bivouac (Mallory intended this time to move Highest Bivouac up another 500 feet to 27,000 feet), and the necessity of leaving behind a supporting party at the Ice Cliff and Windy Ridge 25,000-feet Depots.

Such a chain of support is vital on Everest. The ideal " Polar method " would have a support party of two fit men at each stage ; we had only Hazard and Odell for this support work. Bruce had become much reduced, and was losing weight every day, I think mainly through the rough and unappetizing food of the high camp. Bruce, however, was the father of the porters, so he stayed on at Snowfield Camp to organize the team to go with Mallory and Irvine. He picked eight of the best remaining men. It was not expected that more than two or three of them would reach 27,000 feet, which was higher than porters had ever yet carried loads. Those that broke down would fall out and remain at Ice Cliff Camp. It was hoped, however, as actually did happen, to get two light tents and sleeping-bags, and a supply of food and fuel, up to the North-East Shoulder, 27,000 feet above the sea.

The season was late, the date when the monsoon usually breaks had passed, but fortunately the weather was still clear, and almost ideal. The days were warm and fine, the snow and ice in good condition, and the wind moderate.

Mallory and Irvine succeeded in three stages in establishing their highest bivouac at the shoulder,

500 feet higher than any of the previous parties had done. From " Eagle's Nest " I photographed them on the way up at 26,000 feet. I then went for one afternoon to Ice Cliff Camp ; the same day they went up to 27,000 feet ; and that evening I received the note I have already spoken of—the last letter Mallory ever wrote. His message told me to look out for him next morning at a certain place on the summit ridge which he had previously discussed and arranged with me. I spoke to Lakpa, who brought me the note and who was one of the few porters to attain 27,000 feet. He said that the Sahibs were well and the weather was good, and that they had successfully reached the higher level. After building the camp, the Sahibs had sent the porters down. That evening Lakpa and his companions and my own photographic porters descended to Snowfield Camp. Lakpa had thus that day climbed with a 20-lb. load from 25,000 feet to 27,000 feet and descended from 27,000 feet to 21,000 feet —a great performance. He was one of the three best of the whole porter corps.[1]

Next morning at daybreak I set up my motion-picture camera with a long lens trained on the

[1] He came back with me to Europe afterwards and stayed ten months, appearing at the Scala Theatre, London, where the film " The Epic of Everest " was shown, and toured England, Ireland, Scotland, France and Germany, together with the seven Tibetan lamas from a monastery in the interior of Tibet, whom I also brought back to appear in connection with the presentation of the film.

summit pyramid, 3 miles distant, to watch for
Mallory and Irvine on that last terrible trail.
Mallory in his note saying 8 *p.m.* had made a mistake,
meaning of course 8 *a.m.* I had two keen-eyed men
watching in turns, their eyes glued continuously to
the telescope, but they saw nothing. 8 a.m. went
by, then 10 a.m., and clouds and mist then obscured
the whole summit ridge.

Norton was still in his tent suffering from his
snow-blindness. Bruce, Hingston and I were at
the camp. Odell and Hazard were based at Ice
Cliff Camp and Windy Ridge 25,000-feet Camp.
Mallory's note and verbal messages to us had
cheered us ; and we were all optimistic over their
success in establishing the 27,000-feet Depot.
Should they have passed a good night there and
have started well before dawn (Mallory was always
an early starter), there was a distinct chance they
might gain the top that day.

This was the historic climax of our adventure—
glorious because of the marvel of attainment, sad
because of the tragedy of death.

For Mallory and Irvine had gone for ever from our
sight. Up and up into the blue they had gone
higher and higher—higher than men have ever
reached before. Odell got a single fleeting glimpse
of them within 600 feet of the summit and still going
up. Then he saw nothing more. What happened
no one knows. They never came back.

I will relate all that any of us, who waited and

watched, and searched, and waited again during the next anxious and awful days, knows.

Hour after hour we watched the mountain with our telescopes for what we might see through the mists. The men were a day and a night overdue. We knew nothing. There was no message even from the support party. Had they slipped and been hurled down the 10,000-feet precipice? Perhaps, the summit attained, they had found themselves too exhausted to reach camp by nightfall and had been frozen to death? The silence of the support party meant, we hoped, that they had gone out to search. We could only hope against hope that they would find the two men alive and would bring them down.

To catch the spirit of that tragic time you must realize the terrible state of body and mind that comes upon men in these high altitudes, with the air so rarefied that it can scarcely support life although the wind blows at tremendous velocities. After every effort hearts go pounding until they are in agony; and each spell of toil demands long periods of rest. Worst of all is the state of mind. Men fall into an almost ghastly psychological condition.

Think of what the effort had cost those already tired men struggling towards the pinnacle. Think also of us; our initial joy and expectation sinking into as deep a dejection and anxiety when every fresh hour brought the certainty of disaster and death more overwhelmingly upon us. How we had

desired victory ! Did we not deserve it ? This was the third time we had returned to the task.

Two whole days and nights had now gone by, with hope fading at every hour. Norton, recovered sufficiently from snow-blindness, paced backwards and forwards in front of his tent, speaking little, visibly affected and, I think, already resigned to the worst. Hingston had all his medical aids ready and was prepared to go out at once in answer to a call from the support party up on the mountain. I had left my photographic station on the Cliff above the camp and now had my men posted at my telescope erected in the middle of Snowfield Camp. The men took it in turns to scan the mountain during every hour and moment of daylight. Norton, Bruce, Hingston and I sat about near the little Whymper tent we used for the mess. Now and then we called over to the watchers on the telescope, " Kutch Dekta ? "—" Do you see anything ? " The men turned and shook their heads each time : " Kutch Nahin, Sahib "—" Nothing at all, sir." Then I would at intervals go to the telescope and scan the mountain myself to make certain. The days were fine and the sun shone, although up on the mountain the never-ceasing wind and mist were blowing ; and in the distance in the southern sky over the Rapui La banks of cloud were collecting and rolling up. They told that the monsoon had reached Bengal and would soon sweep up here to break and obliterate everything.

Suddenly our watchers at the telescope called out that they saw figures on the crest of the Ice Cliff!

We riveted our eyes to the cliff-top. We saw through the telescope distinctly a line of men returning and entering the camp. (The tents on the ice shelf could just be seen from Snowfield Camp.) It was Odell with his support party. Presently we saw figures come out to the edge of the shelf. They were coming to make a signal to us. We used to communicate between the camps over the space of a mile by signals; and Norton had arranged with the support party a series by which to tell us their news. As we watched we again hoped, against hope, that they would tell us they had found the men— frost-bitten—exhausted—incapable of moving—anything, but still alive. While life existed we could go to the rescue and do our best and utmost. What would the signal be? Life, or —— ? I saw them place six blankets in the form of a cross. Then they went away. This was the signal of DEATH.

I remember the moment vividly. I saw this signal through my telescope as I was making the photograph of the scene through my high-powered magnifying lens. An electric battery was operating the camera. I was so agitated to read the message that I could hardly have turned the handle of the camera myself. Bruce asked me what I saw. I saw plainly it was a cross, but had not the heart to answer him. I handed him the telescope that he might look for himself. We all looked. We all

tried to make it different. But it was plainly a cross on the white snow.

Norton called a conference and discussed many things. A further search ;—a new search party— the futility of it, since no men so long overdue could possibly be still alive ; the project of searching the glaciers below the precipice for their bodies ; the hopelessness of that task in such a vast area— what cable message should we at once send home ; the approaching monsoon, and the safety of Odell and Hazard and their men ; the advisability of with- drawing them at once down the Ice Cliff that becomes so treacherous in bad weather—and a hundred other thoughts.

In the end Norton ordered an answering signal to be made ; and Hingston had the task of doing it. He went out on the glacier just beyond the tents and placed three lines of blankets spaced apart. It said to those on the Cliff above : " Aban- don hope and come down." It was all over. Soon Odell and Hazard would be with us ; and then they would tell us details. We sat down and waited for them to come.

That night, our party reunited, Odell told us the whole tale—a thrilling tale because of the magnificent attainment of Mallory and Irvine as last seen by him and because of the heroism of Odell himself in the terrific efforts he made to find them.

To Odell must fall the honour and praise for doing the utmost that any man could do. Twice

he went in search to 27,000 feet, the last time alone, because the others with him had fallen exhausted. I will recount his story as he told it to us himself, to the best of my remembrance, it being now three years ago.

" On the day Mallory and Irvine were to make the attempt on the summit, I went up to the 25,000-feet Depot to be in close support of them. I was geologizing [1] on the way, and I made short trips in the neighbourhood of the camps.

" At about half-past twelve there was a sudden clearing of the atmosphere ; and the entire summit of Everest was unveiled. A belt of driving mist sweeping across the northern face failed to reach as far as the summit and left the final pyramid standing out clear against the blue sky. Suddenly I noticed high up in the almost perpendicular wilderness a moving black speck silhouetted on the second step, [2] then I saw another speck move up to join the first. It was no other than Mallory and Irvine within 600 feet of the summit. They seemed to be going strong. I dropped my geologizing, took out my glasses and riveted my attention on the spot. The

[1] His ruling passion, exercised in spite of Tibetan prohibitions.

[2] The second step is the upper of two distinct steps in the summit ridge leading from the North-East Shoulder to the summit and is situated just at the foot of the final pyramid. It is on the edge of the ridge. On the south side the great southern precipice of Everest drops 14,000 feet to the Kangshung Glacier of Nepal. On the north side is the 10,000-feet precipice to the Rongbuk Glacier of Tibet.

wind was tearing round me. Then the mist swept up, and the whole fascinating vision vanished. I waited and watched again, but the mist never cleared, although, I think, up where they were there was little or no mist. But that was all I saw. When I last saw them they were going strong. The sight gave me the first impression that they were going to reach the top.

" It was so late when I had seen them at the second step—a good four hours behind their schedule time—that my fear was of their being overtaken by the night in the descent. I expected that to return to the 27,000-feet bivouac would be the utmost they could do that night. Next day I went up to the 27,000-feet Depot, taking two of the Sherpas with me, hoping to meet Mallory and Irvine coming down. At last I reached 27,000 feet and found their camp. I approached the tents and called out, but there was no answer. I went up and looked in. The tents were empty.

" I and the porters were in a state of exhaustion, and we could not stay up there. I then found a white background and made a signal to Hazard at the Ice Cliff below. We went back to the 25,000-feet camp ; and I spent a night of terrible anxiety. Next morning I found the two porters were incapable of going up again to 27,000 feet and I was in an exhausted state myself, but with oxygen—and there was the third spare apparatus here—I thought I could do the climb again. Accordingly I struggled

up to 27,000 feet again, but alone, leaving the porters behind. I hoped that Mallory and Irvine might perhaps have got back that night and I might find them in the tents. I could then look after them and signal down for help. I dragged myself up to the two tents, which I found standing as before. I went to them and pulled the flaps of the tents apart and looked in. They were empty. The two men must have perished. There was no trace of them. There was no written message left by either of them. I looked at everything. It was beyond my power to search higher up the mountain. The men had been missing from their camp for two nights and they could not possibly survive. I made my way down and reached the Ice Cliff, where we put out the signal to you—that was all I was able to do."

Then Odell added : " I think that it is quite possible and even likely that Mallory and Irvine reached the top and were overtaken by the night in the descent, exhausted and frozen to death."

Such was the simple, heroic and tragic story Odell told us. It was then that we realized to the bitter full how hard and how cruelly this mountain fights. She had allowed the men to come on, and at the last moment had killed them. Maybe she had killed them in revenge after they had attained their victory. Who knows ? She alone holds the secret.

CHAPTER XVIII

SOME FINAL CONSIDERATIONS

Thus the story of Everest ends—tragically, at present. Brief consideration of a few of the theories as to what happened may not be thought redundant, so I venture to deal with them here.

We talked and reasoned and speculated. Norton's opinion, although he always carefully emphasized that it could only be an opinion, was that the end came through an ordinary mountaineering accident. Where they were last seen was a point of no exceptional climbing difficulty, although ever dangerous. A slip or a break of the loose fragile rock would precipitate them to the glacier 10,000 feet below. It is unlucky that Everest's rock is loose and that the strata slopes towards the climber. A foot may thus slip fatally at any moment, whereas if the strata dipped in the reverse direction, it would provide ledges and cracks for nailed boots to grip. On this tragic day, conditions were aggravated by a fall of loose fresh snow, which, of course, made the rocks still more slippery.

Why Mallory 'and Irvine were four hours behind their schedule time will remain a mystery. Mallory was always a believer in an early start, and would

have realized the necessity of getting back to camp by nightfall. The only suggestion we can make is that they were bothered by the oxygen apparatus, and that Irvine had to make some adjustment delaying their start. In all Mallory's climbs, he was never known to be a late starter. Even if ill or unfit he was always astir before his companions. We know by the experience of Norton and Somervell that it is possible to sleep well even at an altitude of 27,000 feet above the sea, so we cannot reason that they might not have slept and were consequently over-tired in the morning. We think the more likely cause is some unforeseen difficulty with the oxygen apparatus.

In trying to reason out the causes of the accident, we must take into account not only the condition of the mountain, but also the character and probable course of action of the men in the conditions they found. Mallory was cautious and sensitive to responsibility, although a man of indomitable nervous energy. He had a young companion, with relatively little mountain knowledge, but of splendid physique, who no doubt through his buoyant temperament would be ever optimistic. Mallory would realize this and temper that enthusiasm with caution. He would hesitate to take an unwarranted risk. Mallory would not have started so late behind his schedule time if he had thought there was danger of being overtaken by the night.

This was Norton's view, from his personal know-

ledge of Mallory. He thought that Mallory must
have been confident of reaching the summit and
returning in safety, and therefore was certain some
accident must have happened. He believed that
Mallory's will power would triumph over all diffi-
culties and hardships, even against exhaustion in
the late hours of the night. Norton remembered
the great climb of 1922 when he with Mallory had
accomplished the tricky descent of the mountain in
the middle of the night, with the whole party
exhausted and with the additional burden of con-
ducting Morshead step by step. Norton himself
had then been in a state of collapse, and frost-bitten
in both hands and feet. It had been Mallory's
leadership and will power that had brought the
party back. Norton, remembering this vivid exper-
ience, could only visualize Mallory's death as the
result of—" An ordinary mountaineering acci-
dent."

There is an alternative theory. At high altitudes
we know that the blood is changed and the action
of the heart affected, and it is within the bounds of
possibility that a climber at such altitudes may sud-
denly drop dead. But this we can hardly imagine
happening to both men at once. Furthermore it
is unlikely, since both men were young and of the
best physique, although we know they were tired
and not in perfect condition before they started.
Odell, moreover, had described them as " going
strong." We can reasonably suppose that their

youth and staying power would have prevented the sudden collapse one might more readily expect in the case of older men. The accident theory seems the more likely: possibly a slip on those loose, sloping rocks treacherously sprinkled with freshly fallen snow on the day of the climb.

Near the foot of the final pyramid is a place the climbers have named " The Gully," which they say will always be a dangerous place to cross. If one of them had slipped here, the weight of the oxygen apparatus would have increased the jerk on the rope and perhaps pulled the other man off his feet too. The oxygen apparatus tended to make a man top-heavy. It projected awkwardly. Hitting a rock round a corner it would tend to overbalance a man in a difficult place like the Gully. If one man slipped, could the other single-handed, in his exhausted state at such an altitude, hold the weight of his companion ?

There arises that vexed question, whether or not men should be roped, and further, whether two is the ideal climbing party, as claimed by certain modern mountain climbers, or whether the party should be of three or four or more. Mr. Douglas Freshfield, the veteran Alpine, Caucasian and Himalayan mountaineer, says of this problem : " With all due deference to the younger generation, I doubt gravely the expediency of sending a party of two. No doubt a party of two moves somewhat more quickly, especially on difficult rock climbs, but

s

on a long and relatively easy ascent a party of three has more obvious advantages."

Now Everest is not a difficult rock climb. Our climbers consider it easy. The ascent of Everest is more a feat of endurance depending upon lucky weather conditions and elaborate preparation and support from a chain of depots. In a party of three, should one be disabled, two can more easily render assistance. One can go back for aid while the other remains with the sick or injured man. The advantages of a party of two are mobility, speed, extension of porter power which will allow successive parties to make a succession of attempts profiting by the experience of their predecessors, and economy in camp and food transportation.

Experience teaches that the necessity of a highly organized system of support to the party making the final effort to the summit is more important than has hitherto been realized. It has been suggested that if sufficient camp accommodation could be provided (a matter only of organization and work) a party of six should set out for the summit from the last bivouac. If one man dropped out, one other fit man would sacrifice himself to bring the casualty back. This would allow for two failures, reckoning that two at least of the party would emerge fit to make the last lap, the last 200 or 300 feet even, to the summit. To gain speed they might move in three separate parties of two, unroped, the whole six combining and

roping together when dangerous places had to be passed.

Another cause of the accident may have been the influence of the gully or the influence of the wind, or both together. Mallory told me himself, when he talked to me of his possible routes up the final pyramid and told me where to watch for him, that he expected to go up the North-East Ridge of the final pyramid, but if he found the gully particularly difficult or if the west wind were particularly bad he would take the Eastern Ridge, missing the gully by passing across the head of it and gaining better protection from the west wind. Such a route would bring him along the knife-edge of the Eastern Ridge. This ridge is corniced by the continual action of the west wind. If a man goes too near the edge of a snow cornice he may drop through ; and in this case would fall down the southern precipice and be dashed to death on the Kangshung Glacier of Nepal, 14,000 feet below. This southern precipice of Everest is probably the greatest sheer drop in the whole world. Again, the wind, which attains a fury of 150 miles an hour over the upper ridges of Everest, might, in a sudden storm, blow the men over the edge.

Still another cause of an accident might be the sudden breakdown of the oxygen apparatus. Deprived of oxygen, a man would easily collapse ; and we knew unfortunately that their apparatus was none too dependable. But again, would both machines have failed ?

Accepting the accident theory, the question then arises : Did it occur on the way up or on the way down ? Norton thought it more likely that it occurred on the way down when they were moving more quickly, were more exhausted and perhaps were going less carefully.

Is it possible that they actually did reach the top, and that Everest has really been conquered ? Odell has said that in his opinion it is possible and even likely ; but others of the Expedition are less optimistic. In any case the Expedition and the Geographical Society make no positive claim whatsoever to the conquest of the mountain. That is obviously impossible, since nothing definite is known.

Try to put yourself in the place of Mallory and Irvine as they were ascending those last 600 feet. The summit, visible at the time, its height foreshortened by looking up, would look encouragingly close. They were going strong, as Odell described, when within 600 feet of it. That does not mean they were going fast. It means only that they were going steadily forward. But at the same time it means that their oxygen supply was obviously working satisfactorily at the moment. The weather was clear and conditions favourable except for the lateness of the hour. You can imagine how they must have been urged on by one dominating desire —the Summit. You can imagine how Mallory's energy of nerve, brain and muscle must have risen to the supreme effort of his life. You can imagine

his spirit straining his physical strength to the last limits. The goal was in their grasp. Should they turn back and lose it ? They were above the clouds, which glided swiftly across the northern face of the mountain, as Odell told us—above those clouds that hid his view of them from below. Their atmosphere was a clear one. Cannot you imagine, knowing the spirit of both, that with the view of half the world below them they were so thrilled that they just HAD to go on ? At the very top, so near, everything on this earth would be BELOW THEM. What a goal ! Might they not indeed throw every other thought to the wind to win such a prize ?

There are many people who look upon mountain-eering adventures and activities as a preposterous waste of human energy, involving unnecessary risks to life and limb. They are entitled to their opinion and may be left to lead their comfortable lives and to die in their beds. The fact remains that there are other men who feel an urge to the high places, men whose spiritual natures are drawn to them, irresistibly, and who there gain the spiritual sustenance their souls crave.

The present Pope, Pius XI, who is himself an ardent and distinguished mountaineer and who followed the Everest Expedition with the liveliest interest, sending us repeated cablegrams of encouragement, congratulation and sympathy, wrote this on the occasion of the anniversary of the birth of St. Bernard : " In his laborious effort to attain

mountain tops, where the air is lighter and purer, the climber gains new strength of limb. In the endeavour to overcome the obstacles of the way, the soul trains itself to conquer difficulties ; and the spectacle of the vast horizon, which from the highest crest offers itself on all sides to the eyes, raises his spirit to the Divine Author and Sovereign of Nature."

Did Mallory and his companion perhaps feel that exalting urge to be above everything in the world and to get a glimpse, so to speak, of God's view of things ?

Did Mallory's spirit drive his body to death ?

THE END

APPENDIX A

OXYGEN

As has been explained in the case of Norton and Somervell's climb, it is now proved to be possible to climb Mount Everest without oxygen. This could be done, of course, only by very powerful and able climbers. It would be safer on a future Expedition to take oxygen, stored and used in approved machinery, which should be much better than the machinery the Expeditions previously have had. Oxygen will facilitate the task and render the climb possible to any ordinary fit human being ; and probably some day in the future the journey to the top of Everest will become an adventurous excursion possible to the ordinary tourist.

Oxygen enables men to walk faster and therefore lessens the time which has to be spent at high altitudes on the mountain, thus reducing the risk of disaster through bad weather. We know how the problem of Everest is 90 per cent. a problem of weather.

The blood and oxygen are two things to be considered together. The colouring matter of the blood is known as hæmoglobin. It lives upon oxygen, and takes it from the air through the lungs. It gives up oxygen with equal readiness through the work of the muscles, glands and other organs, so there is always a process of oxygen coming in and carbonic acid gas being given out. Oxygen is the food and carbonic acid is the poisonous product. The amount of oxygen food is determined by the rate of breathing, and this is regulated by the brain, without the necessary intervention of consciousness, by the reaction of carbonic acid in the blood. Now at high altitudes the air becomes thinner and there is less oxygen. Almost everybody is familiar with the effects of panting and nose bleed-

279

ing caused by going quickly to a great height. Some
people cannot even go beyond five or six thousand feet ;
and if they go higher their breathing becomes laborious
and painful. The pulse beats at a great speed and the
heart dilates and thumps. Headaches come on, with sick-
ness and vomiting, loss of appetite and incapacity to make
any effort, mental or physical. When this stage becomes
acute it is called " mountain sickness."

One of the most serious effects of altitude is this effect
of starvation of oxygen on the blood, causing a mental
condition very similar to " gassing " in the War. It has
been observed in aeroplanes that men become insensible to
their surroundings. An airman once started using his
Lewis gun magazine to beat his companion on the head
instead of firing his gun at the enemy ! A state of intense
irritability becomes one of the salient sensations. The
slightest effort costs more than a hundred yards sprint on
the ground. It used to be thought that there were alti-
tudes beyond which men could not go without the help of
" artificial " oxygen, but this theory—worked out from
scientific tests in oxygen chambers—has been more or less
disproved by the practical test of the Everest Expeditions.
They showed beyond question the astonishing results of
acclimatization ; how life successfully adapts itself to
strange, new conditions.

The celebrated scientist and physician, Dr. Gale, has
expressed the opinion that the effect of artificial oxygen
could be obtained, and more easily, by the use of substi-
tutes which react on the thyroid gland such as quinine,
hydrobromide, pancreatin, insulin and perhaps parathy-
roid. Other doctors have suggested the method of injecting
oxygen by hypodermic syringes direct into the blood ; and
this method, carefully undertaken in correct doses, has
been proved to be of extraordinary benefit and to be a
quicker and more efficient method of applying oxygen to
patients in hospitals, but I do not know of any case in
which it has been tried by mountaineers. It would be
worth trying. Every new method should be tried and

not condemned by theory but proved out by practical test. Breathing oxygen through the lungs is, of course, a comparatively inefficient method, although it is the method of Nature. The climber breathing oxygen from storage cylinders on his back loses a great deal of the gas by breathing out that large proportion of gas that the lungs have failed to assimilate in the rapid panting for breath under severe physical strain. There is a further loss in that the storage tanks deliver a continuous flow of gas whether the man is breathing in or out. When he breathes out the gas is lost. Thus fifty per cent. is lost, although Finch's storage bladder and rubber delivery tube, which he trained himself to grip and seal with his teeth at each out-breath, somewhat counteracts this loss. It was a simple and most valuable invention. Finch was clever at such inventions.

Then there is the question whether to use gas stored in cylinders under pressure with all the attendant disadvantages of the weight of steel cylinders and the difficulty of preventing gas leaks, or whether to use liquid oxygen. Longstaff was the first to express the theory that compressed gas was an inefficient and obsolete method. This has been found so by aviators, who now, I believe, always use liquid oxygen. The difficulty of equipping an Everest Expedition with liquid oxygen is the expense. It is said it would cost about £2,000 to provide the Expedition with a portable oxygen-liquefying plant. If it could be supplied, of course it would make the climbing of Everest almost an easy matter.[1]

From my own observation and use of the compressed-oxygen apparatus we had with us, I formed the following conclusions, which I offer as my humble non-technical opinion.

The faults of the apparatus were :

1. Too great a weight for the gas capacity.

[1] Liquid oxygen evaporates at a fast, steady rate into gas oxygen, and no strength of steel will restrain it from expansion. It has to be used therefore within a matter of hours of its manufacture.

2. Too many complicated adjustments and joints at which under conditions on Everest the gas would, as it did, be bound to leak. I would suggest these be remedied in the following way.

(1) A more powerful and better steel be used for the storage cylinders and a better design of cylinder be evolved, to contain at least six and if possible eight hours' gas supply (instead of four as in 1924) at the normal rate of flow.

Each climber should carry only one of these larger cylinders, and rely upon dumps of supply cylinders and supporting parties for renewal. (In the event of breakdown he would breathe from a by-pass from his companion's apparatus.)

(2) All the complicated gauges, pressure and flow meters, taps, tubes and joints should be abolished. Each cylinder should have *annealed* to it (not screwed only) a pressure-reducing valve, one main opening tap and one by-pass tap. The gas would go direct from the pressure-reducing valve (of which the action is to deliver a constant and steady stream of gas at a fixed rate irrespective of the pressure within the cylinder) by a rubber tube with a Finch storage expansion bladder to the mouth. Thus there is no chance of a leak. (In 1924, 60 per cent. of the Expedition's cylinders of gas were absolutely empty when we arrived at the foot of Everest !) The reducing valve would be set unalterably to deliver gas at what was predetermined to be the most economical minimum but sufficient supply of gas for a climber. All men of the party would therefore be taking gas at the same rate. If any man needed more, that in itself would be an indication that he was unfit to go on, and he would drop at once out of the party going for the top. Thus the leader would know exactly where he was. He would know by his watch (not by a pressure meter) how much gas his men had left. He would be able to make his plans cut-and-dried for his dumps of cylinders.

The cylinders, so made, would be charged at least two months before an Expedition started with perfectly dry oxygen, weighed and tested by weight for full charge.

APPENDIX B

SCIENCE VERSUS NATURE

The pioneer explorer of former days conquered natural obstacles by determination and brute force. It was an age of greater romance ; and we may regret that lost romance. Now, however,we can only adapt ourselves to the conditions of modern times, because the major tasks of pioneering on the earth's surface, except Everest, are accomplished. All the modern explorer can do is to go over the same ground as his predecessors have explored. Yet in going over that same ground a new thrill and interest can be awakened by repeating the task in a different and in a modern scientific way. Where the explorer of former days matched his physical strength against Nature's obstacles and where he rather emphasized his difficulties, the modern explorer vanquishes those same obstacles by the aid of science, minimizing his difficulties and making the facility and ease of conquering those obstacles the measure of the success of his work. Where the explorer of former days won glory through the loss of human life in an unequal struggle with the forces of Nature, the modern explorer considers the loss of human life a mark of failure to his enterprise. Amundsen trekked over the snow to the South Pole with dogs and sledges. Now he flies over the North Polar Continent in an airship with speed, comfort and safety.

Mountaineers have no object in flying over Mount Everest in an airship, because the object of the Everest Expedition is—to climb the mountain. However, I would like to urge here the plea that a future expedition should conquer Everest by science. The climbers, Norton and Somervell, have shown (Norton has definitely expressed his conviction) that the summit of Everest can be reached

by mountaineers without artificial breathing or scientific aids, yet men like those two are rare in the world ; and there are few others who would ever be capable of doing the task. With the aid of science and certain preparations which I am explaining, I am convinced Everest could be put within the reach of the ordinary man. Further, I would make the plea, although I expect it will arouse hostility among devotees of mountain climbing who do not want their sport invaded by outsiders, that Everest is a task which should be accomplished by the ordinary man for the glory of the modern spirit of exploration— to prove that mankind by the application of the devices of science can overcome any physical obstacles of Nature.

People may say : " But why should he want to do this ? Why not leave it to mountain climbers ? It is their special sport. What good can it do the ordinary man ? " I would reply : " Everest is the last stronghold of Nature— the last big exploration task left in the world." [1]

Collect an Olympic team of fine young men, who will represent the manhood of the world, and send them out equipped with modern scientific appliances and devices. Let them not attack nor assault Everest, but let them *walk up* the mountain and prove its conquest without loss, injury or suffering to themselves. Would not such an accomplishment be a stirring victory ? It would be a victory for modern man. It would awaken mankind further to the realization that within themselves they possess infinite capacity. It would be another step forward in the evolution of mankind. I am positive it could be done with the correct organization and method.

Our knowledge of human capacities has been much advanced by the Everest Expeditions. In 1921 we thought the mountain impregnable even to skilled mountaineers ; 1922 showed men their undreamt-of capacity to go to immense heights, but it left our knowledge of acclimatization still uncertain and imperfect ; 1924 considerably advanced that knowledge and proved that men could

[1] Excluding submarine exploration.

rest and sleep at night even at 27,000 feet above the sea. Norton and Somervell's brilliant performance showed that the expert mountaineer had it within his power to reach the summit of Everest on his own efforts unaided by artificial breathing. Formerly people considered that there was a definite limit of altitude at which a human being could live, beyond which he would deteriorate in health and eventually die. Such would no doubt be the case under conditions of inadequate shelter and food and sleep, but I am convinced that if it were possible to provide huts, proper sleeping facilities and well-prepared food, there would be no such limit. Any present limit is more the result of circumstance and local conditions than the intrinsic factor of the effects of altitude on human beings. I believe that, supposing there were a house and food up there, men could adapt themselves to living and staying at the top of Everest.

Of all experience gained on the Everest Expeditions I think the astonishing scope of acclimatization is the most important, and every use should therefore be made of it in planning the next ascent of the mountain, e.g. :

(1) By advancing the whole base of operations 15 miles nearer the mountain and 5,000 feet higher in altitude. The Base Camp should be moved up to the head of the East Rongbuk Glacier.

(2) By constructing weather-proof huts for the whole Expedition to live in at the Base, and light storm-proof shelter huts up the mountain with adequate facilities for sleeping and proper preparation of food, instead of using tent bivouacs which are ever at the mercy of the weather.

(3) By extending the period of the Expedition from the spring to the autumn in order to allow time both for more elaborate preparation and also for the members of the party, living comfortably at high altitudes, to acclimatize.

Those would be the three main ways in which our experience of acclimatization could be applied. In addition :

(1) A differently designed and vastly improved compressed-oxygen apparatus should be provided for use between say 25,000 feet and the summit.

(2) A roadway fit for yaks should be made as far as the head of the glacier where the Base would be established.

(3) A light aerial rope line (1,700 feet in length) should be provided to take loads and stores up to 50 lb. in weight up the Ice Cliff.

N.B.—By means of (2) and (3) all transportation below 21,000 feet would be transferred from men to animals, and up to 23,000 feet (the top of the Ice Cliff) to machinery. This would effect an enormous economy in human porterage and would greatly relieve the burden on the porters. They would carry only from 23,000 feet upwards.

(4) Arrangements should be made for wireless communication for weather forecasts from India, and for wireless intercommunication between the Base and all Depots on the mountain, thus ensuring close support to the parties making the ascent.

(5) Modern oil and spirit cooking appliances should be installed in the Depots, and a normal diet of healthy, appetizing food provided for all.

The organization for all this could be carried out in the following way :

The Expedition would be primarily organized in two groups—the Preparation Party and the Climbing Party.

The summit of the Ice Cliff would be considered the point of departure of the climbing party and the sole object of the Preparation Party would be to transport the Climbing Party to this point from the starting-point in India in the perfection of physical condition without the latter having expended an ounce of unnecessary energy or strength.

The Preparation Party would themselves be sub-organized into (a) an Engineering Party, and (b) a Transportation Party. The latter would take charge of the transportation of the entire Expedition and its stores and equipment in two caravans from India to Mount Everest :

first, the Preparation Party, travelling in the very early spring, arriving at the Rongbuk in March ; and secondly, the Climbing Party, who would follow two months later.

At the Rongbuk Monastery a dump would be made (fed and maintained by the Transportation Party), while the Engineering Party with a corps of one hundred Nepalese and Tibetan coolies (men and women) would build stone-walled huts and animal stables at the site of the old No. 1 Glacier Depot at the junction of the East and Main Rongbuk Glaciers. After this they would smooth a path up the right (east) bank of the East Rongbuk Glacier fit for yaks to follow.

After the 1924 Expedition, in my photographic wanderings over the glacier, I took particular pains to explore the right bank ; and I found that this way could be made comparatively easy for yaks. It would be about 9 miles long, but not more than a total of 3 miles would need work upon it to smooth out a yak path. Where the lateral glaciers join the parent trunk the ice is broken into bergs and the way is now blocked, but, as I have said, not more than three miles of path would here need making. The yak, the highest-going, the heaviest-load-carrying, the most sure-footed and the hardiest mountain-transport animal in the world, is the natural means of transportation which Tibet offers. I think the Expeditions have rather failed to realize the full possibilities of this natural resource of the country.

When this path was made, the Transportation Party with their convoy of twenty-five yaks (owned and bought by them in Tibet) would transport the whole equipment of the Expedition to the head of the East Rongbuk Glacier. The animals would have their base at " Yak Depot," 17,500 feet, at the junction of the two glaciers. Local Tibetans and their yaks would keep the Preparation Party supplied as far as the Monastery. The stage between Yak Depot and the Base Camp at 21,000 feet at the head of the glacier would be a one-day stage.

Special fodder for the twenty-five high-going yaks would

be provided in Tibetan tsampa (barley meal, the ration being two handfuls per yak per day), and bundles of compressed grass brought from India. At the site of this Depot there is good grazing for yaks in the summer time along the moraine shelves, where many charming Alpine flowers, mosses and grasses are to be found by the east bank of the main Rongbuk Glacier about one mile from the proposed site of Yak Depot, places which I visited myself several times during the course of photographic work through the main Rongbuk Glacier. Here also there is a supply of firewood, sufficient for the members of the party, the natives, and one white man as Commandant of the Depot.

Next as to the building of the Base. There a hut on the Polar method would be erected, the object being to enable the climbers to live comfortably at this height of 21,000 feet for a protracted period in order to gain the full measure of height acclimatization. During this period of acclimatization they would get into training by practising on the smaller climbs in the neighbourhood, and would maintain their condition by comfortable sleeping conditions and perfection of diet. Their food would consist of a wide variety of palatable foods to suit all tastes and to invite appetite. Cooking by native cooks on primus stoves out in the open confines the menu to dishes made by heating canned stuffs in hot water and turning them out on a dish. Bread would be baked, and cooking and baking would be done on modern American gasoline stoves.

The site of the hut would be not at the position of the previous camp at 21,000 feet, but on the other bank of the glacier beneath the Hlakpa-La, facing Mount Everest at an equivalent height of 21,000 feet and at the head of the new yak road.

The hut could be made of sectional duralumin framework ready drilled for bolting together with plywood panels and roof, the whole held down by guy cables against the wind. The hut would have three compartments, one for the white men, one for the native porters, and one for the kitchen. There would be windows and doors, and bunks for the men

to sleep in like ship bunks made of screw-jointed tubing and canvas webbing. It should be noted that under this scheme of animal and mechanical transportation fewer porters would be needed, probably not more than a total of fifteen selected men. Ten extra men could be kept at the Rong-buk Monastery to be a reserve in case of necessity but yet be no encumbrance on the Expedition's mobility or provisioning.

From the Base to the top of the Ice Cliff would be one stage, with a dump with shelter tents and tarpaulins at the foot of the Ice Cliff, where the aerial ropeway would start. The ropeway would conquer all the difficulties and obstacles now offered by the cliff to the porterage of equipment and stores. It would enable heavy material in large quantities to be transported so that a large Depot could be built up there. The Ice Cliff is an obstacle which one has every right to defeat by mechanical means. It is not part of the ascent of Everest. It is an outlying obstacle of trouble and annoyance to the climbers. The air line need be only of the lightest wire sufficient to take loads of 50 lb. weight. Its total length would at the most be 1,700 feet, therefore its transportation to Everest would be nothing serious. It would be of enormous service.

Such a plan may arouse violent indignation among some people who will say, " Oh ! This is not sporting." " Well," I would answer, " supposing you are going out to ascend Mont Blanc in the Alps, is it sporting to take the train to Chamonix ? Why not get out of the train at the foot of the mountains and start walking there ? Why do you stay in a comfortable hotel at Chamonix before you climb the mountain ? Why don't you go out and shelter the night in some rock crack half-way up the mountain ? Why are an hotel, a cabane-hut and a fine mule-riding road built on the Matterhorn at the foot of the actual rock climb ? " Simply because the climb is considered to start only from the altitude of 10,000 feet. In the same way the ascent of Everest for a mountaineer starts at the top of the Ice Cliff at 23,000 feet. All transportation below that height

T

and along the glacier should be done in the easiest and most efficient way by animal and mechanical transport. It is an absolute waste of human energy and man power to man-handle the transportation up the glacier.

The air-line wire could be carried up in sections of 40 lb. weight, linked together on the top and shot down by a powerful rocket ; or the draw line of steel strand telephone wire could be fired down and used to pull up the load line from below. There would be a light wheel and handle to wind the draw line.

At the top of the Ice Cliff would be established either permanent light hut shelters, made also of plywood and duralumin frames, or else 40 lb. tents with mattresses and sleeping-bags.

A Depot at 25,000 feet or higher would be constructed using some improved form of shelter, such as small sectional huts of plywood and duralumin framing, held down by wires and adjustable by telescopic supports to steeply sloping rock ledges. This would be as far as the Preparation Party would go. The Climbing Party would determine the position for their high bivouac. For that bivouac improved shelter tents would have to be designed.

It would be the duty of the engineer of the Preparation Party to link the Expedition by wireless with India for the reception of weather forecasts, and also to link up the Base with all the Depots up to 25,000 feet with light portable wireless telephone sending and receiving sets. With the developments of modern wireless this would be an easy problem, involving only simple and easily carried apparatus of very light bulk and weight. It would ensure close communication between the Base, the supporting parties and the climbers. High-powered telescopes on stands should be affixed permanently at the Base and Ice Cliff Depots to watch the progress of the climb. News could also be transmitted home by wireless.

Next as to seasons. It has always been the accepted fact, based on the past fifty years' experience of Himalayan explorers and travellers, that the early autumn season at

the end of the monsoon gives the best mountain weather. In September may be confidently expected a fortnight or three weeks continuous stretch of glorious weather with little wind at the clearing up of the monsoon. This may be followed by spasmodic returns of monsoon clouds before the final clearing up in October, when the weather becomes brilliant and absolutely dependable. But then in October it becomes colder and colder and the days shorter. An objection which has been urged to September is that snow falling will not melt. However, the snow problem on Everest is not so serious comparatively, because the wind, frequently blowing on the summit, will blow the snow off soon after it falls. A greater danger from snow is the risk of avalanches that a fresh fall may cause on the Ice Cliff, but now our aerial ropeway will minimize that trouble.

The Everest Expeditions have been very conservative in not trying the autumn season. In 1921 when Mallory, who had never been to the Himalaya before and had no previous knowledge of Himalayan conditions, met an unusually unlucky spell of bad weather (just as the Everest Expedition of 1924 came into an unlucky spell in the spring of that year) this experience prejudiced him against the autumn season ; and the Everest Expeditions have since, following Mallory's example, chosen the spring season. It must, however, be remembered that the plans of the Committee in 1922 provided for the Expedition to remain out through the summer should they fail in the spring, in order to attempt the climb again in the autumn, but that that autumn campaign was abandoned because of the exhaustion of the climbers, the accident and the death of the porters, and also because, unfortunately, many members of the Expedition became a little too anxious to get home.

With all the preliminary work done by the Preparation Party ahead, the Climbing Party could arrive at the Base one month later and try their hands at the mountain in the pre-monsoon period if they wished, but I, myself,

would make the suggestion that they should arrive later, during July, and remain at the Base hut during the latter half of the monsoon, acclimatizing to altitude at 21,000 feet, practising preliminary climbs during the short breaks of fine weather which do occur even in the middle of the monsoon, and be prepared to make the ascent of Everest the moment the monsoon cleared.

Another advantage of arriving at this later season is that the climbing party would make the journey across Tibet under more favourable conditions and would avoid the hardships and damage to health of crossing the Phari Plains in the early spring, which experience I have no hesitation in saying (as I shared it twice) seriously reduces the physical efficiency of an Expedition. To reach Everest from India, it must be realized, is an effort for which a price has to be paid. In the early period of spring blizzards the price was the life of Dr. Kellas in 1921. Although his serious illness was due to a variety of causes, still it was the hardship of the Phari Plains that finally killed him. General Bruce nearly died of malaria brought on again by sudden exposure to the ice winds of the Phari Plateau after the warm climate of India. It used to be a saying among us that Everest's long arm started to hit us before we ever reached her. Porters fell ill and became exhausted crossing Phari Plain ; fever and dysentery attacked us. The hardships of the fearful wind on the 17,000-feet plateau sapped our strength before we were acclimatized. Beetham, who is one of the stoutest men of the Alpine Club, a man with a marvel of pace and endurance on mountains, a climing companion whom Somervell himself could not outrival in the Alps, in 1924 nearly died of dysentery through the sudden change of climate and food, arriving on the blizzard-swept plains of Tibet fresh from home on this his first experience of the Himalaya. It unfortunately put him out of action altogether. He was a tremendous loss to the Expedition, because, if fit, he might have joined and strengthened Mallory's party for the summit.

Besides this there is the mental depression that takes its

sure toll of the efficiency of all. The journey across Tibet in the early spring is a horrible ordeal. It is vital that the men should be happy and enjoy themselves to the utmost, with their enthusiasm and spirits maintained to the topmost level.

A better plan would be to avoid entirely the crossing of the Phari Plains by travelling through the delightful Tista valley of Sikkim, ascending gradually to the upper Lachen Valley and acclimatizing for ten days at the last bungalow of Thangu at 13,000 feet. Under favourable weather conditions, and acclimatized to altitude, the party would walk over in two days to Khamba Dzong in Tibet and stay there for another short acclimatization period at that charming place, described by Norton as " the sun trap and comfort castle." They would then journey on across Tibet, the ride being a delightful picnic, refreshed by bathing in the streams and the enjoyment of the exquisite scenery of the early summer.

The food problem is one of the most urgent considerations for the success of an Expedition. A competent white man cook should be brought and arrangements made for the preparation of palatable and nourishing food in quantity and large variety, together with the baking of fresh bread. I think the natives, although immensely hardworking and loyal and keen, are entirely ignorant as cooks and not a little dirty. Many times repeated stomach troubles were caused directly by poison from unclean cooking. In 1921 Mallory told me they suffered a great deal at the hands of their cooks. In 1924 Mallory at one time became seriously ill near Khamba Dzong and Somervell prepared his instruments to operate for appendicitis, but finally diagnosed the trouble as poison from the native cook's kitchen. Other members of the party suffered in this respect also. The stomach of course is the mainstay of strength in mountaineering as in any other form of athletics.

One other important improvement in food arrangements would be to form a mess for the native porters under special native cooks assigned to that purpose only. On

previous expeditions the porters have always cooked their own food, sometimes each man independently. This has caused a waste of fuel and loss of time and energy. Each man added his own cooking-pots and food-bag to the weight of his load. On the other hand, if the men were collected together at fixed times for fixed meals prepared on rations apportioned by the stores master and cooked by their own cook, this would mean economy and also increased comfort to themselves. The men would not, after the fatigue of their work, have to set about cooking their own food. Anyone understanding the management of Indian people will know what the cry of " Khana, Khana " (" We must eat ") means. It means that that fellow must be left absolutely undisturbed and not even spoken to. " Khana " is a sort of religious fetish with the " man of India." Often, when there was a job to be done, we would call one of the men. We would probably find him taking his food, because every man would be preparing his food independently and at any odd time of the day or night. He would leave his food in answer to the call because he is naturally obedient and cheerful and willing. But this is not as it should be. He should be left absolutely undisturbed when he is taking his food. That is a vital thing in handling Indian peoples.

Upon the porters so much depends. They must be under the care of one special member of the Expedition, who speaks their tongue fluently and who knows their ways and how to make them contented. He will see that their food is prepared at fixed times as far as possible, that their rations are issued in fairness to all, that each receives his proportion of comforts, cigarettes and other extra rations, that there is always hot tea and tsampa ready for any man who arrives in camp after a hard day's work. He will see that the men are all asleep and lights put out at ordered hours ; and that no one has stolen another's blanket, and so on. These may seem silly and trivial things, but they are just the little points that make natives happy ; and if they are happy, fit and well fed, these simple-minded people

will work with the strength of giants and the joyous hearts of children. . . .

Will Everest ever be climbed ? Of course it will. Why, some day man will fly to the top of Everest and walk down breathing liquid oxygen gas.[1]

This world is owned by man. Man has infinite capacity within himself.

[1] The herculean exploits of the Mount Logan Expedition of 1925 should be studied, and how the results of their experience in depot-laying, general organization and porterage work by white men, as opposed to natives, might be applied to the conditions of Everest.

APPENDIX C

TO EVEREST BY AIR

Whereas the Mount Everest Expeditions, organized solely for the object of mountaineering, have no interest in flying over the mountain, yet the conquest of Everest by air is a project of absorbing attraction for explorers in the field of modern open-air adventure. In my many public lectures on the Expeditions there is no question that I have been more often asked than that of the chances of flying over or to Everest ; and I, myself, after careful study of the problem, hold definite views of the possibility of the feat and of the method of undertaking it. It might therefore be of general interest to append here some brief notes of such a plan as I have conceived it.

The altitude of 30,000 feet is now no difficulty to modern high-flying machines. They can now also be constructed to be able to hover almost stationary against even mild winds. (I do not necessarily refer to heliocopters.) From already proved performances in high flying and in hovering, it would be possible to provide a machine that could hover within 100 feet over the summit of Everest and so allow a passenger from the plane under certain right conditions, and protected by thickly padded clothing which he would discard on landing, to descend by a rope from the machine to the ground. The shape of the summit of Everest, as far as observed by telescope hitherto, seems to offer sufficient space, evenness and snow-covering to make such a landing possible, although there would be no chance of a plane itself landing, nor of even taking off again nor of picking up its passenger. That passenger (there could be two) would, with the aid of liquid oxygen breathing and previous high-altitude acclimatization, descend the moun-

tain as far as the East Rongbuk Glacier snowfield at the foot of the Ice Cliff, where another suitably constructed aeroplane could easily land and pick him up to fly back to India.

The descent of the mountain would be undertaken in two days, using sleeping-bags and food dropped in a suitable place on the mountain during previous flights. A number of these Depots would be dropped for the choice of the climbers.

From fairly extensive knowledge of the Himalayas and of Mount Everest in particular, I, myself, am convinced that there are periods in the seasons when the atmospheric conditions are regular if not sometimes actually calm on Everest.

One aviator has flown north from India towards Kangchenjunga and has reported adversely on the possibility of flying over the high Himalayan peaks owing to the winds and air pockets, but his report is none other than I would anticipate over the country of Sikkim because that country and its valleys and mountains lie in a funnel of erratic aerial conditions; furthermore, the aviator did not fly high enough. The flight to Everest should be made in a northeasterly direction from a Base on the plains of India southwest of Everest and not south or south-east. The aviators should reach 20,000 feet above the plains and then fly direct to Everest.

It must be remembered that the great advantage the flight project enjoys over a mountaineering project to reach the summit is that Everest is so close to India—the flight need not exceed 200 miles. Therefore the aviators can reach the mountain and complete the major part of their feat in one day—the most favourable day. They can, from their Base, set out each day, reach the mountain, test the air conditions, and if not perfect they can merely return to their base and set out again at short notice at any other moment. Mountaineers have a 400-miles journey on foot with enormous impedimenta and caravan of one hundred men.

The actual ascent of the mountain from their Base is a matter of some seven days. They are dependent on the weather, which they cannot forecast, but upon which they absolutely depend during all those days to win or to lose.

I consider it essential that plans for the flight should include the acclimatization of the aviator-mountaineers to high altitude. This could be done by building at the Base on the plains of India a special small house inside which the atmospheric pressure could be exhausted and controlled. The men would not need to dwell all day and night in such a chamber, but could go in and perhaps sleep there for periods to get acclimatized to varying altitudes, —15,000 feet, 20,000 feet, and finally 25,000 feet. Some six weeks would be allotted to such acclimatization.

In this way the aviator-mountaineers would find themselves in the best physical condition when they landed on the summit and would be able to effect the descent of the mountain, although they would be provided with sufficient liquid oxygen to undertake the whole descent to the glacier at 22,000 feet.

The man to carry such a feat to a brilliant conclusion will have to be a man with a bird sense and also a mountain sense, together with the stoutest pluck and tremendous physical endurance. I believe the world will produce such a man.

INDEX

Abruzzi, Duke of, 28; Expedition, 116, 118
Acclimatization, 150, 167, 188, 239, 280, 284–5, 288, 298. *See* Altitude
Adhu, 31, 33, 37, 47, 49, 58
Aga Khan, the, 214
"A. K.," 23–24
Alpine Club, 28, 97, 116, 178, 203
Altitude, high; adaptation of animals to, 234–9; cooking at, 180; food at, 170, 180; fuel for, 204; physical effects at, 170, 254, 272; psychological effects of, 167–8, 197; tobacco at, 172; ultraviolet rays at, 171
Amundsen, 283
Arun, river, 27, 31, 56, 89, 91
Ata Mahomed, 22

Badri, 32, 33
Base Camp (1922), 148, 153, 155, 160, 165, 191; (1924) 223, 232; reorganization of, 285, 288
Beetham, Bentley, 123, 207, 223, 236, 250, 292
Bell, Sir Charles, 97–100
Bhutias, 36
Brahmaputra, 22, 24
Bride Peak, 29, 116, 181
Bruce, Captain Geoffrey, 123, 124, 147, 169, 185–91, 220, 223, 227, 242, 244, 250, 260, 262, 264 *et seq.*

Bruce, General, 28, 76, 83, 120, 149, 153, 154, 164, 198, 206, 207, 215, 218–20, 292
Bullock, George, 101, 105
Burroughs, Wellcome & Co., 214

Chamalung, 136
Changmu, 54
Cheddup (interpreter), 210, 223
Chelmsford, Lord, 97
"Chimney," the, 242, 243, 255
Chomiomo, 88
Chomolhari, 129, 219
Chorten Nyim, pass, 42; shrine, 49–51, 141
Chumbi, 77, 126, 217
Clothes, 173–4
Collie, Norman, 122
Conway, Sir Martin, 122
Crawford, C. G., 123, 191–7
Curzon, Marquis, 28

Dalai Lama. *See* Lhasa
Darjeeling, 35, 90, 126, 214, 215, 218
Dent, Clinton, 117
Dingri Maidan, 26
Dok-pas, 52, 133
Dorji Pasang (" tiger "), 242
Drasrinmo, 85, 86
Dzod-Nga, festival of, 43
Dzongpens, 84

East Rongbuk, Glacier, 108, 115, 148, 153, 180, 287, 297; Valley, 110

299